Praise for Francis Flaherty's *The Elements of Story*

"Francis Flaherty, in this delightful book, captures the art, the craft and, above all, the joy of telling a great story. It's the core talent of any great writer—and also a useful one for any great leader, friend or companion."

—Walter Isaacson, author of *Einstein* and former managing editor of *Time* magazine

"Frank Flaherty's *The Elements of Story* is a model of good sense, a clear, well-lighted path through the jungle of nonfiction narrative. It represents so much accrued wisdom that even veteran writers will want to keep it on hand, and it's fun to read, too." —Luc Sante, author of *Low Life*

"Flaherty's book will be the classic yardstick for how to grab readers and not let go until they see and hear and think exactly what the author has seen, heard and thought." —André Aciman, author of *Call Me by Your Name*

"Both a manifesto and a map for great writing, *The Elements of Story* by Frank Flaherty brings to nonfiction narrative the polish that William Strunk Jr. and E. B. White brought to grammar and usage in *The Elements of Style*. *The Elements of Story* should be on the bookshelf of every aspiring or accomplished writer and in every journalism classroom."

—James O'Shea, former editor of *The Los Angeles Times*

"Ailing writers, not to worry. There is a Story Doctor in the house. His name is Frank Flaherty, and his powerful medicine is on every page of *The Elements of Story*. It belongs on your shelf, right there next to that other *Elements* book." —Roy Peter Clark, author of *Writing Tools*

"*The Elements of Story* is a must-read for any burgeoning journalist. Of course, I imagine Frank Flaherty would push me for a better description than 'must-read.' Alas, some things are cliché for a reason—this creatively insightful, charmingly insidery and eminently wise book belongs on every writer's desk. It just does." —Sloane Crosley, author of *I Was Told There'd Be Cake*

"Frank Flaherty has found the perfect voice to guide writers in creating muscular yet nimble prose. He's encouraging and friendly (exuberant, even!), assured and wry. A delight to read, *The Elements of Story* makes me itch to write."

—Elizabeth Royte, author of *Garbage Land: On the Secret Trail of Trash* and *Bottlemania: How Water Went on Sale and Why We Bought It*

"A virtual *Merck Manual* for story doctors, filled with insightful diagnoses and effective prescriptions."

—William G. Connolly, co-author of *The New York Times Manual of Style and Usage*

"Francis Flaherty has turned his love of writing into a book that will help journalists produce life-enriching articles that can hold their own against the most imaginative fiction."

—Bill Kovach, former editor of *The Atlanta Journal-Constitution* and co-author of *The Elements of Journalism*

"Frank Flaherty's writing guide is fluid, fun and filled with brilliant advice for anybody who wants to improve their work, break into this country's top newspapers or get a glimpse into an editor's mind."

—Susan Shapiro, author of *Only as Good as Your Word: Writing Lessons from My Favorite Literary Gurus*

"For most writers and editors as well as teachers of either, there is a largely uncharted region in the world of word working. It lies north of simple proofreading and copyediting, but south of loftier realms of high-concept story proposing or book pitching. This Middle Earth even has a name: it's the office at the best newspapers and magazines where the 'story doctors' work. One of its ablest practitioners has now written a splendidly detailed guide revealing the secrets of his craft."

—David Abrahamson, Charles Deering McCormick Professor of Teaching Excellence, Medill School of Journalism, Northwestern University

"This is one of those books that will end up on the bedside table of many of America's best writers."

—Jon Franklin, winner of the Pulitzer Prize for Feature Writing (1979) and for Expository Journalism (1985)

"In *The Elements of Story*, Frank Flaherty distills for a wide audience the exceptional instruction he provides to New York University journalism students fortunate enough to take his class. For my students, this book will now be required reading."

—Brooke Kroeger, director, New York University Arthur L. Carter Journalism Institute

"*The Elements of Story* is an essential guide for every writer—aspiring and professional—who wants to understand how to make a story soar. And, fittingly, a joy to read."

—Michael Shapiro, author of *Bottom of the Ninth* and professor of journalism at Columbia University

"Frank Flaherty has written a literate, enthralling and indispensable guide to the increasingly popular genre of nonfiction writing."

—Neil Gordon, dean, Eugene Lang College, the New School

"*The Elements of Story* is the work of a master editor. This book will be invaluable for writers of all kinds, not just journalists, in figuring out the elusive magic that makes for a good story."

—Suketu Mehta, associate professor of journalism, New York University

The

ELEMENTS

of STORY

The
ELEMENTS
of STORY

Field Notes

on

Nonfiction Writing

FRANCIS FLAHERTY

HARPER

An Imprint of HarperCollins*Publishers*

HarperCollins books may be purchased for educational, business, or sales promotional use. For information, please write: Special Markets Department, HarperCollins Publishers, 10 East 53rd Street, New York, NY 10022.

FIRST EDITION

Designed by Cassandra J. Pappas

Library of Congress Cataloging-in-Publication Data
Flaherty, Francis
 The elements of story : field notes on nonfiction writing / Francis Flaherty
 p. cm.
 Includes bibliographical references and index.
 ISBN: 978-0-06-168914-7 (alk. paper)
 1. Storytelling—Handbooks, manuals, etc. 2. Narration (Rhetoric)—Handbooks, manuals, etc. 3. Flaherty, Francis. I. Title.
 PN212.F53 2009
 808.5'43-dc22

09 10 11 12 13 OV/RRD 10 9 8 7 6 5 4 3 2 1

For my family,
small and large,
here and gone.

Contents

Introduction xv

PART I. A HUMAN FACE
*Every story, even the driest, has a human face. Draw
it well and put it on display, for to readers it is a
mirror and a magnet.*

1. Shivers on Wall Street 7
 Every story has a human element.

2. Burrito Heaven Blues 9
 *Talking heads are just heads. Find a whole person to
 tell your story.*

3. White Knuckles 13
 *Emotions are abstract, and describing them is hard.
 But the writer must try, for an article without emotion
 is like a sun-bleached shirt.*

4. The Man Who Glowed 17
 *Empathy is precious for the writer. If he is attuned to a
 subject's inner life, he can double the depth of his story.*

PART II. THE THEME

The writer must be loyal to his major theme. He must study all its facets, and he must tamp down other topics that threaten to displace or diminish it.

5. A Baker Named Muffin 31
 A writer who is jack of all themes will be master of none.

6. Bang the Drum Strategically 35
 A writer must regard his story through theme-colored glasses.

7. What Babies Know 39
 The sound of words and the rhythm of sentences are a language wholly apart from the dictionary. Make sure your story not only says what you mean but "sounds" what you mean.

8. Temptation Alley 43
 Verbs are the most important words in a story, and the most important verbs are those that reflect the main theme. They are verbs with a capital V.

9. Professor Brinker's Obsession 47
 Keep exploring your subject. The more you look, the more you see.

10. Razzing From the Rafters 51
 The smart writer is fair, and he also knows he may be wrong. So he is generous in letting dissenters state their case.

11. The Bentley and the Bodega 53
 Choose your main theme and position it, uncrowded, at center stage.

12. The Skinny Librarian 59

 *A writer must be a sensitive gatekeeper, for every
 tidbit that she puts into her story is a burden on the
 reader.*

13. Drive-By Deliciousness 65

 *A writer can sometimes include a by-the-way morsel
 without hurting his story. But he must be disciplined,
 and make the detour short.*

PART III. MOTION

 *Good stories are a brisk journey, and the reader can
 always feel the breeze in his hair.*

14. Stroke and Glide 75

 *All stories are divided into two parts, the action and
 the commentary.*

15. A Stirring in the Garden 79

 *Making her story move is the writer's main duty.
 Fortunately, there are many engines for the job.*

16. Paintings Without Frames 85

 Breathless writing exhausts the reader.

17. Ask Not What . . . 89

 *Group similar points together. They gain power from
 consolidation, and lose power from interruption.*

18. Cathedral in the Shadows 93

 *Readers appraise a fact or idea in light of the facts or
 ideas that surround it.*

PART IV. ARTFULNESS
*The artful writer sees what others see. He just sees it
in a dawn-fresh way.*

19. The Smell of Pleather 105
The five senses are a writer's most formidable tools.

20. Sparks on the Highway 109
*Look until you see something new, for the writer is the
watcher of the world.*

21. The Sunshine Boy 113
*"Show, don't tell" works because a showing is a telling,
just a more vivid one. But the wise writer knows that
"tell" is sometimes the more prudent choice.*

22. The Ballad of Custer's Horse 117
*Sometimes, say things sideways. The reader will be
grateful.*

23. The Robin and Stone Mountain 121
*Metaphor and other fanciful images are staples of
nonfiction, but the nonfiction writer should consider
even deeper forays into imaginary territory.*

24. The Girl Who Was a Servomechanism 125
Quotations are found art. Use them liberally.

25. Borrowed Grace 131
White is whitest on black. Let contrast work for you.

26. The Pebble and the Pond 135
*Symbols are powerful, so use them.
Symbols are powerful, so use them carefully.*

27. The Secret of the Sea Urchin 139
Sometimes, a writer must be a sweet talker, wooing his
wide-eyed readers with honeyed words. Then, when he
has lulled them, he springs his surprise.

28. The Upside-Down Staircase 143
A writer should seriously consider the use of drawings,
maps and other nonword ways to make a point.
Sometimes, no mot is juste.

29. All My Darlings 149
Like the colors in a painting, words have a beauty and
a worth beyond a writer's composition.

30. Pretender in the Promised Land 155
The writer who indulges in fancy-pants prose
sometimes has too large an ego, and sometimes one
that's too small.

PART V. TRUTH AND FAIRNESS
Writing is an art, and art bestows a license. But the
license is a limited one, and it never sanctions material
omission or unfair play.

31. Something There Is That Doesn't Love a Fence *167*
Writing is an act of assertion and judgment. Do not
evade that part of the job by hiding behind bland
language or others' words.

32. Those Cantankerous Inhabitants of Clinton 173
A writer must let subjects respond fully to criticism,
must parse his words closely to avoid reader offense
and, in features, must be wary of lapses in reporting.

Contents

33. The Rose of Spanish Harlem 179
Feature articles are often about mood and other gauzy matters, but they must rest on a hard nut of logic and proof.

34. The Rose of Spanish Harlem II 183
To strengthen her article, a nonfiction writer will often be tempted to twist the truth. She must suppress this urge, for distortion is a slippery slope, and facts are all the nonfiction writer has.

PART VI. LEADS AND OTHER ARTICLE PARTS
Leads and settings, transitions and kickers: Each part of an article demands its own peculiar art.

35. Colonel Foster, Commanding 197
It is easy to write a defective lead and just as hard to write an artful one.

36. The Heirs of Dr. Cadwalader 201
Good leads come in many shapes. But the common measure of their worth is their power to provoke curiosity.

37. The Artist and the Old Socks 205
By linking unlikely items, the "double take" lead can lure in the puzzled reader.

38. The Secret Taxi Signal 207
The mystery lead can be a brief and powerful way to engage the reader. But used too freely, it sounds cheesy.

39. Norma Rae Comes to Brooklyn 209
The anecdote lead is much maligned, but its low reputation stems more from bad execution than from inherent flaws.

40. Long Lines at Buckingham Palace 213
Of the dozens of lead varieties, three that deserve more attention are the scene lead, the fact lead and the Harry Truman lead.

41. Death of a Banker 217
No words are more important than the lead. Invest the time to compose, and compare, several possibilities.

42. Why Snuffy Stirnweiss Matters 221
Like a diamond, a story needs a setting.

43. The Man Who Met Lincoln 225
Besides furnishing the atmosphere of an article, the setting often answers that vital reader question, "Why should I read this?"

44. Yellow Ribbons and Honeylocusts 229
The nut paragraph is both a map and an ad.

45. The Soccer Girls 233
The best transitions are the ones avoided.

46. The White Tiger at the Garden 239
The end of a story can be the bow on the package. It can also be something more substantial.

PART VII. THE BIG TYPE
Titles and subtitles are turbocharged text. They are your work distilled.

47. Why Change an Apple? 251
The large type presents the first words that a reader encounters. With a big mission and little room, these titles and subtitles are a boot camp for sharp writing.

48. Cabs and Cornfields 255
 Composing a title demands a deep understanding
 of the text and a fine-grained appraisal of different
 phrasings.

49. The Tides of Brooklyn 261
 A subtitle is an outline to a story. But it is more
 concentrated, and written with verve.

50. Pundamentals 265
 Word games offer a nice sideshow for the reader. They
 are never profound, but some efforts are smarter than
 others.

 Afterword 271

 Acknowledgments 275
 Sources 277
 Index 283

Introduction

IT WAS A Tuesday in early spring 1993, my second day at *The New York Times*. I had that nervous newbie look, with a too-pressed shirt and half an expectation that someone would bounce me back onto 43rd Street. In the afternoon, as I was screwing up my courage to ask some mundane, newbie-type question of an editor with the formidable first name of Condon, the call came for the newsroom to gather near the National Desk.

Gradually, journalists drifted to the appointed place.

Arrayed there on dining carts were bottles of Champagne, and stacked glasses. Waitresses in black frocks with white trim poured healthy servings, ready for the taking.

Hmm, I thought. Midafternoon Champagne break. This really *is* the summit of American journalism.

When Max Frankel, the *Times*'s executive editor, began to speak, I of course learned that this was no regular thing. This was a very special thing, the announcement of the Pulitzer Prizes, and John F. Burns, a veteran *Times* correspondent, had snagged one that year for "his courageous and thorough coverage of the destruction of Sarajevo and the barbarous killings in the war in Bosnia-Herzegovina."

At this point, a new guy in a too-perfect shirt is getting the willies, wondering if there is any place for him in a superachieving place like this. Like a writer facing a blank screen and a big hairy topic, I felt way over my head.

But just as usually happens with that writer, things turned out O.K. There was a place for me, for the fortunate reason that journalism is a big rambling house with many rooms—not just Foreign Correspondence (trench coats in the closet), but also Graphics, Investigations, Web Video and on and on, all in need of people with special talents and special interests.

The room where I found a chair is called Story Doctoring. Its inhabitants (and I am one of many) examine texts for what ails them and apply various nostrums. This room is far distant from the whizzing bullets of Sarajevo, and much less heroic, but it is no less close to the heart of journalism. Every writer needs a story doctor—even a story doctor, when he writes a story himself.

It wasn't the Pulitzer Champagne that led me to stumble into that particular room. I stumbled into it because I am just better at story doctoring than I am at other journalism jobs, and because I love story doctoring, which may amount to the same thing. "Follow your bliss," said Joseph Campbell, the late mythologist and life philosopher, and without knowing that's what I was doing that's what I did. I would not know an investigative journalistic breakthrough from 50 paces, but I would know a misplaced paragraph from 50 miles. Usually. That's just how my eyes see, and don't see.

To me, my personal newsroom journey proves that if you love some aspect of writing, you need not worry that you are not John Burns. True, from the outside, which is where I was on that April day, the Burnsian heights seemed unscalable. But the good news for journalistic and literary aspirants is this: when you discover a love for some particular writing thing, as I did, that love trans-

ports you to the *inside*, and the world there doesn't look nearly so daunting. In that place, Condon is just a name. In that place, a blank computer screen is a field of glory. In that place, a big and hairy topic presents as deliciously complex. The world will ultimately decide whether you succeed in that place or not, but you will be happy there, and that's the best measure of success anyway.

What have I learned in my particular place, the Story Doctoring room? I have learned how to weave tales. I now know how to pedal the loom, which fabrics work and which do not, which colors enhance and which detract. I can detect snags, and gaps, and thin patches. I can hide the seams, and make the weave tight. I have very little to do with procuring the fabric, or snipping stray threads, or displaying the fabric invitingly—for that stuff, take it down the hall to Reporting, Copy Editing and Art Direction. But whether you call it fabric, or music, or a trip down a river, a story and its design, from the original idea to the kicker, that's my realm.

This book is about that room. It draws on my 20-plus years as a journalist, nearly all of them at the *Times*, first in the Sunday Business Section and then in the City Section. I have been largely an editor at the *Times*—most recently the deputy editor of the City Section—and in that capacity I have edited hundreds of articles by scores of reporters, from Reed Abelson to Laurence Zuckerman, and by such contributors as the former Harvard President Derek Bok, the essayist André Aciman, the economists Paul Krugman and Robert Reich, the novelists Kevin Baker, Colin Harrison, Joseph O'Neill and Alexandra Styron, and the humorists Bill Geist, Stanley Bing, P.J. O'Rourke and Roy Blount Jr.

The book also draws on my years at Harvard, where I spent many happy hours missing class and learning the writing craft at the weekly *Harvard Independent*, and on the insights I have

gleaned over the last decade from my students at New York University. I also rely on my own experience writing for the *Times*, where I wrote the weekly Investing column from late 1993 to early 1995, and for such other publications as the *Progressive*, *Commonweal*, *Harper's*, the *Atlantic* and *Newsday*.

As this list of writers—students, reporters, academics, essayists—and writings—columns, essays, features—suggests, I find that the tenets of story doctoring apply not just to journalism but to writing writ large. Story doctoring is all about prose that is riveting and persuasive, and as such it has currency for every writer, from the freelancer in his garret to the English grad student, from the beat reporter to the aspiring blogger.

White Looks Whitest on Black

Writers' missteps fall on a small number of paths. This is the premise behind many writing books, and this premise dictates their form. Strunk and White's *Elements of Style* offers just 11 rules of usage, 11 principles of composition and 21 suggestions on style, for example, and that structure implies this: There may be billions of mistakes out there in the world of print, but if the reader masters a modest number of directives, he can pin down the bulk of writing problems.

I think this happy assumption is true. A writer who learns to make every word count—Strunk and White's "Omit Needless Words"—has traveled far toward composing a decent paper or article. With just a few more such advances—"Avoid Fancy Words," "Use the Active Voice"—his writing is well on the way.

Moreover, I believe this pattern also holds for this book; my 50 principles, I hope, cover the bulk of the writing problems I address. This is luckier than it may seem, because I address very different problems than do many writing books.

Other writing instructors work substantially on the level of *style*, of the line-by-line issues of writing. This book focuses instead on the level of *story*, by which I mean the architecture, the bones, the tendrils, of an article. This book is about: how to make a story move (Chapter 15: "A Stirring in the Garden"); how to paint a setting for your story (Chapter 43: "The Man Who Met Lincoln"); and how to use description to buttress your theme (Chapter 6: "Bang the Drum Strategically"). But this book is not about: run-on sentences, errant punctuation, misplaced modifiers, rampant bureaucratese or ambiguous antecedents.

Call it *The Elements of Story* rather than *The Elements of Style*.

Some of these story-level principles are warnings about writing mistakes. For example, a writer may cram too many themes into his story, dooming himself to develop none of them well (Chapter 5: "A Baker Named Muffin"). Or he may set out full sail to explore a terrific topic, but encounter some enchanting sidelight and veer off course (Chapter 13: "Drive-By Deliciousness"). Other principles urge writers to seize good storytelling opportunities. For example, if a writer puts his theme in a contrasting frame, he can make that theme stand out more—white looks whitest on black, so to speak (Chapter 25: "Borrowed Grace").

But whether they are red flags or green lights, this book's principles exist on the story-level plane of writing. There are not many such books, and the ones there are often sandwich their story-level discussions between lengthy article reprints and long explorations of reporting basics, query writing, and line-by-line matters.

This book is only about story. I am not saying there is no overlap with other aspects of writing—overlap is unavoidable—but concern with story is its lodestar.

Although this book does not directly address style, it may help in that department just the same. A writer who knows his Big Thought, for instance, is less likely to commit those adjecti-

val pileups that the stylebooks criticize, simply because he will be more vigilant about relevance. Here's an analogy: In driving school, students are told to keep their eyes focused not close up but far ahead; if they do, they learn, the car will automatically stay steady on the pavement right in front of their bumper.

A word about organization. *The Elements of Story* grew by accretion. Beginning in 2003, as I was editing stories week by week, I would encounter the good, the bad and the ugly, and I would sketch each misstep or smart maneuver. Those sketches soon numbered 50, and they each grew into a full-fledged principle, and those 50 principles divided easily into the seven large sections— "A Human Face," "Artfulness"—that constitute the framework of the book.

The take-away point is that *The Elements of Story* grew organically from the In Box of a working editor, and this provenance is my main argument for its empirical validity. Line-by-line problems of *style* are indisputably common in the world of nonfiction writing, and the how-to literature about these problems is abundant and helpful. But, judging from my not-atypical editing experience, problems of *story* are equally common, and usually more complicated, yet the literature about them is sparse. This is a real mismatch, and my book addresses it.

A few disclaimers. No book is wholly original, especially a writing book; many of these ideas have been expressed elsewhere. Second, I am not an academically trained rhetorician; for such experts, some of my rules may seem obvious or oddly labeled. Third, this book is about composition; it largely assumes a writer has done his basic research and has a basic writing plan. Fourth, my writing rules, like anyone's, are colored by my experience; I have less to say about character development, a crucial topic for novelists, than I do about leads, a central issue for journalists.

Moreover, readers should be skeptical of this, and of any, writ-

ing book. Besides the abiding mystery of whether good writers are born or made, there are plenty of competing cures out there for the prose-needy. Colette found it helpful to pick fleas off her cat before writing, and Kerouac wrote the first draft of *On the Road* in a single typed sheet, 120 feet long. Maybe those weirdnesses made all the difference!

A technical note: Sometimes in this book, I quote from real, published stories and then invent an alternative to the published version to make a point. Other times, I sketch wholly imaginary articles, many but not all inspired by subjects that have been addressed in the City Section.

Finally, I've tried to quote pithily, to illustrate briefly, to get swiftly to the chase. As Strunk and White said, "Omit Needless Words!"

A Human Face

Every story, even the driest, has a human face. Draw it well and put it on display, for to readers it is a mirror and a magnet.

THE CADILLAC MAN

The Sunday Business Section of the *Times* deals only with business, the economy and personal finance, which makes its Op-Ed page the province of fairly arid subjects. During my years as the editor of that page in the early 90's, its top five topics would probably have been downsizing, re-engineering, emerging markets, the federal deficit and global business transparency (don't ask). Pretty abstract stuff, but the upside of this abstruse field was this: If a writer or editor learned to put a human face on a piece about the federal deficit, he learned to put it on anything.

That is what happened to me. One of the other big business stories of those days, the decline of brands, is a good illustration of my experience:

Cowed by the recession of the early 90's, Americans grew reluctant to fork over extra cash just for the privilege of buying a product with a brand name. Business executives reacted fast, slashing prices on their big brands and offering cheap, no-frills, brandless products as well. The upshot was that brands, long cherished in corporate boardrooms as money in the bank, became much less lucrative.

In July 1993, I wrote a column about this business story:

When I heard that brands were dead or dying, I thought about the Cadillac Man. His name was Steve Saccardo, and he lived across the street from us in our Long Island town. He worked in a gas station, kept an immaculate lawn, and achieved some local notoriety one Thanksgiving when a cooked turkey came flying out an unopened window of his house.

But mostly he was the Cadillac Man. Every year or two he'd buy a new Cadillac, usually a dark color. The practice caused the expected notice in a town where Chevys and Fords were the norm.

Mr. Saccardo didn't say much about his Cadillac, but I suspect that when he swung onto the Meadowbrook Parkway he became in his mind's eye whatever it was he most aspired to be. And, on the anonymous road, with only his car to go by, other travelers probably saw him the same way: Cadillac Man.

To corporations, of course, brands (including car models) are bottom-line tools, devised to segment the market and reduce the elasticity of demand. They've done these things well, but now they're faltering. Sharp-eyed shoppers are grabbing generic shampoo in utilitarian packages. Procter & Gamble, the temple of Crest and other premium brands, is slashing its work force. Philip Morris and RJR Nabisco are slashing cigarette prices.

All this reminded me of Mr. Saccardo. Brands may be corporate gravy and sure they cost more, but they also have their uses. It's something the sharp-eyed shoppers should keep in mind.

Brands let you define yourself, for instance. In college, I smoked Old Golds for a time. This meant that I was not an alienated brooder (Camels) or a salon intellectual (Gauloise) or a cowboy wannabe (Marlboros). What I was I don't know, but brands let me say what I wasn't.

Snobs love costly brands, of course, but so do people with

more worthwhile purposes. I know a woman who's had tough times. Money has sometimes been tight, but she has always used only Chanel perfume. This lone luxury helps soften the hard edges of her life. It's brand-as-therapy.

I don't think that Wal-Mart Econo-Size Valu-Pak Perfume would satisfy this human need.

Brands also bring memories. I remember the Charles Chips man delivering his big tan tins of potato chips to our house, and the smell of oil and salt and potato when my sisters and I pried the cover off. I eat them to this day, even though the tins and the delivery man are long gone. My wife recalls fondly the taste of Ipana toothpaste ("Brusha, brusha, brusha! New Ipana toothpaste!"), and I recall, less fondly, the awful smell of that Toni hair goo ("Which twin has the Toni?") that my sisters used. I also remember that candy powder from the 60's (Lick 'em Aid?), and how it turned your tongue parentally alarming colors.

With no jingles or jazzy packages, plain products have no such hold on memory. Who would remember Wonder Bread if not for the name and the package with the cheery-colored circles? And, anyway, what exactly were the 12 ways it built strong bodies?

But brands don't confer just spot memories. They mark the broad contours of a life. My own Entenmann Chocolate Donut Period comes to mind.

But brands are practical too. They impose quality control. Take Sergeant Fury and his Howling Commandos. Like other kids in the 60's, I avidly read World War II comic books. Some lured you with lots of action on the cover, but inside the colors were pale, the plots desultory. Not Sergeant Fury. He gave you gore and glory on every page.

So it is with brands. A candy lover may pay more for Mounds, but he or she knows exactly what's inside the crinkly red and

white paper, sitting on that dark brown cardboard skid with the folded-up sides.

Brands do more than forestall unpleasant surprises, though. In time, they transcend themselves. Consider the Klondike Bar, a satisfying square of ice cream wrapped in silver foil stamped with a picture of a polar bear. Eat enough of them through the years on sweltering summer days, and soon, for you, they are coolness itself. You've thought about them so much in the dog days of August that you can taste them even when you don't have any.

Then, eventually, when you do eat one, it tastes on your tongue much as it did in your mind. It's hard to tell the difference. This is the summit of brands: the place where hope and reality mix, where a pumper of gas can become a Cadillac Man.

This column is no Magna Carta, but it did what I wanted it to do. It spoke of the comforting indulgence that brands can bring in hard times. It underlined the link between brands and memory, and between brands and nostalgia. And it explored the way people use brands to say who they are, or who they want to be.

In other words, the column put a human cast on a bloodless topic—a central skill for the writer, because people are the prism through which readers love to view the world. That skill is the subject of this section.

Chapter 1

·····

Shivers on Wall Street

Every story has a human element.

WHATEVER YOUR SUBJECT, give it a human face if you can. Imagine a story about people who had enough money to invest in the American stock market in 1996, but, for various reasons, did not. Maybe they believed real estate was a better deal. Maybe they wanted to bet on bonds. Or maybe they thought overseas stock markets were the place to be.

But they were wrong. Nineteen ninety-six was a banner year on Wall Street, with the Dow Jones industrial average rising 26 percent.

A *Times* article about these unfortunates appeared in the business pages, and necessarily explored many technical subjects that readers expect to see in that part of the paper—the reasons for the large gain, comparisons to past years, the investors' mistaken theories, and the prospect that their ideas, dry holes in 1996, might strike oil in 1997.

Sounds dull. Sure, you say, this article may be useful to investors, but it hardly seems gripping.

Can it be both?

The answer is yes. There is an emotional center to this story. People who miss out on a good thing are prey to regret, anger and jealousy. Such feelings, in fact, were the original inspiration for the article.

For that reason, I wrote a lead that went like this:

> They are on the outside looking in, noses pressed against the glass, stamping their feet in the chill, watching the festivities within.
>
> Yep, that's right. These are investors who did not attend the Wall Street Revels of 1996. Stocks may have soared and portfolios may have swelled, but these people made less money than the overall market would suggest, or maybe none at all.

This lead displays for the reader the emotions of those left out in the cold. You can elect to write about made-up people, as this lead does, or about real ones, but do not ignore the human side. If you do, your tale will be ho-hum, like this hypothetical lead to the same story:

> Nineteen ninety-six was a banner year for the stock market, with the Dow Jones industrial average rising 26 percent and the shares of many individual enterprises soaring far higher. But some investors, for various reasons, chose not to participate in the market that year. . . .

Boring! Even in significantly technical articles like this investing story, maybe especially in such stories, always fleck at the human feelings in play. As the late Jack Cappon of the Associated Press put it, "The tight housing market is also an old lady evicted with her four cats."

Burrito Heaven Blues

*Talking heads are just heads. Find a whole person to
tell your story.*

THE NEW YORK City Council is mulling a bill to give residen-
tial parking stickers to the people who live in Brooklyn Heights, a
neighborhood near Wall Street with far too many cars. The reason
it is so congested? Many nonresidents park their cars there and
then hop the subway to their financial jobs, so they can avoid
driving into tiny, traffic-packed Manhattan. If the Council enacts
the bill, only Brooklyn Heights residents will be authorized to
park on local streets; all others—including those pesky nonresi-
dent commuters—will be slapped with a pricey ticket.

The bill is big news because in New York, where parking spaces
are as scarce as gridlock in Green Bay, any parking news is big
news. Moreover, although resident-only parking may be common
elsewhere in the country, it is rare in New York City.

A writer sets to work on the story. He consults city transpor-
tation experts, who describe the parking squeeze in Brooklyn
Heights. He interviews the sponsoring politician, who explains

the penalties for violation and other legislative details of the bill. The writer also talks to Brooklyn officials, who tell him about the long-running face-off between the residents of Brooklyn Heights and the nonresident commuters.

Fine. But the writer knows that, even with all these interviews, his job is only half done. For he has spoken to no drivers yet. He has plenty of information from experts and officials, but none from the people who actually park, or try to park, in Brooklyn Heights. These are the "actors," the real folks involved. So he proceeds to roam the local streets and eventually finds one such person, a Brooklyn Heights mother, as she trawls for a parking spot near her home. The writer is invited to ride along, and the scene he witnesses is vivid:

> The car's crowded—there's a mewling baby, a full load of groceries and a bunch of kids antsy from being school-bound all day. A spot opens up, but . . . Shoot! A teenager in a Mini Cooper zips right in. They are two blocks, three blocks, four blocks from home. As the search continues, tensions rise. There's The Border Dispute in the Back Seat ("She's on my side"), The Mysterious Frito Explosion, The Secret of the Cul-de-Sac ("Sometimes there's a spot down this little street. . . ."). There's Mommy the Profane ("*!%$&*!"), The Little Lookouts ("Mom! Over there!"), and The Dashed Hope ("Um, isn't that a fire hydrant, Ma?")

With this scene captured in his notebook, the writer can create a richer story than one that hangs just on issue-parsing interviews with talking heads. Indeed, without the folks whose fate is on the line, this tale has no real juice.

True, it is not as easy to interview a real person as it is to interview an official, but the gains are too great not to try.

Getting an actor acting is best. A reasonable second best is to

get an actor talking. In other words, a ride-along with the harried mother is ideal, but interviewing her the next day about that Race for a Space is also good. If neither of those routes works, a third option is an interview with the mother's neighbor, who learned all about the mother's exasperating search in a subsequent chat with her on the stoop. Fourth, the writer can stand at the curb and watch and describe the complex and dogged choreography of cars, as horns wail and brakes screech and drivers pound the dash. Last and usually least, a writer can make it up, as I did in the last chapter, when I transformed Wall Street investors into shivering waifs.

But however you do it, put actors and not just talkers in your story. To report on a tuition rise at Harrumph College, by all means talk to the administrators, the economists and the student leaders. But also find the ordinary sophomore who works 15 hours a week at Burrito Heaven. Sit in the restaurant kitchen as he washes the lettuce, and ask him how many more heads he'll have to shred in order to pay for college.

White Knuckles

Emotions are abstract, and describing them is hard.
But the writer must try, for an article without emotion
is like a sun-bleached shirt.

"ALL I KNOW is, I want my baby back," said the young mother, *twisting her ring* as she spoke about her vanished 3-year-old.

Nothing says "anxious" better than "twisting her ring." Yet, even in a story with such high emotion as one about a missing child, many writers fail to portray the feelings involved. Odds are, for example, that a report about the closing of a mom-and-pop store after 25 or 50 years will fail to capture the wistfulness, or sense of accomplishment, or fear, of the mom and the pop as they walk away from a lifetime's work.

A story should be dry-eyed, of course. It should not be like some hysterical bad opera. But too many stories are bloodless and bland, with the human emotion washed out.

Why do writers tamp down the human side? For one, they may be in a rush to set forth the facts and issues that frame a story, and—no argument here—those elements are vital and space for a

story is always short. For another, emotions are harder to describe than facts; a teacher on strike may be quick to say that she is paid only 78 percent of what teachers in nearby Boston get, but she may find it much more difficult to express how bitter and slighted this fact makes her feel. The writer, in turn, may himself feel fretful in dealing with so fuzzy a topic; there is no handy number—like 78 percent—to describe feeling hurt.

But these difficulties are no excuse. For writers, suppression of emotion is a high crime. If facts are the skeleton of a story, emotion is its heart. And people are emotional about *everything*. Salsa recipes. Fountain pens. The metric system. Nothing is so trivial or technical that somebody won't get dreamy-eyed about it, or red in the face.

When writers do recognize emotion, they sometimes just toss off the usual abstract adjectives—"worried," "angry," "delighted." Often, these words are too vague—"upset" can mean "frustrated," "disappointed," "anxious," "defeated" or "indignant." Also, although these words are fine to use when a mood is a minor theme, or when they support a more vivid description, avoid them in saying something important. They pallidly tell rather than colorfully show.

Describing common body language—white knuckles, set jaw, drumming fingers, arched eyebrows, clenched fist, downcast eyes—is one way to show rather than tell, but beware of these stock reactions. Better are fresh and individualized signs of emotion—a self-conscious teen frequently touching a persistent pimple, or a hectored wife darting anxious glances at her husband as she speaks. If such telling gestures aren't there, turn to simile and metaphor. I read once of someone so happy that he wanted to bite his toes, and of a teenager so thrilled he wanted to throw his sneakers over a building. Who can read those words and not smile? Who doesn't get it when a teenager in a Junot Diaz novel speaks of a "crazy feeling" "that takes hold of me the way blood seizes cotton"?

Consider that New York City plan discussed earlier: to issue parking stickers to residents of a congested Brooklyn neighborhood. The goal is to stop nonresident commuters from parking cars there and crowding the residents out. Here are some ways to convey one resident's frustration to the reader:

QUOTATION "These cars are bumper to bumper in front of my house every day," she said. "I can't even squeeze my bike into the street between them. It's like my house isn't my home."

BODY LANGUAGE Should commuters be allowed to park in the neighborhood? "No. Way." she answered resolutely, like a judge pronouncing sentence.

ACTION "Look at this," she said, picking up a crumpled coffee cup from her front yard and flinging it into the street. "A gift from a commuter."

SIMILE As a handful of workers strode down her street to their cars at day's end, she stood and watched, stony-faced, like a stern librarian facing down some rowdy teens.

Good writing transports us. We can glide down the Danube, peer into the Grand Canyon, feast at a roadside restaurant in Provence. Readers are greedy for life; their own is not enough. But they don't just hanker to see what others see; they want to feel what others feel. That journey is internal and invisible, but to readers it may be the most transporting trip of all. To spend some time in another person's head—what trip is bigger than that?

Hanging around and watching are good ways to uncover these

emotions. But so is asking questions. Ask, say, the mom-and-pop couple the kind of questions that open the emotional window: What will you miss most when you turn out the store lights for the last time? What will you miss least? What are you dreading the most as you turn this corner of life? Most looking forward to? Maybe Pop is ecstatic because he won't have to lug soda cases up from the cellar anymore, or dicker with the famously crabby Mrs. Frank. Or maybe he's crestfallen—no more cute, candy-crazed kids pouring in after school.

Be patient as you inquire; remember that people don't talk in straight lines, especially about emotions. Ask your questions in different ways, and let your subjects meander in their answers, and you may be surprised where you both end up.

The Man Who Glowed

Empathy is precious for the writer. If he is attuned to a subject's inner life, he can double the depth of his story.

HIS NAME WAS Martin, he was born in Peru in 1579, and he could perform wonders: cure the ill with a handshake, be in two places at the same time, glow when he prayed. But Martin was particularly famous for a compassion that he showered on everyone and everything. According to Sean Kelly and Rosemary Rogers, the authors of a book about saints, Martin even fretted over whether the rats at his friary had enough food.

Writers need not be celestially empathetic like Martin, who is more commonly known as St. Martin de Porres. After all, empathy—turbocharged sympathy—is hardly vital to an investigative piece about counterfeit Rolex watches. But empathy can enrich many stories.

The good news is that connecting with others is often automatic. As Natalie Angier wrote in the *Times* in 1995, "Empathy allows one to sit in a movie theater and blubber over a death that never happened to a character who never lived; it keeps charities

breathing, if somewhat wheezily; and it is the reason why, if you stand in the middle of a sidewalk with a map in hand, looking bewildered, someone is bound to ask if you are lost."

Of course, if flinching when someone bumps his head is natural—after all, everybody has bumped his head—it is not so easy to identify with another person when the circumstances are unfamiliar. Yet the writer must always try. To do his craft well, a white, middle-aged, native-born writer must be able to slip on the shoes of an elderly Hasidic Jew, or of an embittered black man, or of a performance artist with gelled foot-high hair.

Many writers are game for these long-distance journeys, traveling far from their roots. Adrian Nicole LeBlanc, daughter of a union organizer and a drug counselor in Massachusetts, wrote a book, *Random Family*, about poverty, drugs and crime among New York's Latinos. Ted Conover, son of a Navy pilot, wrote about hoboes in *Rolling Nowhere*. And Barbara Ehrenreich, author of books on social issues and the holder of a Ph.D. in cell biology, portrayed the lives of the working poor in *Nickel and Dimed*.

All three strove for as much empathy as they could get across these great divides. LeBlanc spent a decade visiting her young New Yorkers. Conover rode the rails just like his hoboes. Ehrenreich took the same menial jobs—cleaning, waitressing—as her blue-collar subjects.

Sometimes, writers in search of empathy resort to masquerade. In the 1961 classic *Black Like Me*, a white man named John Howard Griffin disguised himself as a black man and wrote up his experiences; in *Self-Made Man*, a woman named Norah Vincent dressed up like a man and did the same. The goal of such efforts is both to taste what life is like in such a disguise—how others perceive and treat the disguised you—and to see how others behave when a person like the real you is absent. How do men talk about women when there are no (apparent) women there? There is a

whole shelf's worth of unwritten masked books just waiting for an adventurous, empathy-seeking author: *Veiled Like Me, Blind Like Me, Gay Like Me.*

Fiction writers go to equally great lengths as these "immersion" writers, if only in their heads. "When I wrote *Beloved,* I thought about it for three years," the Nobel Prize winner Toni Morrison told the *Times* about one of her novels. "It took me three more years to write it. But those other three years I was still at work, though I hadn't put a word down." Much of that time was spent becoming, empathizing with, her characters.

Even without such heroics, writers always need to sit where their subjects sit and ask, without impatience, How does the world look from over here? What would be important? What would I worry about?

A writer attuned to a subject's inner life can double the depth of his article. In one such story, the subject was a Russian immigrant who spoke no English when he came to the United States at age 18, but somehow managed a few years later to get the highest score in the nation on the C.P.A. exam—a test so hard that only 12 percent of candidates pass it on their first try.

In a 1995 *Times* article about this man, writer J. Peder Zane naturally sought the details of his striking accomplishment (What was your score on the C.P.A. test? How long have you been interested in numbers? Are there mathematicians in your family?). But he also went further, learning that his subject, Vitaly Sorkin, was raised amid the chaos of dying Communist Russia, with its rampant crime and economic woes. Zane pursued the topic until he got Sorkin to reveal the link between his mathematics and his inner life: "'As a student there I was drawn to math because it was logic and order,' he said. 'It was a rational realm in a world without reason.'"

This psychological revelation opens up whole new vistas of

Sorkin's life, far beyond those uncovered by the usual factual questions. Not every subject will be as talented as Sorkin in expressing his Inner Accountant, of course, but if the writer bags this game, the gain is great. Suddenly, for the reader, the tale of Sorkin blossoms from something classic but predictable—hard-working immigrant overcomes stupendous odds—to a three-dimensional portrait of a particular hard-working immigrant for whom the chosen profession also furnishes a specific psychological comfort. Numbers robot becomes flesh and blood.

It is often the surface facts, the "wow" part of a person, that draws a writer to a subject. The funny thing, though, is that a story about a striking achievement, like the accountant's, keeps reader and subject at a distance. After all, who can relate to such superhuman accomplishments? But uncover an inner truth about the subject—his yearning for stability in a climate of chaos, say—and the reader nods his head in sympathy. The distance shrinks.

Moreover, the reader will be as interested in these emotions—fury, glee, smugness, guilt, whatever—as she will be in the person's world-class whitewater rafting skills, or in his breathtaking score on the accounting exam.

Good writers try to get beneath the skin of bad guys, too. Shakespeare's Shylock is not rootlessly evil; his malice stems from his own victimization as an outcast. A villain drawn by a savvy writer will leave readers not just saying "Bad dude," but "Bad dude—yet I see where he's coming from." After all, we're all guilty with an explanation.

Empathy can work for writers defensively, too, as a way to stay wary. The empathetic writer knows that, whatever the facts, an entrepreneur may want to paint only the rosiest picture of her venture. That means the writer will pry hard to get the downside of the entrepreneur's business, and will triple-check her assertions of the upside.

Sometimes, defensive empathy will help a writer spot a self-interest that is not as patent as the entrepreneur's, such as the tendency of a detective to magnify the investigative difficulties in a murder that he hasn't been able to solve.

We all have hidden financial, ideological and emotional agendas—sometimes even hidden from ourselves. To uncover them, empathy is the journalist's dowsing tool.

CODA

A story idea: A series of patients visit a dentist in his nondescript office. They speak with the dentist briefly, they settle into his chair, their teeth are examined, their X-rays are taken. Finally, a diagnosis is made.

Sounds like one darn tedious story, no? But in fact this story is a thriller. Written by Chris Hedges and published in the *Times* in 2000, it focuses on a dentist who works for the Immigration and Naturalization Service. Immigrants who are over 18 often claim they are under 18—they have a better chance of staying in the country that way—and this dentist's job is to inspect their teeth to determine their true age. If he decides they are lying, they are sent home—often to poverty, or to prison.

Think of your own feelings as you settle into the dentist's chair for a checkup. Now, picture the outsize emotions of these would-be immigrants. One person was shaking so much that his X-rays had to be retaken.

As this section sought to show, writers often neglect the emotional side of their stories. They shouldn't. Human feelings are so powerful they can be the stuff of heart-stopper tales—even when the stories feature no car chases or perilous mountain adventures, even when they are entirely set in a drab dental office.

The Theme

The writer must be loyal to his major theme. He must study all its facets, and he must tamp down other topics that threaten to displace or diminish it.

Blood on the Manuscript

I have been castigated and criticized by the *Times*'s best. Amy
M. Spindler, a late fashion critic, was so furious at my editing
of a piece on cosmetic surgery for men that she threatened to air
brush her name right off it, so to speak. David Cay Johnston, a
tax reporter who would go on to win a Pulitzer Prize, found my
refashioned lead on a story so wrongheaded that he collared the
managing editor to protest. And although I got along well with
Kurt Eichenwald, an investigative *Times* reporter and the author
of best-selling business books, I remember a strikingly operatic
phone conversation we once had over his weekly Wall Street
column, which I edited.

These clashes fetched up in various ways; sometimes I was
right and sometimes I was wrong. But they reveal this: Writing
raises the emotions.

Of course, high feeling is not a bad thing. For one, it supplies
much of the fuel for first-rate prose; words are wordsmiths' achieve-
ments, and true wordsmiths take them seriously. For another, the
quality of the words on the page is usually better after a newsroom
dustup than it was before—an editorial survival of the fittest.

Moreover, even the most spirited back-and-forths do not nec-

essarily portend blood on the manuscript. In fact, they sometimes signify a sweet collaboration. When Disney and ABC merged in the summer of 1995, a former *Times* designer devised a brilliant graphic to convey the news: He popped Mickey Mouse ears onto the black circle that was the ABC logo. Voilà, merger. Simple, pithy, striking. Everyone loved it. But of course, many wanted to tinker. What their suggestions were I don't exactly remember— Can we put Mickey's tail on the circle? or some such—but I do recall thinking that it was such a fine idea that everybody wanted to share in it, just out of excited, good-hearted glee.

And yet, all that being said, high passion is no unalloyed virtue. Writers and editors bob in toxic, foamy eddies of ego and territoriality, and once in a while they start to thrash about. Sometimes they sink like a stone, and when they do their computer screens get blurry under the water, and these word people, sadly, ironically, cannot see their words clearly.

I sank below the surface myself, back in the days when the standards editors of the *Times* compiled weekly packets of dos and don'ts. They were called the greenies, they were printed on yellow paper (long story), and they would chastise us for writing 77-word sentences, praise us for using "that" and "which" properly, or otherwise cheer or boo our efforts.

So, in 2003, for a graphic about the many defects a fire hydrant can have—graffiti, cracks, a loose base and so on—I wrote this headline: "Doggone it." Not my best moment, but, hey, it fit the space. The next week the greenies were sicced on me. "Unsubtle and unwitty," they said about the headline. "Beneath the level even of a tabloid."

Some *Times*ians shrug and take these remarks as the valuable exercise in self-crit they are meant to be. Not me, at least not that time. For weeks, whenever I ran across a bad tabloid headline, I would collar whoever was close at hand—colleague, wife,

neighbor—and say, "See this headline? It's awful, right? Well, I once wrote a headline that was *beneath* the level of this headline. It wasn't, say, 'just as sucky' as this headline. It was *suckier*. In a contest between my headline and *this* headline, *this* headline would win!" I would jab repeatedly at the awful headline, glaring at my cowed listener.

I am not alone in such rants. Turf and ego often set the fur flying between writers and editors, their claws out, mad mama bears defending their word-cubs. Very often, these scrapes revolve around the subject of this section—an article's major theme—and the reason for this pattern is obvious. When one idea in a story is anointed the Big Idea, all the other ideas are necessarily demoted. The champions of the now-lesser ideas protest, and then the snapping and the snarling begin.

But do not be depressed. There is always Derek Bok, the former Harvard president. He did not sink shamefully into the frothy waters of ego, as I did; he was lifted above them, by the better angels of human nature. When he wrote an essay about lawyer salaries, I was his editor and he said something like, "Frank, here's what I'm trying to say. I've said it as best I can, but you're the wordsmith. If you have suggestions for a better way to say it, I'm grateful."

Bok did not see me as a threat to his ego or as a marauder amid his words. He saw me as a resource. Why? Because he was looking only at his message. He was asking, Does this metaphor (whether yours or mine) convey the right tone? Does this paragraph (whether yours or mine) stray too far from the topic? Ego, in other words, was exiled to parentheses.

A Baker Named Muffin

*A writer who is jack of all themes will be master of
none.*

A NEW YORK baker, a Mexican immigrant, has been robbed
and murdered. This crime, unsolved, offers a writer many possible
themes: the man's life; the ongoing investigation; his grieving
wife and children back in Mexico; his forlorn co-workers; and the
failure of a teeming city even to notice his horrible death.

Tempting subjects, and in a book there may well be enough
room to explore them all. But for an article of modest size, the
disciplined writer will force herself to spotlight just one. Sarah
Wyatt, the writer of a 2003 *Times* story about just such a murder,
chose the man's mourning co-workers as her topic. The title of the
article reflected her choice: "An Empty Spot at the Counter."

The 1,200-word story did not ignore the unchosen themes. It
spoke briefly of the lack of witnesses to the crime, and it included
a few sentences about the family that the man, Mario Vilchis, had
left back in Mexico. But Wyatt devoted most of her space to her
big focus. She described the photo of Vilchis that his workmates

kept by the cash register, their memories of his special Mexican-style cinnamon toast, the money they raised to track down his killer, and the co-worker who ran the New York Marathon with Vilchis' photo pinned to his shirt.

In other words, by restricting her theme Wyatt freed herself to dwell at satisfying length on the bakery part of the victim's life. Here is part of what she wrote:

> Mario Vilchis was one of the first people to be hired when Eli's Manhattan opened five years ago. He started out cleaning floors and sidewalks, accepting deliveries, stocking the bread department and delivering groceries. But before long he had become the market's unofficial baker.
>
> He baked the frozen croissants delivered from Eli Zabar's other market 12 blocks away, brushing egg-white glaze over the warm, flaky half-moons. He molded the extra dough into Danish pastries, scooping cherries into their centers. He used day-old brioches to make bread pudding. When he noticed that unsold raisin nut bread was going to waste, he topped slices with cinnamon sugar, toasted them and sprinkled them with powdered sugar.
>
> "We called them Mario's recipes," said Elaine Kessel, who lives near the market and shops there several times a week.
>
> At the store he had two nicknames: Sapo, the Spanish word for toad, a nod to his round froglike face, and Muffin, because he could often be found baking muffins.

And so on.

Good writing, in other words, can make for bad math: one idea is often more than three, or four, or five. It's not just a matter of preserving enough room to fully unfurl an idea. A writer is like a gardener who knows that one tree can serve as a focal point in a

garden, but that many trees will just muck up the impact of each. Also, a good writer realizes that readers have the mental room to store just one large thought from a story.

Why is "writing by committee" so bad? Because each of several contributors is highlighting his particular strand of the truth, and each of these unconnected segments is short and therefore unsatisfying. Those segments can be tied together, but the result will be a stubby bit of string, not one smooth length.

Of course, Wyatt might have chosen to focus on a different strand of truth in the baker's murder—its unnoticed nature, for instance. She could then have presented the compelling details of that theme: the dramatic contrast between the horror of the crime and the short, bland newspaper item about it; the fact that the baker's neighbor not only did not know of Vilchis' death but did not even know Vilchis; and the police department's confusion between the baker and a different man of the same name who had been murdered the month before.

But that would be a different article. Its headline would not be "An Empty Spot at the Counter," but "A One-Paragraph Life."

A subject is not a story; it is many possible stories. To write is to choose, which is to exclude.

Bang the Drum Strategically

A writer must regard his story through theme-colored glasses.

A WRITER CAN describe his subject in many different ways, but not all descriptions are equal. Consider these two stories, and the descriptive choices their authors made:

- A 62-year-old man named Eugene Bennett, who directed school marching bands for years, has been inducted into the Drum and Bugle Corps Hall of Fame. In a 2002 *Times* profile, Jim O'Grady writes that the man "speaks the way his marching bands move: precisely. He carefully recounts each step in his career, . . ."
- For decades, Prospect Park in Brooklyn has hosted a weekly pickup soccer match. Early in a 2000 *Times* article about the longstanding game, the author, Tara Bahrampour, writes: "For strangers seeking to orient themselves in Brooklyn, the Long Meadow section of Prospect Park is not the best place. A vast sky, banished years ago from Manhattan, stretches across a

tree-lined bowl of grass between the band shell and the duck
pond. Block out the top of an apartment building at one far
end, and there's nothing to show you're in a big city, let alone
what neighborhood you're in."

These very different descriptions have something in common.
They both highlight the larger themes of their stories. In the
drum and bugle article, O'Grady emphasized that the man loved
the orderliness, the straight lines, the scriptedness of his profes-
sion. So he described the band director's manner of speaking in
a way that echoed that theme. In the soccer story, Bahrampour's
theme was that the game and the park are havens where the play-
ers can shed their workplace identities and flee the urban hubbub.
So she described the physical park in a way that underlined this
psychological reality.

There are many ways the authors could have handled these de-
scriptions. For example, O'Grady could have written: "Mr. Ben-
nett speaks with an old-style New York accent, one that evokes
egg creams and trolley cars." But that description would not have
amplified his main idea.

A description does not always have to augment a story's Big
Abstract Theme, as in these two articles; sometimes, it can rein-
force an important story fact. For example: Teens in New York
City sometimes sell M&M's on the subway to make pocket
money, and in 2007 the *Times* ran a report about the stores where
the teens stock up on the candy. At one point, the writer, Alex
Mindlin, describes one teen's "droopy backpack" as he saunters
into one of these stores. That bit of description is better than
"dreadlocks" or "low-rider jeans" because it's related to the candy;
when the teen exits the store, that backpack will bulge with the
M&M's that he just bought.

To boost both big and little themes, a writer must always be

looking through theme-colored lenses. This little tale makes the point:

> Two friends are having lunch at a tavern. Just as they tuck into their surf 'n' turf, the TV weatherman predicts a heavy, driving rain. Both men, their forks in midair, drop them with a clatter and poke at their cellphones. "Honey," says one, "please move those pots of portulacas onto the porch. They like it dry, and it's gonna rain hard." The other says, "Bob, put $100 on Conchita in the eighth. She's great on a wet track."

Each man swiftly linked the forecast to his idée fixe—gardening or gambling. A good writer does the same thing.

Of course, ideally if not in day-to-day writing, no detail belongs in a story if it doesn't serve some role therein. As Chekhov said, don't put a gun on stage in Act I if it doesn't get used by the end of the play. I'm a little loose myself about what "role" means—a background explanation, or even a bit of color, can be fine. But writers should be especially vigilant for the thematically telling detail, like the clipped speech of the drum and bugle man.

Choose individual words that are thematically telling, too. If you write a piece about football players in the locker room, and your theme is the muscular, animalistic nature of the scene, make their laughter rollicking, not loud, their horseplay bruising, not energetic, their laundry sweaty, not dirty.

The best writers also zero in on theme-colored metaphors. In a lighthearted piece about caviar, the *Times* columnist Clyde Haberman says the soaring prices of the delicacy are "high enough to give a czarina the vapors." In describing a sidewalk memorial to a Brooklyn teen named Twitch, another *Times* columnist, Dan Barry, writes of the candles' "teardrop flames."

Even a reporting setback can be a chance to beat the drum

for a story theme. A movie theater closes from lack of business. When the writer tries to rustle up some quotes for the story from passers-by, it turns out they didn't even know the place had closed. The writer is frustrated, but then light dawns. Of course! "It's no wonder the place is shuttered," the cagey writer writes. "It's so little patronized that it died *and hardly anybody noticed.*"

Write with one eye always on your theme.

What Babies Know

The sound of words and the rhythm of sentences are a language wholly apart from the dictionary. Make sure your story not only says what you mean but "sounds" what you mean.

PICK A LULLABY, any lullaby. The chances are that, like the word lullaby itself, the lyrics have plenty of l's and s's or other "soft" letters:

> *Sleep, baby, sleep*
> *Our cottage vale is deep*
> *The little lamb is on the green*
> *With snowy fleece so soft and clean*
> *Sleep, baby, sleep*
> *Sleep, baby, sleep*

Why these particular letters? Because lullabies have a lulling purpose and so their predominant sounds are soothing. Countless dozing babies are the proof.

These "sound meanings" of words may coincide with their dictionary meanings, or they may collide with them. "Lilt" and "lull" happen to have sweet and soothing sound meanings as well as sweet and soothing dictionary meanings, but you could just as easily put a prelanguage baby to sleep with, "The lion loped into the hushed village, lunging at the locals and leaving only human hash behind."

Sound, in other words, is an entity independent of denotations and connotations, and that means it is a second arrow in the writer's quiver. Just as a writer deploys the sense of words to convey his theme, he can marshal the sound of words and the rhythm of sentences to do the same.

Francine Prose, the novelist, respects the power and the appeal of sound. "I have heard a number of writers say that they would rather choose the slightly wrong word that made their sentence more musical than the precisely right one that made it more awkward and clunky," she wrote in *Reading Like a Writer*. And: "Rhythm gives words a power that cannot be reduced to, or described by, mere words."

At a simple level, writers can recruit onomatopoeic words to add sound to sense. "The bacon was sizzling" is better than "The bacon was cooking" because sizzle sounds like what it means.

A sentence can do the same thing, employing a rhythm that mimics the dirge or the dance or the explosion that the sentence describes. Consider: "The tattered battalion marched over the hot African sands, plodding steadily uphill, pausing briefly at the crest, scanning for signs of the enemy, resuming its trek downward, and punctuating its steps with wipes of brow, and swigs of water, and squints at the endless sun."

That sentence says slog but it also *sounds* slog, making it superior to a sentence that does only the first.

Armed with such poetic devices as meter and alliteration, the

writer has at his fingertips a "sound" dictionary as hefty as Webster's. Pick a mood—wistful, happy, angry, dramatic, austere, baroque—and there may well be a sound that "says" that. The mood of Michael Herr's *Dispatches*, the definitive novel of the Vietnam conflict, is chaotic, and his fractured, herky-jerky sentences echo exactly that theme. One sentence jumbles together 196 words, 17 commas, 7 quotations, 3 parenthetical phrases, 3 question marks, 4 exclamation points and 2 words in all-capital letters. It's the fog of war in sound as well as sense.

Writers can use sound not just to echo the sense of their words but to seize reader attention. When the natural order of words is inverted or otherwise altered—A Tale Fantastical!—the abrupt change in the expected rhythm or sequence tells the reader, Listen up. When a writer constructs a "suspended" sentence, with the most important action delayed by long, introductory phrases, he is giving us a drum roll, maybe teasing us a bit, before unveiling the Big Event. ("The manuscript, lovingly tended by a family in Cornwall for 100 years, sold during hard times to a rich Scotsman, and bequeathed upon his death to the British Museum, was burned to ashes in a fire last Tuesday.")

Repetition is a sound signal, too. Martin Luther King Jr. declared "I have a dream" no fewer than eight times in his famous 1963 speech, and with that repetition he was "saying" several things—that the dream of racial justice is majestic and spiritual, that the road has already been long, and that he is resolved to see the dream made real.

When a writer relies primarily on one sound style, it becomes the wallpaper of his work—which means that by departing from it he can rouse the reader's attention. Shakespeare's preferred style is iambic pentameter; an iamb is a metric foot of one unstressed syllable followed by a stressed one ("compare"). Thus, when Shakespeare wants to alert readers to a character's emotional state

or some such, he will switch from his standard iamb to, say, the trochee, a metric foot which features a stressed-unstressed syllable sequence ("only").

Of course, writers can go as wrong with words' sound as they can with words' sense. In 1952, Herbert Read, a British literary critic, wrote that Emerson "was so concerned with the aphoristic quality of his sentences that he forgot the rhythmical life of his paragraphs." This may seem like an odd criticism; after all, Emerson is beloved for his maxims, from "Hitch your wagon to a star" to "Sometimes a scream is better than a thesis." But you be the judge of Read's claim. Here's a paragraph from Emerson's "Essay on Friendship," a reflection on human attachments:

> We have a great deal more kindness than is ever spoken. [Despite] all the selfishness that chills like east winds the world, the whole human family is bathed with an element of love like a fine ether. How many persons we meet in houses, whom we scarcely speak to, whom yet we honour, and who honour us! How many we see in the street, or sit with in church, whom, though silently, we warmly rejoice to be with! Read the language of these wandering eye-beams. The heart knoweth.

Don't these choppy, staccato sentences sound as if they were slapped together into a paragraph after they were written? Well, in fact they were. "His essays," Read writes of Emerson, "were actually composed by grouping together sentences which he had separately entered into a journal."

The lesson? To put it in an Emersonian one-liner, "Write with your ear."

..

Temptation Alley

Verbs are the most important words in a story, and the most important verbs are those that reflect the main theme. They are verbs with a capital V.

WRITING SCHOLARS HAVE plenty of smart advice about verbs: Choose strong, striking verbs over weak, abstract ones—"grabbed" not "took," "ate" not "consumed." Pick your verbs with care—"smiled" means something different than "grinned" and "grinned" means something different than "smirked." Favor the active voice over the passive—the latter has its uses, such as highlighting the receiver of the action, but the former is more vivid and usually shorter. Most important, the experts say, lavish much attention on your verbs; they are the engine of your text.

To that long list, add this: Select verbs that convey your story's Big Idea.

When a writer decides on the kernel of his story, he can begin to enlist verbs that will punch up his tale. Consider a 1999 *Times* article by Peter Duffy about White Sands, Brooklyn, a tiny,

80-year-old enclave which was to be demolished to make way for a big home-improvement store and parking lot.

As the writer heads off, he may already suspect that residents' wistfulness about their doomed neighborhood will figure large in his story. Verbs suitable to that mood swirl in his head: the neighbors may *muse fondly* on the receding past, they may *rummage through* or *poke about* in their attic of memories, they may *hearken back* to the old days. Maybe they will *mourn* and *rue* the passing of their little piece of earth.

Of course, the writer must confirm these sentiments through reporting. Assuming that he does, notice that all these verbs not only satisfy the standard verb rules—they are vivid and active—but they also amplify the big point of the story. These words all say "death of a much-loved neighborhood" in a dramatic way.

Another example, taken from a 2001 *Times* story by Adam Fifield: There is a bus stop in Queens where newly freed inmates from Rikers Island, a New York jail, are dropped off. Imagine that the writer wishes to focus on the just-released inmates' struggles to go straight and to avoid the temptations offered by the drug dealers, pimps and prostitutes who loiter near the bus stop and await their arrival.

This writer, too, can root about for verbs that hammer home his "temptation" theme: "*Drawn* to the drug dealers as they *beckoned*, the inmate hesitated, but *resolved* to turn toward the subway instead. . . ."

Many stories have a large set of vivid verbs that sound the major theme. A writer doing a travel piece about a huge waterfall, for example, can have the water *roar* and *crash* and *foam* and *splash*. And a writer covering a fierce political debate can have the rivals *face off* and *joust*.

These two articles may be full of chances to use other fine verbs.

Maybe in the waterfall story, a lizard *skittered* across the rocks; maybe in the account of the debate, one of the candidates *fluffed* his thinning hair. Such verbs furnish great vividness. But the verbs that sound the primary idea in the two articles—respectively, the power of nature and political rivalry—are freighted with even more importance.

Chapter 9

Professor Brinker's Obsession

Keep exploring your subject. The more you look, the more you see.

AN IMAGINARY WRITER gives her editor a draft of her article about the dumbification of magazines. An excerpt:

> The news racks once displayed dozens of serious general-interest magazines that explored literature, politics and the arts. Today, however, those weighty periodicals are limited to the *Atlantic*, *Harper's* and a few others, and the news racks are filled instead with fanzines, gossip sheets, and frothy, advertiser-driven vehicles. A reader will struggle to find a half-dozen intelligent magazine pieces about terrorism on today's newsstands, but he can easily stumble on twice as many stories about the adventures of Paris and Britney.
>
> How do today's magazine readers feel about living with the print version of a sound bite? One frustrated reader, Carol Montesano, grumbled, . . .

The editor pauses at the phrase, "the print version of a sound bite." There's something amiss. The excerpt deals primarily with article *subjects*—serious versus frivolous. The phrase "sound bite," however, pertains not to subject but to length; in the world of broadcasting, "sound bite" means a very short quote.

Suspecting that there's another idea lurking in the draft, the editor asks the writer: "You have a lot of good stuff about the fluffiness of magazine subjects today. Did you learn anything in your reporting about trends in article length?"

In fact, she did. She interviewed a Professor Lawrence Brinker, who has studied magazines that were published from 1950 to 2005 and found that the average article shrank 35 percent during that time. And he is hopping mad about his findings. "How complex can a thought be if a writer only has 150 words or so to explain it?" he fumed.

The writer wasn't wrong, but she did blur, or conflate, two different notions. Her editor teased out the distinction between them, and so she added to her paragraphs about article subjects a few paragraphs about article length.

But she and her editor keep talking. Turns out that Brinker has also examined grammatical errors in magazines, and he found a 15 percent rise in them during the 55 years he studied. So the editor has the writer add a paragraph or two about this idea, too.

The reader can now ponder the dumbification of magazines by three different lights—silly subjects, shorter lengths, careless writing. By untangling these different strands, the editor and the writer have made their story richer, more textured and more conceptually clear.

The lesson: Look long enough at your subject to see its nooks and crannies. Here's another example:

A writer gathers reams of anecdotes about strange wedding proposals, and they make for great reading. One guy stages a

fake arrest of his fiancée so he can "read her her rights," which of course include the right to be happy with him forever. Another man proposes to his teacher-fiancée over the school P.A. system, and her second graders cheer. And on and on.

But will the article be just a procession of cute stories? It shouldn't be, because a list is not a story.

And so Richard Weir, the author of this 1999 *Times* article, distinguished these tales with theories and observations, gathered from wedding planners, matchmakers and others, about the *motives* behind these unusual proposals. Some men use a public forum for their proposal—a school, say—because they are so happy they want to share their love with the world. Some, like the false-arrest man, may want to make a proposal that will endure forever in family annals. These and the other motives constitute variations on the theme—just as one finds in music— and these motives both distinguish the anecdotes from one another and grace the story with deeper meaning.

Generally, the bigger a topic is in a story, the more distinctions a writer should make.

Before you say that you do not smush different ideas together, think again. Many writers unwittingly do this, simply because they know more about their subject than the reader, and knowledgeable people tend to skip over steps as they explain things. An analogy: A swing by Ken Griffey Jr. may seem like one smooth motion, but it embeds many discrete acts, from the grasp of the bat to the placement of the feet to the slant of the shoulders. For a rookie learning to swing—or a reader confronting an unfamiliar topic—the best way to fully appreciate something is to tease it apart.

Razzing From the Rafters

The smart writer is fair, and he also knows he may be wrong. So he is generous in letting dissenters state their case.

You ARE FLIPPING through a glossy magazine, and she appears. She is a model in a makeup ad and she is gorgeous, stunning. But . . . unreal. She is just too perfect.

Like the designers of such advertisements, some writers "air brush" too much, erasing everything that wars with their major message. The results are just as unconvincing.

Consider two stories. One, a profile, describes a longtime New York City parks commissioner as enthusiastic and effective. The second, a story about union organizing, portrays recycling workers as poor and exploited.

These are the writers' major ideas, their themes. However, every theme has a "but." Call the but a caution, a qualification, a caveat or a "to be sure" (as in, "To be sure, not everyone likes sushi. . . ."), but they all do the same thing—put a little smudge on the writer's shiny theme. In the first story, for instance, some officials may consider

the parks commissioner to be largely *in*competent, and they may offer up solid evidence to support that claim. In the second story, the recycling firms may put forth data to show that their workers are not exploited, and that low wages are inescapable in their fiercely competitive industry. These "buts" may be facts, but they may also be opinions or even moods.

The writers of the two stories are excellent researchers, and they know all about these "buts." However, in weighing all that their reporting has uncovered, they still draw the contrary conclusions. So those are the themes that they put at center stage.

As they write, the authors can hear the contrary voices up in the peanut gallery, hooting and disputing their chosen themes. The writers want to eject these pests! After all, these dissenters are drowning out the writers' finely wrought, meticulously researched conclusions.

But the writers resist these exclusionary impulses. They cede these "buts" some time on the stage of their story. The commissioner's critics get a chance to claim that he failed to stand up to the mayor, for example, and the recycling executives get to unfold their balance sheets.

Why should the writer give these dissenters a soapbox? First of all, honesty demands it; a writer, even in an essay of opinion, is not a lawyer parading only the evidence helpful to his side.

Moreover, the writer may be wrong. Including opponents' viewpoints prevents misleading the readers, allows them to judge for themselves, and may stave off later embarrassment for the writer.

Finally, like the model in the cosmetics ad, one-sided stories are just plain hard to believe. If you really want readers to draw the same conclusion you do, don't censor the other side.

The Bentley and the Bodega

Choose your main theme and position it, uncrowded, at center stage.

A STORY IS a tree. No one ever looks at a tree and puzzles over what is trunk and what is branch. Just the same, there should be no confusing the main theme of a story and all the subsidiary stuff.

An article idea: New York appears to be a city where rich and poor frequently mix. On the subway, investment bankers sit next to deli workers; in Midtown, fashionistas and traffic cops buy lunch from the same sidewalk vendors. But a closer look reveals another side to the story. The preppy kids on the Upper East Side may have a few minorities in their private-school classes, but the latter's parents are often lawyers and doctors, not cabdrivers. The playgrounds of New York's rich—the charity balls, the pricey Flatiron restaurants—are virtually poor-free, while in the bodegas in Queens, where the less affluent shop, the rich are as rare as Bentleys. Manhattan's density may make economic intermingling seem real, the author concludes, but dig deeper and you'll find it's not always so.

Fine. But the writer of this imaginary 3,000-word tale knows that rich and poor *do* mix in New York to a certain degree. He has interviewed one wealthy family, for instance, that sends its kids to public school so they don't grow up in a "bubble of privilege," as the dad puts it. So, to be accurate, the writer wants to set out this and other qualifications high up in the story. In the made-up excerpt below, the first three paragraphs set out the primary "two worlds" theme, while the next three set out the qualifications:

Real estate prices are one big reason that New York's rich and poor live in two worlds. On prime Upper East Side blocks, co-ops start at seven figures and monthly rents average around $4,000. Of course no poor person can fork over that kind of cash, meaning that an Upper East Sider's neighbors, in his building and across the street, are all well-off. Where are the poor? Well, they live mostly in their own, more modestly priced, neighborhoods.

What is true of New York's neighborhoods is true of its schools, restaurants and shops. Prep school tuition can reach $30,000 a year, and hip TriBeCa restaurants want $22 for a ham sandwich. There may be a public school next to a preppy academy, there may be a bodega close to that TriBeCa restaurant, but there are still big walls between these close neighbors, and these walls are constructed of stacks and stacks of dollar bills.

"Nearness doesn't mean mixing," said Kathleen Walther, an NYU sociologist. "Blacks and whites lived close to each other for decades in the South, and society was still segregated."

Still, New York's is not a tale of two totally separate cities. Regina and Wilson Muir—he's the heir to a spark-plug fortune— have enrolled their twin boys in the local public school. "The boys brought home a school friend yesterday," said Wilson, with a hint of pride. "His dad is a subway motorman."

The Muirs said another well-heeled family they know also

opted for public school, and Wilson detected a trend. "Affluent people in their 40's, like us, are much more interested in exposing their kids to the nonrich world than our parents were."

Moreover, today's prep schools are catering more to the nonwealthy than they once did. "Over the last 30 years we have seen a 300 percent increase in need-based scholarships," said Jeanette Tanzer, a spokeswoman for the American Association of Independent Schools.

At first blush, these six paragraphs seem fine. They can be more fully developed lower down. But there is a problem. The three qualification paragraphs are nearly as long and detailed as the three main-idea paragraphs. By the time the reader gets to Tanzer's remarks, he may wonder if the story is a tale of the separate worlds of rich and poor—our writer's intended main theme— or of the growing overlap of those worlds.

That is, the reader is wondering, "What's the trunk and what's the branch?"

What's worse, the writer is planning to add two other caveats to his story—that economic mixing is hard to measure, rendering any conclusions a bit wobbly, and that the New York City Council wants to erect a lot of mixed-income housing, which would substantially increase economic blending. Pile these qualifications on top of the above three paragraphs, and the reader will really struggle to distinguish trunk from branch.

The cure is to boil down the qualifications so that they occupy less space than the main ideas, but are still fairly represented. In this version, instead of two caveats occupying three paragraphs, four occupy just one:

Still, New York's is not a tale of two totally separate cities. The rich seem more open to sending their children to public school

than they once were, and rich prep schools have been offering
more seats to scholarship students. The City Council may soon
subsidize a large amount of mixed-income housing as well, and,
in any event, statistics on inter-income blending are not too solid,
making any conclusions about separateness a bit murky.

Nevertheless, the worlds of New York's rich and poor inter-
sect far less than a tourist, seeing them shoulder to shoulder on
the subways and sidewalks, might assume. . . .

In that one quick paragraph, the writer has tipped his hat to
all his qualifications—they can be elaborated upon, also at pro-
portionate length, lower down—and then scrambled back to his
main point. With so brief a foray, the reader has no doubt what
the story is mostly about.

As this example shows, the struggle over trunk and branch
is often one of relative length. Branches are slender, trunks are
thick. If a main idea is set out in three paragraphs, the qualifica-
tions should consist of roughly one paragraph, as above. But if the
main idea occupies just one paragraph, the qualifications should
get about one sentence.

The trick, of course, is to compress and still be comprehen-
sive, fair and accurate. It is not a solution to lop off an important
caveat, like the fact that the data on rich-poor mixing are squishy.
Notice that even though the Muirs and Tanzer have disappeared
from the shorter qualifications section, their ideas have not.

Trunk-and-branch problems often pop up at the top of a long
magazine or newspaper article, where the major points are first
set forth. But these challenges can arise anywhere summarizing
is needed. For example: In an imaginary book lambasting Miami
Beach as "a mindless year-round club," a writer selects as her main
characters a group of sodden twentysomethings. But, in her re-
porting, the writer becomes charmed by a cluster of moderate,

sensible Irish young people, who do their fair share of clubbing but also visit local museums and learn about the area's famous Art Deco architecture. The writer wants to write about these Irish folks, who do after all represent another Miami Beach reality, but she also knows that her main theme is Sodom-by-the-Sea. How much of the Irish is too much? For the answer, look at a trunk, look at a branch.

Writers can never be "in for a dime, in for a dollar." They must learn to summarize, to dab, to evoke. Hard, yes, but much of writing is about what you leave out, not what you put in.

Just as trunk-and-branch trouble pops up in books, it pops up in a mini way in paragraphs, sentences and phrases. Consider this made-up article:

> The 2008 presidential campaign was in full swing, and the spirited group of political activists—artists, film editors, writers, composers—gathered around a table at Sky Blue, a music venue in the heart of liberal Greenwich Village. But their politics were not what you might think.
>
> Dale McAteer, a soap opera script writer and a Giuliani campaign aide, had orchestrated the meeting. "We're committed to the Republican cause and we're willing to spend our time and money to accomplish our mission," she said.

The point of the story is that these creative types are unusual—Republicans in the heart of Democratic New York City. But, oddly, the first sentence of the second paragraph tucks an important fact about this theme—McAteer's link to Republican Giuliani—into a short, by-the-way phrase ("a Giuliani campaign aide"). To make the point more prominent, this phrase should be lengthened and transferred to the main part of that sentence: "Dale McAteer, a soap opera script writer who had orchestrated

the meeting, is a campaign aide to Rudolph Giuliani, a leading Republican contender."

This recast sentence makes a lot more sense than the original. Our basic message is not that McAteer organized the meeting, but that she is a Giuliani supporter, a Republican in Democratic territory.

Every writing decision, from punctuation to paragraphing, is a chance to transmit story priorities. If a phrase is in parentheses, for instance, it is usually not of paramount thematic importance; if it follows a stage-clearing, drum-roll colon, it may well be.

How does the trunk-and-branch problem look from the reader's perspective? This image may be overly dramatic, but not by much:

> A small child clutches his mother's skirt as they arrive at the play-ground. Shy but curious, he releases the skirt and ventures ten-tatively toward the monkey bars, toward two girls jumping rope, toward a knot of kids playing with action figures. Every few steps, he looks back to verify that Mom is where he thinks she is. But one time he turns and—no Mom. No longer brave, he retreats with just one thought in mind: Find her and grab that skirt.

Without a safe home base, a trunk, the reader is similarly adrift and tentative.

Finally, don't confuse the trunk—that is, the major theme—with the whole truth. The trunk is just the topic that the writer has chosen to emphasize. The writer of our rich-poor story may decide to stress the separateness of New York's economic classes because he believes that facet of the truth is underrepresented. Or he may write the opposite story, for the opposite reason. He can write either story, as long as what he says is true and as long as he doesn't ignore the other side. But if he fails to label the trunk that he has chosen, the story center will not hold.

The Skinny Librarian

A writer must be a sensitive gatekeeper, for every tidbit that she puts into her story is a burden on the reader.

DON'T ASK BARBARA how her morning went. She's the type who will give you a *full* accounting—everything about breakfast (bran muffin, orange-peach-mango juice, used up my last coffee filter), everything about the trip to work (left 10 minutes late, made up the time on the Taconic State Parkway), and everything about everything else.

Barbara is not wandering from the question. She just thinks that her listener has a boundless appetite for facts and a Texas-size capacity to absorb them.

Don't be like Barbara. A writer must realize that every name, fact, detail, title, date and source that he inserts into his story is another item plopped into the reader's arms. If there are too many, the reader will be staggering about, like a skinny librarian with a stack of oversized books.

There are powerful forces, some good and some not, that make writers drop lots of stuff onto the hapless reader:

- A writer is taught to be precise. "407 Flannery Avenue, Apt. 6C" is better than "407 Flannery Avenue."
- Leaving things out is the hardest part of writing.
- A writer wants to show what she knows. After all, she had to dig deep to learn that the mayor she is profiling was the hopscotch champion of Dover Plains Elementary School.
- A writer, fresh from his research, is an expert in his story. This knowledge often makes him unaware of the headache all these items give to his comparatively uninformed readers.
- Facts are fun. Hopscotch queen! Understandably, a writer wants to share.

How can we lighten the reader's load?

One common bit of counsel is to strike unwarranted terms from a story; as Strunk and White say, "Omit Needless Words." "Used for fuel purposes," they direct, should be trimmed to "used for fuel."

That's helpful, but single words are the smallest game. Trim-minded writers can also bag entire paragraphs or sections. How? By looking to the contours of the article. A woman may have had seven children, but if a story focuses on her career as a biochemist, why burden the reader with all their names, ages, occupations and states of residence? This information about her children may be cast in the leanest of language, but because those facts are marginal to the article theme—the woman's profession—every word in those sinewy sentences is, weirdly, flab.

The biggest herds of unneeded words are skulking in the brush outside the proper boundaries of the story. So that is where the cull will be the biggest. This is what tripped up Barbara. Her friend was asking for a story called "The Most Interesting Thing That Happened to Barbara This Morning," but Barbara misread the request as "Everything That Happened to Barbara This Morning."

These matters are not always black and white, of course. Some topics sit at the center of an article, others are off to the side, still others sit on its margins, and some, like Barbara's bran muffin, are outside the story altogether. The further a topic is from the heart of the story, the fewer words it merits. In the biochemist article, "Her mother was a homemaker and her father was an ironmonger with an affinity for single-malt Scotch," may be fine, but more than that may be excess because the parents are not at the story's center.

And remember that, in easing the reader's burden, words are not the only quarry. Needless complexity is another. The nation may have imported 340,684 miniature Eiffel Towers in the last year, but a reader will more easily absorb a round number: "about 340,000." What is lost? Nothing. Similarly, "the Tuscaloosa office of the Alabama Bureau of Tourism and Travel" may be your exact source, but "Alabama tourism officials" will usually serve your purpose just fine.

Banish long, obscure or Latinate words, too. "Housing complex" and "residential development" are each two words, but the first is the better. The number of syllables matters as much as the number of words.

In this hunt to shorten and simplify, you can sometimes hit your target by aiming somewhere else. That is, if you try to punch up the vividness of a story you will often find that the word count drops as well, and it's easy to see why. To make a sentence vivid often means replacing some just-miss words (damp, chilly) with one that really works (dank); this is commonly the case with verb phrases, those typically wishy-washy formulations like "have to" and "took over," that are ejected in favor of the shorter and more vivid "must" and "seized."

Erasing words may seem hard, but a writer does it long before he starts to tap the keyboard. Choosing to write about Topic A

means choosing not to write about Topic B. No writer will use 100 percent of his research; that means making many decisions about what to omit. The writer also rejects flocks of words as his fingers are poised above the keyboard, deciding what to type. Then come the danged editor's restrictions on length, requiring more triage. Some sculptor once said something like, "To make a statue, I carve away anything that doesn't look like a man." The writer does the same thing, only with words. Jack Cappon called writing "the great winnowing."

There are two basic ways to shorten. One is to leave stuff out, the route the late writing teacher Donald M. Murray was referring to when he said, "Brevity comes from selection and not compression." The other way is to leave something in, but in greatly reduced form. Sadly, writers must do a lot of the latter, and this concision can be as hard as haiku.

Imagine: A writer is assigned a story about "New York's Most Sue-Happy Man"—a tenant who has hauled into court every landlord he ever had. Sounds interesting, but the writer is freaking out. The court-crazy man has buried him under reams of affidavits and depositions, the various defendant landlords have done the same, and the writer has just 400 words to paint the man's portrait, convey his personality, describe his lawsuits, and be fair to all sides. How to boil down pounds of legal paper into a paragraph or so? And do it fairly? Especially with both sides averring that every jot and tittle of their cases is crucial?

The befuddled writer must basically realize this: He can't say everything. Freed from the burden of comprehensiveness, he can then give an example or two of the issues from both sides, reassuring himself that it is fine to give just a flavor of the judicial goings-on. For example: "Among Mr. Starr's many complaints against his landlords are the failure to return security deposits and the sporadic delivery of heat; the sued landlords, in turn,

blame Mr. Starr for damaged walls, tardiness in paying rent, and interfering in their dealings with other tenants."

That's a fine and fair statement, in just one sentence, about all those reams of legal chatter. In writing, you are allowed to nod toward a topic, furnish an example or two, and then trot off elsewhere.

Finally, after making all these various trims, the writer must calculate the total weight of his story. If it still bristles with proper nouns and facts, he may want to snip some more. And he should not just take out the "air" words in a vain attempt to leave every itty-bitty fact in. That is also what Murray's "compression" remark meant. A story should not be as heavy as a fruitcake.

Maybe the best advice for the trimming writer is to remember this: Every word you write, the reader must read.

Drive-By Deliciousness

A writer can sometimes include a by-the-way morsel without hurting his story. But he must be disciplined, and make the detour short.

AN IMAGINARY TALE: A Rottweiler, owned by an odd man who subscribes to a raft of paramilitary magazines, terrorizes a Boston condo tower. The dog snaps at the mostly older residents in the elevator, barks ferociously at all hours and slavers all over the hallways.

Good story. But let's also pretend that back in the 40's, the mayor of Boston was caught in bed with his mistress in the same building. Generations of Bostonians have sniggered over the tabloid photos of the two—in bed, covers drawn up, their mouths open in shock (quite a feat for the mayor because he still managed to chomp on his trademark cigar).

Delicious! But we are writing a story about a Rottweiler today, not about a mayor in 1948. Do we include this juicy historical tidbit? Here's my answer: Much of this book is a stern warning to stick to your theme and bar the door when unrelated matter

comes knocking. But don't be inflexible. The fact is, reading is meant to entertain, and Boston's readers will be grateful for the reminder about their randy mayor.

The secret is to keep the meander short: "In the tower—the site of much municipal amusement when Mayor Quinn was caught there with his mistress in 1948—the Rottweiler has spurred many residents to take the stairs instead of the elevator." Notice how this sentence advances the main story even as it offers up the juicy bit.

Unfortunately, many writers will be tempted to set out *all* the tawdry details of this by-the-way story—that the mayor's mistress was an actress, that she had a small part in "Miracle on 34th Street" ("gorgeous but wooden," said one critic), and that the mayor's livid wife bopped him with a rolled-up *Boston Globe* when the photos appeared. As these added bits get trotted out, the growl of the Rottweiler gets fainter and fainter, and readers will wonder what the main point of the story is. To live outside the law of writing relevancy, you must be brief.

The other danger in drive-by deliciousness is "the shoehorn." Eager to fit in the tidbit, the writer may insert it awkwardly: " 'I can't sleep at night with that dog barking,' said Posie Smith, who lives next to 4B, the apartment made famous in 1948 when Mayor Quinn was found in flagrante there with a ripe redhead."

Of course, smart writers may find a way to marry an aside to their main story, and thus smooth the mention as well as earn the right to dwell on it a little longer.

If the writer worked for a tabloid, an enjoyably bad pun might be enough of a connection: "The mayor of Boston panted in this building with his mistress in the 1940's, but the panting these days is of a different sort. . . ."

For a higher-grade publication, the writer might forge a "tolerance" link: "The residents of 802 Commonwealth Avenue

tolerated a randy mayor and his mistress back in the 40's, and for years now they've put up with traffic tie-ups from the Big Dig construction project. But some of them have finally reached their limit with Bismarck the Rottweiler."

Or the writer might try an "in the news" connection: "The fine folks of 802 Commonwealth Avenue lead generally quiet lives. Over the last 60 or so years, they found themselves in the news only once—when a philandering mayor made a love nest on the fourth floor. But they are in the unaccustomed limelight once again. . . ."

Also be sure to consider a very different option—putting the mayor's story in the separate, accompanying article known as a sidebar. That approach will keep the main story unsullied and still share the scandal with the reader—often at greater length than would be prudent in the primary piece.[1]

Even as I offer ways to sneak the mayor's frolics into the story, my main message for writers is to beware. Seductive anecdotes are just one of the many temptations that lead writers to swing open the story gates too far, and admit creatures who don't belong there. For example:

- The quote from a Big Name that does little to advance a tale. The writer knows the quote is valueless, but darn if he isn't going to pop it in just to show that he did in fact interview Oprah, or Lance, or Hillary.
- The socko image—"like Tarzan in a tutu," say—that makes the author who coined it proud. So proud, in fact, that he strays from his story line in order to develop extended related metaphors involving Jane, Cheeta the chimp, local tribesmen and pith-helmeted colonials.

1. Novelists Nicholson Baker, Junot Diaz, David Foster Wallace and others have focused on another way to get fun sidelights in: the footnote.

• The oh-so-human desire to eke out at least some gain from any work that took a lot of sweat. Writer Annie Dillard explains the idea in this Zennish parable:

Every year the aspiring photographer brought a stack of his best prints to an old, honored photographer, seeking his judgment. Every year the old man studied the prints and painstakingly ordered them into two piles, bad and good. Every year the old man moved a certain landscape print into the bad stack. At length he turned to the young man: "You submit this same landscape every year, and every year I put it on the bad stack. Why do you like it so much?" The young photographer said, "Because I had to climb a mountain to get it."

Call this trio of temptations Big Name Dropping, Pride of Authorship, and the Labor Theory of Writing. And remember, they have plenty of friends who will also happily lure the writer off course.

CODA

It is August 2008, a week before the start of the Olympics in Beijing. You are sitting at a desk, and arrayed before you are six hats bearing the names of six different magazines: *Scientific American, Teen Vogue, The Nation, Architectural Digest, Ms.* and *The New England Journal of Medicine.* Put on each hat in turn and jot down two article ideas about the Olympics suitable for each publication.

In performing this exercise, you have traveled from the breadth of "topic" to the singularity of "theme." All the ideas you wrote down are about the topic of the Olympics, but only one of the six magazines would run "The Secrets of Speedy Olympic Swimsuits: Body Compression and Low-Drag Fabric," and only one would run "Beijing's Stadium Refutes Purity of Modernism." This section has set forth ways to enhance and shield your theme, and the magazine exercise reveals why those tactics matter: A topic will never be a tale until a theme makes it so.

Part III

MOTION

Good stories are a brisk journey, and the reader can always feel the breeze in his hair.

COLONEL FRUIT BAT, SIR

Metaphor Man became my friend during my years in the Sunday Business Section. Whenever I had to deal with a floaty, ethereal topic—bonds, the flat tax—I could gaze out the two or three panes of my window not hidden by annual reports and see him on the roof of the Times Square Theater, martini in hand, launching paper airplanes of inspiration to me across 43rd Street.

O.K., not really. There were no martinis and no guy on the roof, but that's my point. Metaphor is magic.

When Joel Bleifuss, a columnist for *In These Times*, wrote an Op-Ed piece for me in 1994 about public relations, he could have said, "P.R. agents are paid to gloss over dismal corporate news," or "P.R. agents are paid to put bad news in the best possible light." But he freshened the phrasing. P.R. agents, he said, "earn their living by sticking Happy Faces over unpleasant realities." That image is exactly right and, unlike more prosaic formulations, it stays with you.

These images sometimes fail, of course, but that is just the writer's fault. Blame the gardener, not the tool.

Just as Metaphor Man is not real, there is no stack of Happy Faces in a flack's office. This is an obvious fact, but it is also one

that nonfiction writers need to dwell on more. If I make the point in a grander way—*Fiction is acceptable in nonfiction*—the potential becomes clearer. Nonfiction writers! You must be factually accurate, but you are not limited by fact in your choice of expression.

Nowhere is fiction more prized than in an article cursed with little natural action. If a tornado tears up a town, the facts give the writer all the action he needs to write a story. But if the topic is the planned expansion of the local library, what's the poor writer to do?

For such occasions, one of the many ways to make a story move—the crucial subject of this section—is fiction. A good example comes from P.J. O'Rourke, the conservative humorist, who wrote a *Times* Op-Ed piece arguing that environmentalists are gauzy-eyed dreamers who treat nature as totally sacred and cute. Here's how he enlivened his abstract point:

> First of all, we spend too little time contemplating the ugliness of nature. If we spent more, we'd get some needed ecological perspective. Take the Jamaican fruit bat. This bat looks like a colonel in the rat air force. And it's got a set of teeth you could use to perform an appendectomy. If I were Jamaican, I would keep the fruit out in the garage, or maybe rent a mini-storage space.

The only fact in O'Rourke's paragraph is one animal's unpretty face. But look at all the hubbub—planes zooming, bats chomping—that he conjures from the rich, action-laden land of the unreal. And hubbub he surely needs, for his topic, the idealization of nature, can be pure Ambien.

Stroke and Glide

*All stories are divided into two parts, the action and
the commentary.*

A STORY IS a trip down a river. As the captain of the ship, the
writer must perform two duties: keep the boat moving and, at the
same time, describe and explain the scenery to his passengers.

If the writer paddles with no commentary—that is, provides
the bare-bones plot and action but no more—the passengers will
speed along but will absorb little of the passing scene. The story
will be spare and colorless, just like an old-time telegram: "Arriv-
ing San Francisco 8 p.m. Will call." And if the writer just props
his feet up and discourses on, say, that interesting, gnarled tree on
the riverbank, the passengers will glance at the idle oars and say,
"Captain, hate to interrupt, but aren't we supposed to be going
somewhere?" That story will be a still life—pretty, but not a ripple
of motion.

Consider a made-up story about a famous English gardener.
Here is a description of her grounds in late winter.

Gertrude Jekyll's garden is brown and leafless now. The branches of the butterfly bushes are cold and bare, as are the raspberry canes clustered by the patio. The crocuses that Jekyll buried in the lawn have not yet appeared, nor have the ancient peonies that reside near the birdbath.

Static, no? The writer forgot to row, to propel his story forward. But if he takes a few good pulls on the oars, then, at least for as long as the boat coasts, he can engage in static activities—explaining, describing, defining, opining—without making his readers feel marooned.

Here's Jekyll's garden again, this time with action:

The garden is brown and leafless now, but the juices of spring are bubbling inside the butterfly bushes and the raspberry canes that are clustered by the patio. There is, unseen, a new stirring in the crocus bulbs nestled in the lawn, and the red shoots of the peonies that surround the birdbath are just biding their time, poised to push through the soil with a touch more warmth from the sun.

By piggybacking the description of the garden on some movement—and there are different kinds of movement to choose from—the "still life" paragraph has turned dynamic. The reader who dozed while reading the first version perks up. The static paragraph is not necessarily wrong; there may be enough action in the neighboring paragraphs to keep the story boat "coasting" through a straight description like that. But if the story needs more oomph, if the boat is slowing a bit, the second version can help while still performing the static chore of describing the garden layout.

On the other hand, the writer can take an already "active" paragraph like this one . . .

Mrs. Jekyll set the weathered birdhouse on a sunny stone bench and repainted it a pleasant forest green. Then she raked up some dead leaves and dumped them on the fallow farm field next door.

. . . and drop into it some static but necessary background facts:

Mrs. Jekyll, who is a retired book illustrator, set the birdhouse on a sunny stone bench and repainted it a pleasant forest green. Then she raked up the dead leaves from the garden, which is a squarish plot on the west side of her blue cottage, and dumped them on the fallow farm field next door.

Smart writers, knowing in advance that they will need both movement and description in a story, design their reporting to supply both. In a 2006 *Times* article, Paul Vitello writes about two animal welfare workers who drive around Long Island, N.Y., looking for dogs in need. Vitello builds his story around one of the volunteers' trips, which furnishes him with enough movement to carry along such "still life" parts of the tale as who the volunteers are, what they do, and for whom they work. The two elements, stroke and glide, are apparent in the lead:

The underfed pit bull puppies were not the worst cases they had come upon in the two years of running what some call their soup kitchen for dogs.

But for Linda Klanpfl and Kathleen Boylan, members of an informal network of animal welfare workers who scour poor communities around the country to take food and medical care to pets who might otherwise end up sick or dead, they were typical poster-puppies, the kind they see all the time.

"He knows I hate the way he breeds his dogs," Mrs. Klanpfl
said, referring to the owner, . . .

This reads smooth, but a tyro's efforts may be bumpy. For
example, he may insert descriptions into his text in odd places,
suggesting weird things: "Schooled at Harvard, Jones was a dedi-
cated nudist all his life." Keep trying.

More fundamental, how does a writer know when a dose of
movement is needed? How long exactly can he "coast"? There are
helpful practices; one is to write in "right-branching" sentences,
which offer up a big dose of action in the beginning so that the
writer can branch out into static descriptions and explanations
in the later, righthand clauses. ("The boat smashed into the pier,
both because San Francisco's famous fog blinded the captain, and
because the two night watchmen had decided to warm up with
some rum below decks.")

In the long run, however, to keep his passengers from getting
fidgety, the writer needs to fashion a bell that rings as soon as his
story-boat comes to a stop. Only experience can build this bell,
but once constructed it rarely breaks. Just as everyone somehow
knows when an elevator is stuck, a veteran writer knows when he
needs to dip his oars in the water again.

But even for the seasoned writer, pride can bring matters to a
standstill. As Stephen King has written, "In many cases when a
reader puts a story aside because it 'got boring,' the boredom arose
because the writer grew enchanted with his powers of description
and lost sight of his priority, which is to keep the ball rolling."

A Stirring in the Garden

Making her story move is the writer's main duty.
Fortunately, there are many engines for the job.

OF THE TWO jobs a writer must do—make a story move, and describe and explain—movement is the more important. The novelist John Gardner called this quality "profluence"—"the sense that things are moving, getting somewhere, flowing forward." Here are the main engines of story motion:

NATURAL ACTION A story about how Gertrude Jekyll, the famous gardener, prepares her soil in springtime brims with much natural movement—the cleaning of the shovels, the pruning of the butterfly bush, the raking of the brush. The fortunate writer can exploit it all:

> Mrs. Jekyll wielded her loppers like a pro, trimming the boxwood to just two feet high.

HIDDEN AND FUTURE ACTION The writer who is assigned the Jekyll story in the spring, a peak season for the garden, is lucky. But what of the writer who draws that assignment in winter? How can he make his story move? Well, he can look deep into that wintry garden to see the springtime juices percolating, and he can also nudge his story forward in time a smidgen, to the busy season just ahead:

> The raspberry canes look dead, but inside them chemicals are flowing and churning, gathering the strength needed to fatten their buds and, in a few weeks, to force them open.

MADE-UP ACTION With metaphor and simile, either his own or a source's, the wintertime writer can also stir up some movement:

> "A garden in late winter is brown and leafless, but I think of it as a parade that is several blocks away," said Mrs. Jekyll. "The street may be empty now, but you know that soon enough you will see soldiers marching, drums booming, horses cantering and flags waving."

There is no real action in the paragraph, not even one horse clop. But there is some fanciful action, and that does the trick.

MENTAL ACTION Physical movement is one way to put vigor into a story. Another is mental movement—a new idea:

> Mrs. Jekyll's herbs have achieved great fame; her dill was a British Herbal Association prizewinner last year. But this year she has made a shocking if grandmotherly decision: to devote her sacred herb space to tomatoes. "My granddaughter Emmy adores tomatoes, especially the cherry ones," she shrugged. "I need all the space I can get!"

A tiny bit of news. But it stirs the story waters a little.

TURBO VERBS Every writing instructor commands, "Use strong verbs!" Such verbs will make a story more vivid and more fun, they say, and that is true. But on a story level, the biggest benefit of robust verbs is that they can propel a story far. Consider the garden article:

Putting her gloved fingers into the cold dirt, Mrs. Jekyll . . .

This sentence has movement, certainly. But rev up the verb and the boat gets even more zip:

Thrusting her gloved fingers into the cold dirt, Mrs. Jekyll . . .

TO AND FRO Alternating between general statements and specific ones can also bestow a sense of motion. Consider these three general observations:

Gardening means paying attention to details. It means sweating and sore muscles. And it means honing one's sense of color and proportion.

This paragraph is snoring. But when three specific statements are popped in among these three general ones, it awakens:

Gardening means paying attention to details. "I watch my beds like a hawk," Mrs. Jekyll said. "Just the other day I found a small ginkgo tree growing on the west side, and I potted it up!" The hobby means sweating and sore muscles, too. "Last year, I used up a case of liniment," she said, shaking her head. "The lower back is the worst." Most of all, though, gardening means honing

one's sense of color and proportion. "One year, as a young gardener, I planted mostly purple and dark blue flowers—it looked like something that dreadful Edgar Allan Poe might plant!"

William E. Blundell, a former *Wall Street Journal* editor, calls this back and forth "the alternation of opposite elements." It swings, he says, "from the abstract to the concrete, from the general to the particular, from the mural to the miniature."

THE MIX Vary the rhythm and structure of your sentences, and your writing will grow perky. Consider these three similarly shaped sentences:

Mrs. Jekyll grows mums and moonflowers in her eastern flower beds. She tends to dahlias and hollyhocks in the western ones. She has hyacinths and columbines in the southern plots.

Plodding, no? Sometimes, of course, parallelism—a repeated framework—is exactly the sentence structure the writer wants; used deftly, it can clarify the complex or convey dramatic emphasis. But this is not one of those times. Try this paragraph instead:

Mums and moonflowers grow in Mrs. Jekyll's eastern beds and, in the western ones, she has put dahlias and hollyhocks. The flowers of choice in the southern beds: hyacinth and columbines.

Both paragraphs say the same thing, but the varied sentence structure in the second adds a pep missing in the first.

Varying individual words can also jog a story along. To see how word variation affects story motion, replace the words "change,"

"vary" and "alter" in the following sentence with just one of those three: "Mrs. Jekyll likes to alter her garden layout from year to year, sometimes changing the location of her calla lilies, for example, or varying the mix of petunias and pansies."

With the substitutions, isn't the sentence more sluggish?

...

Paintings Without Frames

Breathless writing exhausts the reader.

CHRISTOPHER WANTS TO slip by his parents the fact that he spent much of the day screwing around with his friend Bob, whom the parents consider to be an aimless nitwit and a source of temptation for their brilliant son. So when the parents ask Christopher how he spent the day, he says:

> Went to the deli and got some Twizzlers—the best!—and helped Mr. Miller move his old dishwasher to the curb and sat around talking to his daughter Helen, who won the junior year math medal. Was at Bob's for a bit, and then called Ms. O'Meara about next weekend. She wants me to clean the winter stuff out of her yard for $10 an hour. Then I hung out on the lawn and counted how many old people walked past the house in 10 minutes. Then how many dogs. The dogs won. . . .

Christopher knows that by packing his answer with bushelsful of fast-following facts, his parents may miss his brief mention of

slacker Bob. Think of cars zipping down the freeway. If there are lots of them, and if they are packed closely enough, a passer-by cannot count them all.

But a writer wants his words to be noticed, not unnoticed. It's the reverse of Christopher's goal, and the strategy is the reverse, too. Writing requires pacing, an unhurried, uncrowded revelation of facts that allows the reader enough time to pause over an idea, absorb it, and reflect upon it.

But that's not what many writers do. For example, they may mound up the adjectives before a noun as if they are writing a classified ad for which one pays by the letter: "The partly renovated, four-bedroom, cul-de-sac Tudor town house. . . ." Better to say, "The Tudor town house, which has been partly renovated, has four bedrooms and sits at the end of a tranquil cul-de-sac. . . ." The "air" words, like "which has been," furnish the reader with a pause that refreshes and allow him to visualize.

Of course, this seems like awful writing advice. "Omit Needless Words," say Strunk and White. Yet my description of the Tudor home is 21 words; the one I discarded, only 9.

The problem is that the 9-word formulation has no buffers to protect and display the terms that have rich meaning. That version is like a wall covered with paintings, but with no wall space and no frames separating them. Where the edge of one painting ends, the next immediately begins. The viewer feels baffled.

With the paintings framed and spaced, however, the viewer can fully appreciate each.

There is a second type of turbocharged writing. Call it breathless prose. This panting style aims to whip up reader interest with extreme adjectives ("red hot"), splashy verbs ("zoom"), alarmist

punctuation ("!") and outsize claims ("unprecedented") that far outstrip the underlying facts.

The breathless writer is like the Ugly American, who thinks that, by talking ever louder to the Frenchman, he will force him to comprehend English. The *New York Post* knows how to shout in print; after an important but not huge event, the vice presidential debate between Governor Palin and Senator Biden in October 2008, the *Post*'s headline ("Sarah Show") used letters as large as kiwi fruit. In its report about 9/11, perhaps the biggest story of the surrounding 20 years or more, the *Times* headline ("U.S. Attacked") had letters just half as high.

Breathlessness is a hallmark of teenage girls (OMG!!!), but they at least have the excuse of hormones. What excuse do local newscasters have, when they introduce a teeny-weeny report ("In Scarsdale: The Raccoon Capers") with welling, swelling orchestral music suitable for Caesar's return to Rome?

Eventually, of course, breathlessness destroys itself. "Red hot" soon means merely tepid, and orchestral music attracts no more attention than elevator tunes.

Such breathlessness may be the news media's biggest sin. As Roy Peter Clark and Christopher Scanlan write of modern journalists, "We dip our pens in steroids."

Ask Not What . . .

Group similar points together. They gain power from consolidation, and lose power from interruption.

THERE IS A new porno store in Chelsea and the residents are hopping mad—but not for the usual reasons. This is a hip, edgy area of Manhattan, and there are some raunchy stores there already. What upsets many Chelseans about the new store is not its wares but its kitschy facade.

Nevertheless, some locals do object to the store on more conventional grounds: that it is inappropriate for the neighborhood and bad for children. To be accurate, the writer must report these concerns in his article.

But where should these "to be sures," these qualifications, go? The writer, Denny Lee, bunched them all together in one paragraph, and then, in the three following paragraphs, elaborated on his main theme:

Some people voiced the expected objections. Local block associations noted that Public School 11 and a church are around the corner. Wade Watson, a photographer who is the parent of two children and lives nearby, complained: "It's in the center of a residential block. Our children walk right by there."

But for others on this racy stretch, the problem is not the aisles of pornography but rather the display of blue neon stripes set against a blacked-out window.

"I don't mind the porn shop, but it's just so outrageously garish," said a Chelsea resident who owns a local restaurant and asked not to be named for fear of protests. "It's just really bad taste."

Matthew Bank, the publisher of HX Magazine, a gay weekly based in Chelsea, declared: "The facade is tacky. It's big, bright and blue."

This consolidation of the "to be sures" is smart, because it gives the newsier, unconventional paragraphs that follow the power of an uninterrupted run.

The wisdom of this sequence becomes clear if you pretend that the main newsy idea and the qualifications were scrambled together. Say, for example, that the "expected objections" paragraph—the "to be sure" section—sat between the "garish" and the "tacky" paragraphs. Notice how fitfully this jumbled-together passage reads and how it interrupts the dramatic flow. It's as if a race car driver tapped the brake right in the middle of the straightaway, and then tried to recover his speed. The momentum vanishes.

Imagine if John F. Kennedy had declared, "Ask not what your country can do for you—of course, all citizens are entitled to

the benefits of our social welfare laws and should not hesitate to invoke them—ask what you can do for your country."

In other words, while "to be sures" may go before or after the payoff part of a story, be sure to bunch them up. And what holds for "to be sures" holds for all parts of your text. As the cardinal writing rule says, "Keep related material together."

..

Cathedral in the Shadows

*Readers appraise a fact or idea in light of the facts or
ideas that surround it.*

CONSIDER THIS PASSAGE:

When it comes to America's birth, Philadelphia may be our most
historic city. It is the location of Washington Square, where
many Revolutionary War soldiers are buried. It is the home of
Ben Franklin and Betsy Ross, the creator of our flag. And it
is the site of Independence Hall, where the two fundamental
documents of the nation, the Declaration of Independence and
the Constitution, were conceived and born.

Now consider the same paragraph, rearranged:

When it comes to America's birth, Philadelphia may well be the
nation's most historic city. It is the site of Independence Hall,
where the two fundamental documents of the nation, the Dec-
laration of Independence and the Constitution, were conceived

and born. It is the home of Ben Franklin and Betsy Ross, the creator of our flag. And it is the location of Washington Square, where many Revolutionary War soldiers are buried.

These two paragraphs present exactly the same three arguments—just in the opposite order. The first starts out with a good point, moves to a somewhat more persuasive one, and ends with the strongest. Strong, stronger, strongest—it's the written equivalent of a musical crescendo. The second version moves from strong, to less strong, to least strong.

If the only difference in the passages is the order of the arguments, why is the first version so much more convincing than the second? The answer involves the same principle that makes dramatic contrasts so powerful.

That principle holds that the impact of a passage can be powerfully amplified or muted by the passages that surround it. Just as describing a father's hand as "thick-fingered, with veins like ropes under rugs" can underscore the tininess of the infant's hand that he holds, so the persuasiveness of an idea can be affected by the strength or weakness of the idea that went before.

In the Philadelphia passages, a reader is asked to appraise the claim that the city is the one most central to America's birth. In the first version, when he learns that the city is the site of the not particularly famous Washington Square cemetery, he'll say, "O.K., that's a reasonable point." But when he reads about Washington Square in the second passage, he'll be less impressed because he has already encountered the Declaration of Independence, the Constitution, Ben Franklin and Betsy Ross. Against the backdrop of those heavyweight names, Washington Square seems even more obscure.

It is scary that people can be so swayed by the sequence of

things, rather than just by their substance. But so it is, and writers should know it.

Feature stories, which traffic in drama and climaxes, are the natural home for crescendos, whether of facts, arguments, quotations or scenes. News stories, on the other hand, may be more welcoming to a "diminuendo," to stick with the musical metaphor. The most important news comes first, then the middlingly important facts, then the least important.

The crescendo effect extends far beyond music and writing. What if a fireworks display began with the finale? Well, the actual ending would be a fizzle. Another example: A few years ago, my niece Mary visited a series of waterfalls on the Brazil-Argentina border. For the first part of the trip, the guides showed the tourists impressive falls that range from 200 to nearly 300 feet in height. But it was not until the end of the tour that they brought the group to Garganta del Diablo, or Devil's Throat, a monster waterfall that is shaped like a U and is 490 feet wide and 2,300 feet around.

Mary was glad Devil's Throat came last. If it had come first, she said, the other waterfalls would have seemed tiny by comparison.

Henry James would understand her feelings. He once said that if Rochester Cathedral were in America, people would "go barefoot to see it." But instead, he said, the structure had the great bad luck to stand in England, "in the great shadow of Canterbury."

CODA

In his 1999 novel *Motherless Brooklyn*, Jonathan Lethem writes about a cop on the beat who routinely rousts loitering teens, chasing them off the stoop or wherever they are. If the teens protest and say they should be allowed to stay, the cop is dismissive. "Yeah, yeah," he says, continuing to prod them onward. "Tell your story *walking*."

That phrase is a fine slogan for the principle that this section has explored—the necessity of narrative motion. Make your writing move. Tell your story walking.

Part IV

ARTFULNESS

The artful writer sees what others see. He just sees it in a dawn-fresh way.

The Man Who Stole the Moon

Let words bewitch you. Scrutinize them, mull them, savor them, alone and in combination, until you see their subtle differences and the ways they tint each other.

Also, play with them. All wordsmiths do, even the most august. *The New York Times Manual of Style and Usage* is the highest authority on language at that newspaper; the staff does not trifle with its stern mandates. When it directs me, a graduate of St. Brigid's School, *not* to capitalize "he" in reference to God, no problem. Sorry, Sister Mary Harold.

But even the two standard-bearers who wrote that manual, Allan M. Siegal and William G. Connolly, were not above a little fiddlin' with the language. Flip through the book and you will encounter various hypothetical people whom the two authors invent to make their points; you'll find a "Pastor Miel," for instance, a "Sergeant Bildots," an "Admiral Karitsa" and a "Dean Cordero." Google those words and you'll find . . . Siegal and Connolly giggling. The names mean "lamb," in, respectively, Romanian, Basque, Finnish and Spanish. Browse through the book, and you'll find many more lambs in disguise—nearly 30 in all, Connolly told me.

Intentional wordplay like this is fun, but accidental wordplay may be even more fun. When a source says "Rimbaud" and the writer mistakenly scribbles "Rambo"—as happened in the *Times* in April 2001—that's good. If the source means "Rambo" and the writer hears "Rimbaud," that's probably even better.

But it is wordplay on purpose that is a staple writers' tool—and not just for diversion as in the style manual, but for reader ease and education. A pair of my Op-Ed writers, for example, once wanted to address a potential yawner of a subject: the vast multiplication of brands and products in the marketplace. To do so, they coined a handy and vivid word—sneakerization.

Sneakerization! For a word junkie like me, the newsroom has always been one giant yummy bowl of alphabet soup. I love to put wonderful words—comeuppance, wangle—into the paper. As long as they fit, and often they are the best or only fit, they make the story richer. This is not the high school kid's nerdy obsession with the thesaurus. O.K., maybe it is a little. But mostly it's the impulse, the need, to experiment with all the instruments in the music room so you can sound just the right note.

It's a short hop from great words to great images. Nineteen ninety-seven was the year that Princess Diana died, and the year that Hong Kong was handed over to the Chinese, but for me it was also the year of a bull's-eye image in a *Times* story by Jim Yardley about two new Trump skyscrapers. In the article, after a woman in an apartment house complains that the towers will diminish her view of the sky, Yardley brilliantly writes, "What mere mortal could take away the moon?" His answer, "Who else but Donald J. Trump."

There are thousands of stories about Trump. But Yardley's fine image graced this one with the aroma of fable, of romance, of fantasy, of Icarus. The headline writer zeroed right in on the conceit. "Trump Eclipses the Moon," he wrote on p. 1.

The way you say things—the subject of this section—makes all the difference.

The new *Times* building, a 52-story tower on Eighth Avenue in Midtown Manhattan, is literally an alphabet soup, an homage to typeface. The company's iconic "T" is glazed on scores of glass doors and walls. The closets are accented with brushed-metal punctuation marks—this one a comma, that one a carat, another, a dash. And in the vast cherry-red, pumpkin-orange lobby, a digital artwork flashes various texts—sentences containing the word "purple," crossword puzzle solutions—that have been plucked from the billions of words that the *Times* has published since 1851.

All of them, acts of worship in a temple of words.

..

The Smell of Pleather

The five senses are a writer's most formidable tools.

IF YOU WANT to feel as if you're rowing down the Amazon, nothing beats rowing down the Amazon. The rich tropical smells, the caws of neon birds, the heat like a huge hand cupping your body. You sense it all up close, unfiltered, on every side and all at once. Reality: the original sensurround.

Reading about rowing down the Amazon is a poor reflection of the real deal. In some ways, it is much weaker than a movie, which can splash the audience with tropical sounds and colors. (And even smells. At a 1981 John Waters film called "Polyester," each viewer got his own "smell track"—a scratch 'n' sniff strip.)

But writers do have one industrial-strength tool: the reader's brain. If a writer prods that brain enough he will stir its massive contents, putting into play many things the reader has seen or read or dreamed that bear on the topic: a *National Geographic* show about the Amazon; a drawing of parrots in a library book; a story he heard about Brazil from a world-traveling uncle.

That's still not a real trip down the Amazon, but it's not bad. What's more, it's interactive. The reader is not just some agog filmgoer, absorbing what the blaring screen tosses at him. He owns this "trip" in a way a movie fan can't.

The way to stir the dozing reader, to propel him down the river, is to exploit the five senses. How do you wake a sleeping teenager? Fry some bacon. The smell, so ethereal but so strong, will lift him right up, float him down the stairs and deposit him at the kitchen table, just as in a cartoon. Rouse your reader in the same way.

Sight is the sense most favored by writers, but don't slight the other four. Consider this appeal to the sense of touch in Diane Ackerman's *Natural History of the Senses*: "[W]hen I climbed up out of the cave and stepped into the blinding light of a hot Bahamian day, the sun was burning from ninety-three million miles away, *yet felt like fresh sandpaper on my arms and legs.*"

That's powerful. What's more, the kinds of touch that a writer can invoke are vast: something can feel grating or jagged, or scratchy or suffocating, or rubbery or gooey. There is the first pain of a stubbed toe, which is small but dread-tinged because a second, bigger wave of pain is on the way. There is that lurch of your innards as you jam on the brakes, and, when you drink overfizzy seltzer, there's that beehive tingle on your tongue. We are never not feeling something. What are you feeling right now?

What about smell, the sense that so enthralled Andy Warhol that, according to the writer Avery Gilbert, he maintained a "smell museum" of his partly used cologne? Again, the list is vast. There is the aroma of the tollbooth, of car pleather on a hot day, of a just-cracked book and of the supermarket produce aisle (half-apple, half-Lysol).

Taste? Freezer-burned hamburger has a distinct flavor, as does the sugar slush at the bottom of the coffee cup—the drinker's reward. And we have all sampled various inedibles, from scrunchy dandelion stems to minty toothpicks.

Sounds? A schoolboy knows the slight *ffftt* of a baseball as it leaves his throwing hand, and everyone knows the imperious warning beep of a truck in reverse. The writer Brian McDonald says the actor Ben Gazzara has a voice "like a blender on chop." Other languages often have great words that can inspire us to pay more attention to sound. Gulum, for instance, is an Indian ethnic group's term for the swallowy, echoey sound of a stone plopped in a well.

Whatever sense you choose, do not be hasty in describing it. Let the reader inhale slowly. Here is Verlyn Klinkenborg, an essayist and a member of the *Times* editorial board, on the smell of a Southwestern shrub called chamisa:

> "It smells like a rank little fox," said one Santa Fe resident. "It smells like being four years old," said another. . . . To use the perfumer's language, the scent of chamisa is at once woody, green and animalic, with several miscellaneous notes thrown in. It smells like a kitchen full of fresh herbs where a mouse has died behind the stove. It smells like a sachet in a drawer full of rubber gloves.

Enriching the sensuousness of nonfiction writing is not easy, but a writer can always invent. In a 2006 *Times* article about baseball, Dan Barry writes, "To imagine a New York where Mets and Yankees fans wish one another well, you would have to imagine a New York where the subways smell of potpourri and feature passenger sing-alongs at rush hour."

Ask a guy on the street if it is possible to use the word "potpourri" in a baseball essay, and he would say no. But the writer's mind is a freeing thing.

Ideas enchant humans, but we sure do love our senses. A woman sees a swatch of fabric and says, "When I was 10 I had a hat that shade of green." Our senses hold us in thrall, and cunning writers know that.

Chapter 20

..

Sparks on the Highway

Look until you see something new, for the writer is the
watcher of the world.

LOOK AT HOW Nicholson Baker, in his novel *Mezzanine*, portrays
the ordinary act of tossing a cigarette butt out a car window:

> [O]nly after I had become a commuter had I noticed the way
> cigarette butts, flicked out narrowly opened windows by invis-
> ible commuters ahead of me, landed on the cold invisible road
> and cast out a small firework of tobacco sparks [T]hese
> cigarette sparks were the farewell explosions of such intimate
> items, still warm from people's lips and lungs, appearing just
> beyond your headlights and then washed out by them, as you
> passed the still wildly spinning and tumbling butt that was trav-
> eling at forty miles an hour to your sixty-five. This had reminded
> me of how I used to open the window on car trips when I was
> little and release an apple or pear core into the bolster of air
> and noise and watch it shrink away into the perspective of the
> road behind the car, still bouncing and spinning fast—suddenly

changed from something I held in my hand to something not mine that would come to rest on a stretch of highway which had no particular distinguishing feature, a place between human places, as litter; and I was wondering whether the people who tossed their cigarette butts out in the darkness did it simply because they preferred this to stubbing the cigarette out in their ashtray, and because they enjoyed the burst of cold fresh air from the quarter-opened window as they flicked it away, or whether they knew what moments of sublimity they were creating for the nonsmokers behind them. . . .

By meticulously observing and heroically rendering a mundane act, Baker is doing the work of a writer. As the rest of us dash around and forge ahead and carry on, the writer must stand still. And just look. Then he stops us in our hurried tracks, directs our heads to the scene and says, "Check this out." And we see the discarded butt, or the grooves of an escalator, or the curves of a rose blossom, as if for the first time.

But if writers are the watchers of the world, some of them abandon the role. They bound about just as fast as their readers, and consequently offer only wafer-thin, forgettable descriptions. They fail to gaze. They may do this out of nervousness or impatience—got to get on to the next sentence!—but nothing is worth failing to ponder your subject. The fact is, most of writing is thinking.

Of course, if a scene or a description is minor in the overall story, do not spend too much ink on it. Baker talks of the "cold fresh air" that whips through the open car window, and "cold fresh" is short and familiar. But that is O.K. because he has other writerly fish to fry—namely, the ejected, tumbling cigarette.

As a general rule, though, sweat over your descriptions. Keep looking until you see something new. Anyone can give a first glance; the writer's job is to give a second and a third.

And don't be freaked out by Baker's laser-beam writing. His *Mezzanine* may be 135 intensely observed pages about just one ride up an escalator (!), but every writer need not construct the towering descriptions that are his trademark. Usually, one vivid image is enough to give a reader new eyes. Picture this: a tract of small, virtually identical houses, plotted with mathematical regularity in a largely treeless landscape. How to describe that scene in a fresh way? Ed Cullen, a commentator on National Public Radio, had a fine answer. He said the houses had "that air-base look."

Similarly, in a mere 57 words, the *Times* columnist Dan Barry makes an everyday object look as it never looked before. "The lobby of Macy's offers a study in how we carry umbrellas like weapons," he writes in 2005. "People flowing into the store aim theirs to the ground, shake them free of rain bullets, and tuck them away, as if in holsters. People leaving the store wince as they pull the trigger, as though shooting a blunderbuss they don't entirely trust."

As Thackeray said, "The two most engaging powers of an author are to make new things familiar and familiar things new." (A great place to find new phrases is old books, in images that have so faded over time that they are vivid again. According to the British literary critic Herbert Read, for example, Anglo-Saxons called the sun "world candle" and the eyes "head jewels.")

Finally, while abstract adjectival phrases like Baker's "cold fresh air" are useful, be very wary of them. Don't say that an executive's office is "palatial" if you can just as easily and briefly show his teak desk and marble busts. Don't say piano moving is a "tough" job if you can say it's a "grab and grunt" job or a "liniment" job. And don't say "the dazzlingly white tropical beach"—travel-brochure triteness—if you can let your reader wiggle his toes in the warm sand, or hear the grouchy calls of the gulls, or watch the sun throw a line of fire across the sea.

The Sunshine Boy

"Show, don't tell" works because a showing is a telling, just a more vivid one. But the wise writer knows that "tell" is sometimes the more prudent choice.

CONSIDER THIS LEAD to a 2001 *Times* tale, by Corey Kilgan-non, about how New Yorkers creatively seek out that most rare thing in Manhattan, winter sunlight:

In summer, West 109th Street is a sun-splashed block. But by December, as the low winter sun is shut out by the buildings on the south side, those warm rays are a distant memory.

Victor Matos, a doorman whose building faces the street, is not deterred. He knows that, from 1:25 to 1:55 p.m. each day, through a series of perfectly aligned alleyways running clear through to 107th Street, a shaft of sunlight shines, laserlike, onto his building's facade. On cold December days, when the breeze off the Hudson is strong enough that, as Mr. Matos says, "I've watched a sofa blow up the street," he positions himself

outside his building, 370 Riverside Drive. At precisely the right moment, he begins to bask briefly in a rare patch of warmth.

Isn't this a beguiling beginning? The reader will be charmed by details like the supposedly tumbling sofa and the shaft of sunlight. At the same time, he will not have to wait long for a direct statement of the story's subject; it can come right after this lead.

Imagine that the writer instead used this hypothetical lead, one that tells rather than shows:

New York may have lots and lots of things, from caviar to celebrities to Cadillac Escalades, but one item—winter sunlight—will always be rare. Since New Yorkers are New Yorkers, however, they have managed to snare this scarce resource in many inventive ways.

This lead is not wrong, but it is blander than the first. Such a "tell" lead, which basically says, "Here's my topic," appeals to the writer who wants to get his subject out there fast. But don't jump to "tell" too quickly. Although readers *do* want to know upfront what a story is about, they are often more than happy to read a vivid, well-told, on-point anecdote first. Moreover, nothing's irretrievably lost with a "show" lead because showing is just another way of telling. By reading the doorman anecdote, the reader already knows the story has something to do with sunlight and winter.

The "show, don't tell" rule applies to all parts of articles, not just to the lead, and to all types of writing, not just to anecdotes. Quotation, for instance, is a fine way to show a person's mood, especially when coupled with action ("'Throttling? No, throttling's too good for him,' Amy said as she skewered the kebabs with gusto."). But many writers go too far, believing that "show, don't tell" means "always show, never tell." Not true. Look back

at the alternative "show" and "tell" leads at the start of this section. The "tell" version is much shorter and more straightforward—and those are the big virtues of "tell." Use "show" tactics for the juicy parts of your story, which often include the lead; let "tell" do the journeyman work for the less juicy parts.

There are two ways of showing. In one, the reporter is an interviewer; for example, Kilgannon questions Matos about his sunshine-hunting and writes up the answer. In the other, often superior way, the reporter is a witness; he sees something happen. Here is a hypothetical lead of the second sort:

> Victor Matos, the doorman at 370 Riverside Drive, checked his watch one cold day in mid-December. It was time. He headed out the doors of his building, stepped sharply to the left and soon stood happily in the middle of a tiny shaft of sunlight that had shot down the alleyway. He had found what he wanted, something that, in New York City in winter, is as rare as gold. . . .

Why are such witnessed events better? Because, for a writer, watching a person do something is more real than listening to him talk about doing something. That makes it realer for the reader, too. Also, for the writer, watching a person in action aids accuracy; the account is not filtered through the speaker's possibly faulty memory or language skills, or colored by his self-interest.

Of course, watching is often not possible. When a World War II veteran describes his experience of D-Day, telling is the only choice. If he is deceased, then his wife's retelling of his telling is the only option.

But writers can witness more than they think. In profiling a local astronomy professor, for example, do not just interview her at her office. Meet her at the observatory, where you can watch her do what she loves: look at the stars.

..

The Ballad of Custer's Horse

Sometimes, say things sideways. The reader will be grateful.

TWO SOUTHERNERS ARE squabbling over whether one poached from the other's peach tree. A neighbor sidles up and ventures his own opinion. One of the two, annoyed, turns to the newcomer and says, "Hey, you got a dog in this fight?"

Of course, the annoyed man means, "This is none of your business, mister," but his picturesque phrase is a more entertaining way to make the point. English is shot through with ways to do this, from metaphor to understatement to irony. (And ironic it is that these figures of speech often bear the most unvivid names imaginable, like "synecdoche" and "metonymy.")

Without these figures of speech the language would be robotic. They allow us to import vividness into our writing even when the subject is abstract. When Howell Raines was criticized and ultimately deposed as executive editor of the *Times* in 2003, the dispute centered on abstract management issues, but what he said was colorful: "I'm as full of arrows as Custer's horse." When

Mike Huckabee's poll numbers improved in late 2007 and he drew fire from other presidential candidates, he said, "Hey, dogs never bark at parked cars."

Besides being colorful and concrete, figures of speech like these have another, relatively unsung benefit. They hand the reader a puzzle to solve—not the annoying kind of puzzle that comes from inartful language, but the kind that makes the reader a player in the story rather than a passive observer. The kind that lets him flex his mind.

An example: It's Santa Fe in 1957 and the boys at a local school have split into gangs. Some are white, most are Mexican-American, and the tension between them sometimes flares into fights, with bicycle chains and worse. Here is how, years later, one white boy wrote about his encounter with his dad over these gang activities:

> My involvement came to my father's attention one night when I came home somewhat worse for wear after a dispute with another gang over something important I don't recall.

Why is it more fun to read "over something important I don't recall" than to read the actual meaning of that phrase, "over something that was clearly trivial but seemed important at the time"? Simply because the first version presents an apparent contradiction (How can you not recall something if it was important?) that the reader must resolve, while also recognizing the wry self-deprecation behind it.

I know this is not physics; the writer's real meaning is quickly clear. Readers aren't the slow ones here; it's writers, who don't understand how much fun readers have when they are asked to figure even a small thing out. But writers should understand. How long does it take to read the average book? Seven hours?

Ten? That means the reader of a book is sitting in a lecture hall for basically one full day, listening to Professor Writer yap on. In such a fix, any diversion is appreciated.

That's why a smart writer—like Jon Franklin, a two-time Pulitzer Prize winner who is in fact that boy from Santa Fe—knows that sometimes he should draw just half a face, and give his pencil to the reader to do the rest.

Many jokes operate on this half-a-face principle. The teller delivers his punch line. A couple of seconds pass, and then a smile blossoms on the listener's face. In that small space of time the listener has connected the dots, and in that linking lies much of the enjoyment. ("Dyslexic guy walks into a bra . . ." See? Slight pause, laugh.)

The half-a-face principle pops up all over the language. Of the 62 common figures of speech defined in a 1959 textbook called *The Encyclopedia of English*, a stunning 32 give the reader an active role in sussing out the meaning. There are familiar terms on the list, like hyperbole and oxymoron, but also more obscure ones, like pleonasm and enallage.

No less an artist than Hemingway knew that, generally speaking, it is not wise to divulge everything to the reader. "The dignity of movement of an iceberg is due to only one-eighth of it being above water," he wrote in describing what literary scholars call his Iceberg Theory. "A good writer does not need to reveal every detail of a character or action."

Indirection and incompleteness are not always good, however. They can be pretentious, fusty and needlessly complicating, as they often are, for example, when writers use double negatives. To cure writers addicted to this tweedy habit, George Orwell urged them to memorize this sentence: "A not unblack dog was chasing a not unsmall rabbit across a not ungreen field."

But as the huge popularity of mysteries proves, readers do in

general like to flex their brains, to divine what's going on apart from or even in spite of the words on the page.

"Description begins in the writer's imagination, but should end in the reader's," says Stephen King. According to Norman Sims, a scholar of literary journalism, John McPhee concurs. "The reader is ninety-some percent of what's creative in creative writing," McPhee told him.

Two very different writers, the same idea.

Chapter 23

..

The Robin and Stone Mountain

Metaphor and other fanciful images are staples of nonfiction, but the nonfiction writer should consider even deeper forays into imaginary territory.

SOMETIMES, THE FACTS fall a writer's way. On Veteran's Day 2007, the *Times* ran a profile of a Jewish man, Werner Kleeman, who grew up in a small Bavarian town called Gaukönigshofen. His life was an epic. After his arrest by a local Nazi he was sent to Dachau, the concentration camp, but a generous American cousin secured his release and he fled to England. A year later he emigrated to the United States and, eventually, was drafted into the Army. He soon found himself back in England as an American soldier, landed at Normandy on D-Day, fought across France and Germany, entered his Bavarian hometown just days after Germany's surrender and, in a sparkly cinematic touch, found himself arresting the very Nazi who had arrested him years before.

Wow. The Holocaust, war, Nazis, narrow escapes and, then, the Mother of All Revenge Fantasies. To top it off, Kleeman spent his postwar years as a carpet maker in a little house in a

quiet precinct of Queens—giving the writer, Richard Firstman, a nice contrast to the world-spanning drama that went before.

This is the sort of story where you cast the characters for the movie even before you turn the first page. Who to play Kleeman? John Turturro?

Sadly, the facts are rarely this generous. So, unlike Firstman, most writers need to pump their stories up—that is, enliven them with the writerly arts. As the saying goes, "When you have a story, tell it. When you don't have a story, write it."

Many of these writerly arts rely on tools, like metaphor, that are fanciful. These brief images are fine as far as they go, but once in a while nonfiction writers should take more extended trips into the unreal. If they do, they can stir up even the most plodding of topics—a lonely widow's endless afternoon, a security guard's tedious nighttime shift, the slow creep of shade up a garden wall.

Or the magnitude of the federal deficit. In a funny but serious 1993 essay in the *Times* on that topic, to help readers understand just how big the deficit really is, the humorist Roy Blount Jr. turns to a fictional Southern preacher's description of eternal hellfire. The preacher, Blount writes, might say this:

> Now you take Stone Mountain and a robin redbreast.
>
> Now say that a robin redbreast was to fly over Stone Mountain every morning, carrying a worm. And as that little feathery bird went over the top, it brushed that hu-u-u-u-uge mound of rock ever so slightly with that little slimy dead worm. Now just try to imagine how long it would take that little robin redbreast to wear down that big hard mountain to the flatness of a parking lot!
>
> Well now. Along about then, that would just be suppertime (not that you'd get any supper) of your very first day in hell.

This fictional robin redbreast works better for Blount's point than many shorter bits of fancy might have. Unfettered by fact, Blount can unfurl several paragraphs that immerse the reader in a whole fantasy scene. The robin flies, the worm brushes the mountain, the sun rises, the bird does it again. The reader has time to *dwell* on Blount's idea.

Such yarn-spinning is squarely in the human tradition. The Oracle at Delphi, the Indian medicine man, the wise rabbi, the savvy grandpa rocking on the porch—they all make factual points not just with images but with whole stories. Sometimes, the best way to make a point is to jaw on a bit about something else.

Here's the beauty part. Such forays needn't be full-blown narratives like Blount's; sometimes, they can just be the leisurely spinning out of an interesting perspective. In a 1992 article in *The New Yorker*, Richard Preston writes about Blount's very same subject—huge numbers—in a very different way.

Preston was putting together a profile of two mathematicians, and he needed to describe pi, the ratio of a circle's circumference to its diameter. Preston's main goal with that description was to convey the idea of infinity, because although pi is about 3.14 its exact value is famous for being infinitely elusive, with mathematicians having worked it out to billions of decimal places with still no end in sight.

How could Preston make vivid and concrete such an airy idea as infinity? His conceit was simply to substitute letters for pi's endless stream of numbers:

If you were to assign letters of the alphabet to combinations of digits, and were to do this for all human alphabets . . . then you could fit any written character in any language to a combination of digits in pi. According to this system, pi could be turned into literature. Then, if you could look far enough into pi, you would

probably find the expression, "See the U.S.A. in a Chevrolet!" a billion times in a row. Elsewhere, you would find Christ's Sermon on the Mount in His native Aramaic tongue. . . . Also, you would find a dictionary of Yanomamo curses. A guide to the pawnshops of Lubbock. The book about the sea which James Joyce supposedly declared he would write after he finished *Finnegan's Wake*. The collected transcripts of "The Tonight Show" rendered into Etruscan. . . .

By substituting letters for numbers, Preston lets us wallow in the bigness of infinity, so much so that, after reading it, readers like me are even inspired to try their own hand at his technique. ("If pi's infinite decimals are rendered into letters, somewhere along that endless chain you will find every known recipe for octopus salad, the real meaning of Stonehenge, and this very sentence, written in pig Latin.")

Ultimately, Preston returns to his mathematicians and his profile. But the reader won't forget the pawnshops of Lubbock, or the new feel he has for infinity.

The Girl Who Was
A Servomechanism

Quotations are found art. Use them liberally.

THE JAPANESE USE quotation marks that look like corner brackets, the Germans use our left quote mark as their right quote mark, and the French include attributions—he said, she said—*within* their quotation marks.

But whatever the global variations, the basic fact is that the quote mark is everywhere.

That is no surprise for many reasons, and here is one of them: The best writing in the world—the most profound insights, the most colorful yarns, the snappiest puns, the most heart-rending *cris de coeur*—is done by nonwriters. After all, wisdom and articulateness are spread among billions of people; writers are relatively few in number.

And yet, quotations from these billions are rare in the average article; most of the time we hear the writer's thoughts, or the writer's paraphrase of what her sources have said. To make mat-

ters more lopsided, many of the quotes that do surface come not from those muffled billions but, no surprise, from the effusions of other writers.

Isn't that odd? If writers are supposed to transmit others' thoughts and perceptions, they sure don't quote them much.

But they should. For one thing, readers perk up when they see quote marks. The marks signify that a new person has arrived at the party, that, to try a different image, the story has switched drivers. For another thing, readers are often more attuned to the words of real people, the people the writer is writing about, than they are to the writer's. Why? Because real people are the horse's mouth. Even the most exquisitely empathetic writer can only interpret a person's emotions; he can never be as close to those feelings as the person feeling them.

For all these reasons, the most important skill in the art of writing may be the art of listening. To appreciate what a person is about, a writer must listen to him, to his words, to his rhythms, to his images, to the sequence of his thoughts.

Treat the interview—the writer's formal act of listening—with the deference it deserves. Do not parachute into an interview with a predetermined set of questions from which you will not be moved. Do not assume. Defer. Be humble enough to wonder if the story is different from what you thought. Do not be Bill O'Reilly. If you have seen his show, you have said to yourself, steaming: "Zip it, Bill! Let me hear what your guest has to say!"

Do not ever be impatient when speaking to a source; an interview is a conversation, and sometimes it takes a while for people to size each other up and be at ease. And do not yak too much yourself. Let your source have the floor. If his answer to your question is not immediately responsive, still hush up. Let him wander around.

After you've done these good things, in order to let your read-

ers fully appreciate your interviewee, quote him at length, in full sentences and not in lopped-off, control-freak little pieces. Let them "listen," too.

Quotation is also a fine way to show, not tell. The late Studs Terkel, the master of the all-quotation approach, interviewed a 24-year-old woman who was working in the 1960's as a receptionist for a big Midwestern business. Listen to her:

> I changed my opinion of receptionists because now I'm one. It wasn't the dumb broad at the front desk who took telephone messages. She had to be something else because I thought I was something else. I was fine until there was a press party. We were having a fairly intelligent conversation. Then they asked me what I did. When I told them, they turned around to find other people with name tags. I wasn't worth bothering with. I wasn't being rejected because of what I had said or the way I talked, but simply because of my function. After that, I tried to make up other names for what I did—communications control, servomechanism.

Terkel could have called the receptionist "intelligent" and "articulate" and "alienated," all of which she resoundingly was, as the full profile made clear. But her own words showed these traits much better than his telling would have.

The zenith of the interviewer's art is when the subject surprises herself. In his 2007 memoir, Terkel tells of a mother he interviewed in a housing project. When he played back the tape so her four kids could hear her voice, she listened intently and at one point said, "I never knew I felt that way." When a writer delivers news *to a person from that person*, that's heady stuff.

There is something more about quotations. When a writer sensitively quotes a person, it is as if the writer is a witness. This

witnessing can be respectful, even sacramental. The writer shelves his ego, and steps aside, and allows his readers an unobstructed, untinted view of his subject.

The true worth of quotation hit me in 2002, when I was unable to use one that I dearly loved. I was editing a great *Times* story by Erika Kinetz about the psychiatric emergency room at Bellevue Hospital, in New York City. A psychiatric emergency room is a rare place; there are fewer gunshots or broken bones, but just as much distress. It is a regular emergency room with many of the wounds turned invisible.

In one scene, a violent young man, strapped into a wheelchair, spewed forth a stream of invective that told untold volumes about him, about the emergency room, about his illness, about his family, about his life. There was no way we could print the obscenity-filled language—the *Times* is a family newspaper—but I knew that in this case the price was steep. No paraphrase could do justice to his feelings or perspective. I still mourn, and that's not overly dramatic a word, what we lost.

With their many virtues, why are quotations so rare? For one, some people have a rough time saying what they mean, so writers need to translate their words to truly make the point. A less admirable reason is that some writers are hams. They yearn for the limelight, and don't want to share it. Misapprehension of what writing is, is another reason. Am I a writer if my "writing" has lots of others' words?

Resist these latter impulses. Many fine writers, such as Janet Malcolm, do not stint on quotation, and Studs Terkel even built a Pulitzer-winning career on others' words. His *Working*, for instance, one of his several oral histories, is a compendium of people's thoughts about their jobs, from a bitter washroom attendant to a happy stonemason to the "servomechanism" woman quoted above.

Terkel is a collagist, taking stuff "made" by others to create a wholly new work.

Quotation may often be disrespected today, but things have been worse. When Samuel Johnson wrote parliamentary reports in the 1700's, he "made no attempt to recreate what people had actually said," the *Times* reported in 1984. Instead, "he put the best possible words into everybody's mouth."

..

Borrowed Grace

White is whitest on black. Let contrast work for you.

A FOIL IS something that, through contrast, enhances some-
thing else. If a gardener wants to set off his prize pink peonies,
he may plant them in front of a trellis of dark green ivy. The dark
backdrop highlights the pinkness of the flowers.

A writer should always be on the lookout for foils. Used
subtly—don't conk the reader over the head with them—they
can set off his theme powerfully.

For example, imagine that a writer wants to profile a sidewalk
coffee peddler, and that he particularly wants to emphasize the
tininess of the man's operation, from his snug cart, where barely
two can stand abreast, to his "personnel policies" ("Sometimes, my
wife will help, but we fight. She says I make the coffee wrong.")

As the writer interviews the vendor, call him Bashir, on a
Greenwich Village corner, he notices a Starbucks nearby. (In New
York, there's always a Starbucks nearby.) The writer sees a chance
for a foil.

The final story contains this paragraph: "Bashir's small menu

is growing, and he now offers a few drinks, a handful of pastries and even some culinary flourishes, like vanilla to flavor the coffee (25 cents a squirt, free with large cups). But he has a long way to go before his menu, hand-lettered by his teenage daughter, *matches the one at the nearby Starbucks, which fills a wall five times wider than Bashir's whole cart."*

Notice that, as the writer unfurls his foil, he also advances his description of the coffee cart.

Foils need not be visible. Consider the reputation of New York City. True or not, the city is widely seen as brash, ambitious, tough, rude, energetic, opinionated, fast-walking and fast-talking. The smart writer can turn these traits into foils for stories on many different subjects.

For example, imagine a support group for shy people. They gather together and try to learn how to be assertive, how to remain firm, how not to be wallflowers. Very interesting, no matter where the group assembles. But now pretend that this bashful group meets in Midtown Manhattan—the center of in-your-face New York. In just a phrase or two a crafty writer can underline the contrast between these people and the place they're in—"meek little minnows in the City of Sharks!"—and add a bit more fun to the article.

Sometimes, the contrast is itself the inspiration for the story. Imagine that there is a young, very religious couple, and that they regularly host "drawing parties," in which guests sit, chat, and illustrate Bible passages. If these gatherings occur in the Bible Belt, an editor may judge the idea only mildly interesting. But what if they are held in Williamsburg, Brooklyn, where hipsters clad in ironic T-shirts slouch down the street? And what if the local hipsters are intrigued by the parties, and come in droves? Then, it's much more interesting. And it is this contrasting framework— this wall of ivy so to speak—that makes it so.

Even a writer's style can serve as a foil. Hemingway's flat, restrained prose makes a compelling contrast to his unrestrained topics, like war and bullfighting. He sounds as if he's writing about bonds, not bombs.

Nor are foils just for writers. To highlight the safety of its cars, a company once ran ads depicting them in raw urban scenes, making them look like havens in a hostile world. Consider the scoutmaster, too, who gradually lowers his voice as he tells a ghost story, the more to terrify the campers with his screamed climax. And when a pitcher hurls a series of fastballs in order to catch a batter off-guard with a changeup, he is doing the same thing—shifting the batter's frame of reference, and then shocking him with something completely different.

Foils use contrast to achieve an effect; white is whitest on black. But oddly, the opposite tack—stressing sameness—can be powerful, too. Consider a story about "petworking," a phenomenon in which New Yorkers who are walking their dogs try to network with other dog owners in order to gain clients or jobs. It's a twist on the old game of meeting a pretty girl by petting her pet. The goal is not love, though; it's money and business.

To add juice to this *Times* story, the writer, Laura Pedersen, invokes the reputation of New York as a crafty and ambitious town, saying its networkers are *so* success-minded that, even "amid the biscuits and the leashes," they "are sniffing out tips on jobs."

This is not a foil's dramatic contrast. It's dramatic similarity.

The Pebble and the Pond

Symbols are powerful, so use them.
Symbols are powerful, so use them carefully.

"COLOR SYMBOLISM IN the Work of Stephen Crane." "Symbolism of Water in Faulkner's 'The Sound and the Fury.'" Dissertation writers are famous for slapping symbolic meanings on everything. But then again so do we all, on colors, on animals, on flowers, on fabrics, you name it.

The appeal of symbols is clear. As outward signs of inner notions, symbols help us think; they are conceptual shorthand. New York City may stand for ambition, drive, competition and aspiration, but if you represent those abstract qualities with one concrete place—say, the Empire State Building—they are far more graspable.

Even a simple symbol can stand for the messiest, most abstract, most convoluted idea. Take the weighty concept of a chain of events—the notion that one force can put into motion a series of events that continue on and on, maybe even far away in time and place from the initial push. Let's say that a father abuses his

children, and that, as they grow, some of the children replay that abuse with each other, and some get married, and some then mistreat their spouses and their kids, and some of that generation eventually do the same. Further down the line a woman dies of the abuse, and her parents grieve and her sister grows depressed, and those travails are traceable to that original abusive ancestor from several generations back and three states away.

What symbol can capture such an elaborate chain of causation? Why, something as simple as a pebble tossed in a pond, sending its ripples outward. Symbols can be atomically powerful in this way, and that is what makes them a great writing tool.

Symbols are also enjoyable to read. They add heft and color to the abstract, and they are artfully indirect, hinting rather than baldly stating. That layer of dust on the sick woman's bedpost testifies to her family's neglect of her. That church stone, polished smooth over centuries by the hands of pilgrims, is faith made visible.

Sometimes a symbol is a modest piece of a story, a tool of art for a preexisting subject, but sometimes it is the centerpiece of the tale and even its inspiration. A writer eats dinner at a restaurant on Mulberry Street, in New York's fabled Little Italy. The maître d', it turns out, is Mexican. Now, it is not news that, in New York's evolving ethnic makeup, Little Italy has gotten less and less Italian. But the writer knows that the restaurant maître d' is an icon of Little Italy, etched in people's minds as the cajoling, flirting presence on the sidewalk, importuning passers-by to come in and dine. A Mexican maître d'? In Little Italy? That's a potent symbol of a shift in a mythic neighborhood, and worth another story.

My favorite symbol, partly explored in a 1999 *Times* story by Abigail Beshkin, is a barrel that New York's Caribbean immigrants use to send goods back home to their loved ones. The immigrants typically ship the heavy-duty cardboard cylinders,

which are a few feet high, at Christmastime, but they frequently buy them in July and, slowly over the months, as often-meager paychecks roll in, fill them with gifts. There might be a soccer ball for 9-year-old Andrew, Skechers for 11-year-old Irie, and Slim Jims for Grandpa, who cannot get them in Trinidad.

As the containers get filled, each layer of items is like the ring of a tree, telling its own stories. "I found these cloth slippers for Luisa for $1 in Chinatown!" one barrel buyer might say. Or, "Guess what? A week after I got this Jonas Brothers CD, Rosa doesn't like the Jonas Brothers anymore!" Or, "I bought this size-small shirt for Neville, but by Christmas he was a medium!"

However told, this story is powerful because it is awash in human emotion—love, the pangs of separation, the pride of being able to purchase gifts for loved ones, the pain because the money goes only so far. These are all abstractions, of course, but the cardboard barrel, a symbolic vessel brimming with affection and heartache, makes them palpable.

Of course, do not go overboard with these devices like the 19th-century Symbolists, who saw symbols in everything and everything as a symbol. And be sure to earn your symbols. We should all have a nickel for every dime novel that seeks to redeem its weak plot with a Christ figure.

Most of all, though, be alert to the biggest danger of symbols— their inability to admit of any doubt or qualification.

In the story about abuse, for example, is the writer sure that the original father was an unalloyed villain and that it was solely his harshness that traveled down the generations, spreading to his offspring and his offspring's offspring? Would a psychologist, and the man's own family, agree? Is it possible the evil started before the father? Was he in fact also a victim? Did some descendants add their own measure of evil?

If the writer is unsure whether his theory is fundamentally

true, then he should not fling that powerful, rippling pebble into
the pond and fix the idea of the father's guilt vividly in readers'
minds. Symbols don't come with howevers.

The 19th-century poet Gerard Manley Hopkins invented a girl
for whom the falling leaves of autumn signify the finiteness of her
life ("Margaret, are you grieving / Over Goldengrove unleaving?
. . . It is Margaret you mourn for."). But for the nonfiction writer
who encounters a real Margaret in a real forest, things are trickier.
Why is Margaret sad? Is it because summer is ending and she has
intimations of mortality? Or did she just skin her knee?

Of course, not all symbols carry great risks of falsehood.
A battle scar is a surefire symbol of service in war, but what of
Washington's confession of chopping down the cherry tree? The
truth of that symbolic tale is highly suspect, but even if true it is a
long way from it to full proof that he was an honest man. He may
have been, but to say that a battle scar is a symbol of a person's
military service is a much shorter, safer distance to travel.

Some people—flacks without principles, for example—are
indifferent to such concerns. Seizing on our habit of stretching
one vivid image into a larger truth, they counsel politicians to
kiss babies and to wear fuzzy sweaters, and they design ads for oil
companies that show people gamboling in the forest. But is that
smooching pol really warm? Is the company really "green"?

The Secret of the Sea Urchin

Sometimes, a writer must be a sweet talker, wooing his wide-eyed readers with honeyed words. Then, when he has lulled them, he springs his surprise.

CALL IT close-to-the-vest writing, or the Art of Gradual Revelation. This sly writing strategy is a staple of whodunits and complex nonfiction narratives, but it also works well in other genres.

Consider a *Times* story about a fiftysomething man who lives in Manhattan but who was raised in Brooklyn and still loves his birth borough dearly. In 2003, when a plan is unveiled to build a basketball arena in Brooklyn for the New Jersey Nets, the man is smiling from ear to ear. Why? Because one of the great tragedies of Brooklyn's past was the departure of its beloved Dodgers for Los Angeles in 1958. The Nets plan would not only mark the return of professional sports to Brooklyn, but the arena—poetic justice!—would rise on the very spot where the Dodgers' stadium would have been built had the team remained.

Soon after the plan is proposed, the man attends a party in Brooklyn. He assumes that the partygoers, like him, all love the idea. After all, they, too, are Brooklynites.

But in fact the other partygoers are *not* happy about the Nets plan. They worry about the pollution and traffic congestion that the new arena may bring—something the man had not focused on, living as he now does in Manhattan. Also, many of these newer Brooklynites have never heard of the Dodgers; they are foreign-born, and their sports are soccer and cricket. They shrug apologetically in the face of the writer's high emotion, but they themselves are not moved.

Our writer, who is Michael Shapiro, a Columbia journalism professor, does not divulge this indifference right away, however. He shrewdly lets the readers misbelieve what he misbelieved—that today's Brooklynites love the Dodgers as dearly as did past Brooklynites—and lets us learn about his error only at the moment that he does, at the party. "My friend and his guests," he reveals in his punch line, "were appalled at the idea."

Shapiro's artful sneakiness lies between the lines; his approach is, "What I shall assume you shall assume." Sometimes, however, the surprise sits in full view. That was the case with a 2005 *Times* article about a reeking bag of garbage that sat on a Manhattan sidewalk.

It had been a sweltering week, and everyone at first assumed that the bag contained unusually juicy trash. The next day, however, the odor became transcendently awful. Veteran New Yorkers covered their noses; hardened cops wore masks. A mail carrier said darkly, "It smells like a crime scene."

By setting forth tantalizing details like these but keeping the mystery intact, the author, Abeer Allam, strings the read-

ers along. They wonder: Is the mound the dismembered leavings of a new Jack the Ripper? Foul chemicals from a mad scientist's experiment? Terrorism? Finally, in the 11th paragraph of the 19-paragraph story, she divulges the true contents of the bag— particularly aromatic fish. Had she disclosed the contents early in the story and then given us the "crime scene" remark and the other details, readers would have been far less enthralled. "Yecch" is better than "Eh."

Even while loosing our fantasies, close-to-the-vest writing like this has the contradictory effect of making it all very real. Readers relive the experience of neighbors, police and passers-by, speculating and fretting along with them.

Writing is sequential—you can say only one thing at a time— but through the Art of Gradual Revelation the smart writer can turn that limit into a tool.

Consider a final close-to-the-vest strategy, perhaps the sneaki-est of the three. Let's pick as a topic scuba diving in New York City. It is an activity that has been written about in the *Times* and elsewhere as New York's water has gotten cleaner, but it still surprises many. New York means Wall Street and the subway, it means go-getters and Broadway, but one thing it does not mean is scuba.

One way to underscore the unexpectedness is to paint a vivid scuba scene without saying where it is. Then, in the punch-line paragraph, the writer of our imaginary story can shock the reader by revealing the surprising site:

> The divers dove deep and saw dozens of lobsters scuttle away, and clusters of starfish and sea urchins. French angelfish and Caribbean jacks sometimes drifted by, as well as sea horses and, on one occasion, scores and scores of sea bass.

But these divers were hardly frolicking in the Caribbean. They were in the East River. . . .

How does this deception drive home the point of the story? By making the reader complicit in the very assumption that the article ultimately contradicts: that if it's scuba, it's not New York.

The Upside-Down Staircase

A writer should seriously consider the use of drawings,
maps and other nonword ways to make a point.
Sometimes, no mot is juste.

SCULPTORS WORK IN many media, and choosing the best material for a particular creation—the cool clarity of glass? the warmth and complex grain of wood?—is part of the artistry.

Writers have similar choices, but they pay them less mind. The typical writer sees himself as a wordsmith, and that's that. Yes, yes, within the world of words he will mull and make choices. He will labor mightily to find the exactly right word and, more broadly, he will consider the best form for his article. If the mayor he wants to write about is not especially articulate, for example, the writer may opt for a profile, so that he can use his own words to portray his subject. But if the mayor is a folksy raconteur with lots of backwoods bons mots, the writer may decide on a Q&A and so use more of the mayor's own language.

By contrast, the typical writer will spend little time sizing up media other than words. He is like a gardener who tries to

do everything—mow the grass, prune the apple tree, plant the bulbs—with just a hoe.

What are these other media? They are graphics and photographs and illustrations; they are charts and maps and diagrams. In the era of the Web the choices have only grown, with slide shows and videos, interactive maps and long threads of reader comments. For a particular topic, any one of these may be a better medium than pure words.

Let's imagine that New York's Metropolitan Museum of Art is quarreling with its neighbors. To house its growing collection of ancient Egyptian artifacts, the museum wants to add an annex to its building. The neighbors bridle at this, however, because the museum sits in Central Park, New York's signature green space, and a bigger museum would mean a smaller park.

At one point in the story, the author wants to describe the museum's five major growth periods. But to portray this expansion only in words would be unwieldy and confusing. For example, she might write: "During the next big growth spurt, the Met added a second floor on its southern rear wing, and lengthened its main building by 100 feet northward on Fifth Avenue." Multiply such leaden descriptions by five, and readers grow frazzled.

So, instead, the writer draws a diagram. This diagram shows the current museum layout, and the writer color-codes its various wings and annexes by date. The 1886–94 growth period, say, is colored rust; the 1906–26 period, blue. The proposed new addition is set off by dotted lines rather than solid ones—to show that it, alone, doesn't yet exist.

As presented in the diagram—the *Times* ran a similar one once in an article by Erika Kinetz—the information is quickly clear. The reader can even glean from the diagram facts that might not have surfaced at all in a verbal rendering. The wings built in

1906–26, say, might be gigantic, dwarfing the space added in all the other periods.

A writer often has many different nonword choices, even in just a single article. In an imaginary report about a toy company, for example, the writer can display its stock price in those familiar squiggly lines known as a fever chart. Or he can make a round "pie" chart to show how the total toy market is sliced up among the different toy companies. Or he can draw a timeline to summarize the company's history—founded in the 1950's by a hula-hoop salesman, a soaring success with its pet rock in the 70's, the subject of a takeover battle in the 80's. Or he can do more than one of these things.

What's more, any of these nonword tools can supplement the story with entirely new information, or recast and emphasize information that already appears in the text.

And one level of choice may not be enough. After the writer of the toy company story decides he wants to portray the stock price in a chart, for example, he needs to choose further between a fever chart, which tracks the price continuously over a chosen period, or a bar chart, whose thick bars give the price at specific times—say Dec. 31—during the relevant years. If the price has risen consistently upward, a bar chart would look like a stairway, and might tell the story with great visual impact. But if the stock price has had both dips and ascents, the fever chart may tell the tale more fully, and the bar chart may even be misleading.

Pictures, of course, are a language unto themselves. And they are a rich language, too, so, as with charts, the vocabulary is large and often requires more than one decision. For a story about a car crash, a photograph of the accident scene makes sense, but how do you illustrate an article about claustrophobes who live jumpily

in shoulder-to-shoulder Manhattan? A drawing, maybe? Edvard Munch's "Scream"? A photograph of an impossibly jammed subway?

If the choice for a particular story is a photo, should it be a straight-on picture, an abstract mood shot or a detail that symbolically stands for a whole? Is one image best, or two, or more? A series of photos, for example, may work for a wide-ranging article about a newly hip area of town. Like the choice of words, the choice of pictures also raises questions of tone. A snapshot of kids happily cavorting at P.S. 123 does not work if the article is about pre-exam stress at P.S. 123. La photo juste.

Wordcentric writers frequently put matters of geography into prose rather than in the obvious alternative—a map. The reader pays the price, slogging through stultifying descriptions like this: "The district would encompass about 20 blocks and would be bounded by Bette Road on the north, Essex and Tillary Streets on the west, and segments of Garrard Street, Sterling Place and Antioch Road on the east. The southern border jogs along—one north-south block, then one east-west block—and makes the western portion fatter than its eastern counterpart."

A smart writer can liven up this dizzy passage ("The proposed district looks like an upside-down staircase . . ."), but, in the end, medium is destiny, format is fate. If you choose poetry to write a TiVo instruction manual, you're in trouble. In this case, a map is the only thing that makes sense.

These nonword choices are like a painter's palette—green for words, red for pictures, yellow for graphs—but these options can also be mixed to make wholly different "colors." *Maus*, the Pulitzer Prize–winning work by Art Spiegelman, tells the story of the Holocaust in both words and drawings. (Jews are mice, Nazis are cats.) As in all such graphic novels, the art colors the words and

the words color the art, and the two media together make a color that neither has alone.

Nonword tools often offer the best way to do bread-and-butter writing, too. Imagine that a bus company goes bankrupt, stranding students from 14 parochial schools. The writer has a fine description of a scene: "The students from St. Raphael's yelped and caroused, excited by the break in their 3 p.m. routine. Meanwhile, worried parents gathered in tight clusters nearby; they had been summoned from their jobs by the principal to escort their children home."

Good. But now the writer needs to name the 13 other schools affected—perhaps the most important part of the article. If he lists them in a paragraph in midstory, the readers will have to search for them, and the writer's narrative will be interrupted. What is the solution? Run a list of the schools in an attention-getting box, separate from the article.

To master a tool means knowing its limits. Sometimes, there is no right word, because words aren't right.

All My Darlings

*Like the colors in a painting, words have a beauty and
a worth beyond a writer's composition.*

IMAGINE A SWIRL of purple color, a purple so dark that it takes
bright sun to reveal its real hue. You love it. It looks like the Nike
swoosh, and it has lighter-purple traces radiating from its body,
aerodynamic touches that suggest great speed. The swirl could
be a cartoon depiction of a whirlpool, or an Art Deco touch on a
fancy cruise ship.

As you savor this swirl of color, you do not fully realize nor
care that the swirl is on a wing, or that the wing is on a butterfly,
or that the butterfly is on a lily, or that the lily is part of a flower
bed of intricate and delicate design. You will eventually step back
and take all that in, but for the moment you just zoom in and
dwell on this one little sight.

Most of this book is about how to fit words together effectively,
about how to choose and assemble them for the greater good of
the article. This section is an asterisk to all that.

Like the swirl, words are sensuous and precious apart from their

role in a piece of writing. They are independently, isolatedly, dissociatively delightful, in their sounds and their shapes and their meanings. Many writers are bewitched by words in this way. At some point, they will see a lovely word in its proper context—yes, the swirl is on an insect and, yes, the insect is in a garden—but often, just for a bit, they will pause on its insular charms. And so will their readers.

So: Write rich!

To enrich our writing is one reason we turn to synonyms for a word that otherwise we would have to repeat frequently in a story. In a piece about the search for a fugitive killer, say, a writer might variously use the synonyms "hunt," "chase" and "pursuit." Why? Because relying repeatedly on the same word—"hunt" . . . "hunt" . . . "hunt"—saps the piece and dulls the reader. Route 80 is a long, straight, flat, tedious highway that slices across Pennsylvania; use the word "hunt" enough in the tale about the killer, and it becomes a Route 80 read. Take the scenic route if you can.

But avoiding boredom is not the only reason we love words as words.

For another, we love their sounds. Listen to a toddler as he puffs out the letter p, or rolls the letter r like a marble in his mouth. Words that are fun to say and hear: ballyhoo, waddle, klezmer, lackadaisical, chasm, tootle, quahog, fuddy-duddy, doily, lagniappe, cruddy, nougat, thrum, junket, pang, foible, tweak, sluice, banter. Onomatopoeic words—words whose sounds mimic or evoke what they mean—double the fun. One of my favorites is "apoplectic," which sounds just like the red-faced sputtering of an apoplectic person.

Words' sounds and meanings blend in rich, wonderfully ponderable ways. Why do so many rhyming words—"hocus-pocus," "handy-dandy"—start with "h"? asks Roy Blount Jr. in *Alphabet Juice*, his toast to the language. And why do words of disapproval— "tacky," "twit"—so often begin with "t"?

You may say to me about this word-love thing, get a life; I say I'm not alone. And here's John McPhee come to my defense. In a profile of Euell Gibbons, McPhee offers long lists of edible plants that the famed naturalist gathered in the woods:

> Gibbons and his wife caught crayfish in Washington lakes and sold most of the catch. They also gathered and sold dewberries, and, just for themselves, they collected salmonberries, blackberries, raspberries, salal berries, serviceberries, sea urchins, crabs, clams, mussels, moon shells, lamb's quarters, purslane, wild mustard, and camass ("very much a local wild food, a sweetish and smooth-flavored bulb").

This list certainly serves story purposes; it shows the plenitude of wild foods and is the very language, the dictionary, of Gibbons's world. But notice that many of these items are undefined and undescribed—and this is not the only partly unexplained list in the Gibbons profile. McPhee's pure affection for words must play some role in these passages.

Word lovers—logophiles!—also cherish words' meanings. Who doesn't relish the idea of schadenfreude, the enjoyment of others' misery? Or of penumbra, that light area of shade next to a dark area of shade? Or of acnestis, which is the area of an animal's back that it cannot quite scratch? And isn't it nice to know that there exists a word, blabburt, for a nasty remark about someone that is accidentally overheard by the dissed person?

(Word dabblers: For more, get a copy of *Mrs. Byrne's Dictionary of Unusual, Obscure, and Preposterous Words*, by Josefa Heifetz Byrne, or Ammon Shea's *Reading the OED: One Man, One Year, 21,730 Pages*. And check out *The Meaning of Tingo*, by Adam Jacot de Boinod, for sweet foreign words like neko-neko, Indonesian for "to have a creative idea which only makes things worse.")

The vividness of words captivates us, too. Sure, a profile of a small-town politician may say he "quickly and aggressively silenced" the opposition, but wouldn't it be more colorful for him to have "squelched" it? Never forget that clarity is just the start of the writer's job. Legal briefs are indisputably clear; "the party of the first part" will never be confused with "the party of the second part." But those bathwater-gray phrases leave you feeling logy, as if you've just triple-checked your taxes.

Here's where I get wacky. Bear with me.

I believe that the shape of letters adds to words' richness—the baroque G, the mystical O, the sturdy A, the gravity-defying F, the back-of-a-fat-cat Q. Who hasn't fiddled with the typeface choices on his computer, with their luscious names, Franklin Gothic and Edwardian and Cheltenham? And who hasn't doodled away in curlicue heaven, turning his name into something out of Dr. Seuss?

Wouldn't it be great if English had more than 26 letters? Imagine this: Congress, taking its cue from Russian and other languages, authorizes the creation of three new letters, the 27th, 28th and 29th, to stand for the sounds "ch," "sh" and "th." The statute asks the U.S. poet laureate to conduct a design competition for the new letters, which will appear in the alphabet after "T" and before "U."

I believe that tens of thousands of people would enter such a contest. (Put your entries here: _____. _____. _____. You know you want to!)

Why would this event be so appealing? Because letters are the landscape of our lives. We look at them all the time, we see them in clouds, we see them in carpets. Is there a place in your home where you can't see any letters?

We know letters as we know our mother's face, keen to their every aspect.

We also love the shapes of whole words. "Philadelphia," with its up-and-down pattern, is frilly and sweet and girlish; "Boston" sits like a burly burgher on the page, solid and four-square and manly. Word shapes can be symmetrical (dollop) or saggy (Egypt) or slim (lilt). Sometimes, even, shapes overlap meanings. Who doesn't love the shape of "look," which mimics what the word means? Or "parallel," where two letters have volunteered to make the point? Or "cocoon," whose c's do just that to the o's? Or "eclectic," whose three abrupt, chopped-off syllables exactly ape what the word says.

(Is there a word for words that *look* like what they mean?)

Words whose shape I love: Pez, illin', powwow, belly, baobab.

Get a life, you may say again. I'll admit this: No writer is checking his work to see if he has used enough frilly "Philadelphia" words. But there are lots of Scrabble boards out there, and more than one writer has said something like, "I hope someday I can write a story that has the word 'alabaster' in it." Sylvia Plath so loved words that she called herself "Roget's strumpet."

The extra good news is that, while a vivid word has an isolated charm unlinked to the overall story, it also often happens to be superior to a bland word for larger article purposes. A double benefit. If an article about a wild frat party says "chairs flung" and "bottles in smithereens," for example, those vivid words are probably better for the article theme than "chairs thrown" and "bottles broken."

Similarly, those lists of synonyms, like "hunt," "chase" and "pursuit," can furnish a writer with a whole word-palette for the different shades of meaning that he needs to convey as a story evolves.

Consider, for instance, the search for the fugitive. "Hunt" may suggest the hunters' determination to capture their quarry, but it doesn't convey any sweaty strenuousness or physicality. "Pursuit"

does, though—you can hear twigs snapping under running feet. In the part of the story where the police close in and the pace quickens, then, "pursuit" may be the optimal word. The word "search" is more detached and forensic; it may be the best choice for scenes early in the story, when the police are inspecting a tire track or a cold cup of coffee to determine which way the fugitive fled. If the searcher is the husband of the murder victim, though, and he has doggedly tracked her killer for decades, "quest" may strike the right determined note.

Does this fine verbal tuning matter? Twain thought so. He said the difference between the right word and the almost right word is the difference between lightning and lightning bug. Roget went Twain one better, arguing that synonyms do not really exist because every word has a unique meaning.

But beware too much word-love. Do not get too juiced by the joy of words; love it but learn to curb it, as if you were "a compulsive punster at a funeral," to use John Gardner's phrase. Why? Because word-love can blind you to the overall structure of the story. It can prompt you to fill the story-room with lots of trinkets that are pretty one by one but, together, are jarring and excessive.

That is, while the purple swirl on the butterfly is enthralling, you can use it only if it fits. If the article is about the elegant designs that grace the natural world, from the fan-shaped ginkgo leaf to the architecture of the three-chambered nautilus, the swirl may be a great and telling example. It may also fit nicely if the article is about the hidden evolutionary role of some of nature's designs; maybe the purple swirl mimics the brow of a hawk and deters the butterfly's predators.

But if the story is a dark study of the tensions between a couple as they sit on the patio near where the butterfly lands, the swirl may have to go unsung as thematically irrelevant, or even thematically subversive.

···

Pretender in the Promised Land

*The writer who indulges in fancy-pants prose
sometimes has too large an ego, and sometimes one
that's too small.*

OFTEN, EDITORS GET a lively, direct, vivid pitch for an article.
They commission it. But when the finished article arrives, that
lively, direct, vivid idea is sporting some pince-nez and a pair of
spats. The piece is plagued by obscure words and weird allusions
that only an Oxford don would know. The writing is fusty and
musty, and the fun has flown.

The editors scratch their heads and wonder, "What the heck
attracted us to this piece?" Only by rereading the original idea do
they remember what they liked.

The writer caught a bad disease. Call it the Snoots. He seems
to have grown pedantic, and some muttonchops.

A closer look often tells the opposite story. The writer does
not feel like a don; he feels dumb. So he dresses in an academic
robe and procures from under it the most ornate syntax and the
smartest words he knows or can look up. Why? Because the writer

is afraid that if the editors and readers see him as he really is, they will judge him stupid or uneducated.

His nightmare: He will be drummed out of the halls of the esteemed magazine that accepted his article, while the *real* smart people, the ones who truly belong there, shout "Pretender!," mutter about their grave mistake, and shoo him out the door. "He *seemed* like one of us," a silver-haired editor murmurs with a shake of his large and noble head.

Besides donnish prose, other symptoms of the unsure writer are overattribution, overexplanation and repetition. (I said it, but I probably said it wrong, and anyway maybe no one was listening. So let me say it again.) In all these cases, the real story goes untold, or told badly, because fear and low self-esteem got in the way.

Sometimes, the problem is an oversize ego. The self-absorbed writer's goal is not to tell a story; it's to put himself out there for all to admire. The turns of phrase! The effortless elegance! The bons mots, tossed off with such insouciance!

This person needs to be grabbed firmly by the ears and told, "The reader, Mr. Writer, wants *the* story, not *your* story." This ego drive may of course stem from the same lack of confidence suffered by the faux Oxford don, but, sometimes, a ham is just a ham.

Occasionally, the excessively tricked-out story may derive from mistaken notions of what good writing is. The writer believes that big puffy words add zip to his tale. That's often an error of youth, the first blush of enthusiasm for the glories of the language. It's sweet, and it usually will be tempered by maturity, like the high-kicking colt who gradually smoothens his gait.

Lack of confidence or an oversize ego are stickier ailments that often a lifetime won't shake. The cure may be therapy or meditation or other spiritual salve beyond an editor's competence, but that editor can at least offer specific, writing-related advice: Focus

on your subject. Realize that everyone gets the jitters. Write and keep writing till you don't feel edgy; soon the true you will emerge. Join a writers' group and let your stuff be regularly criticized; that way you can see it as something outside yourself.

Whatever the remedy, the most common of these psychological writing ticks is the trotting out of those—ahem—Oxonian words. H.W. Fowler, whose *Dictionary of Modern English Usage* is a standard writing guide, lists 161 terms that deal directly with the art of writing and speaking. A daunting 20 of them—more than 12 percent!—describe various species of fancy-pants prose.

"Gallicisms," Fowler writes of one type, are "borrowings of various kinds from the French." "Wardour Street," he writes of another, is "the use of antique words." (He got the name from a London road known for its antiquarian shops.) "Genteelism," he writes of a third, is "the rejecting of the ordinary natural word that first suggests itself to the mind, and the substitution of a synonym that is thought to be less soiled by the lips of the common herd. . . ."

The diagnosis in all three cases: The Snoots.

CODA

In an artful story, the elegances that I explored in this section—symbols, synonyms, foils and so on—are not enough. Writers must also sound the littler grace notes. Call them artfulness with a small "a."

The *Times*'s "brunch rule," for example, reminds writers that readers may be munching on a bagel (or whatever) as they scan the paper. For that reason, *Times* descriptions of body functions or medical procedures tend to be comparatively fuzzy. It is not artful to be gross, whatever the article topic.

Times writers also avoid repeated abbreviations. Why? Because to pepper a page with "A.F.L.-C.I.O." or other jumble of periods and capitals creates "mottled typography and choppy prose," says the paper's style manual. Artfulness, in other words, has a visual dimension.

And do not look for many brackets or ellipses within *Times* quotations; the paper prefers paraphrase to those contrivances. Why? Because, again in the manual's words, those devices "divert attention to the editing process." That's like having the director of a play dash onstage to straighten an actor's bow tie.

Part V

Truth and Fairness

Writing is an art, and art bestows a license. But the license is a limited one, and it never sanctions material omission or unfair play.

One Letter, One Apostrophe

Of all the slogans of journalism, perhaps the most poignant is "too good to check." The phrase refers to a star quote or anecdote or detail, a touch so sweet or sad or otherwise perfect that the writer *fears* the act of confirming it. Why? Because if it is not true, then this gem will slip through his ink-stained hands like sand at the beach.

Of course, the phrase is tongue-in-cheek. The writer does check that fact, even if it is "too good to check." He bridles at the need to do so, but he does, because, in nonfiction, truth is paramount. Maybe in Journalism Heaven something can be "too good to check," but not here.

Writers hew to the truth for noble and ignoble reasons—dedication, integrity, fear of getting fired, fear of getting sued. I also think nonfiction writers know that if they betray the truth, there is nothing for them to hold on to. Vertigo. How do you report an article once you start to lie? How do you do anything? Jayson Blair, the disgraced *Times* reporter, once lived around the block from me in Brooklyn. At any moment, when he was supposedly reporting in Maryland or Texas, he could have bumped into me or another *Times* person at the corner grocery and his cover could have been blown. How did he live under that dark cloud? I don't know.

But most writers do prize accuracy—the subject of this section—and that is good because the stakes are often significant. Sometimes, the importance is practical. If a newspaper prints the wrong winning lottery number, some poor guy with the right ticket may toss it away, and some even poorer guy with a wrong ticket may go on a spending spree and then get buyer's remorse big time. Sometimes, the importance is factual. A *Times* picture caption in 1997 identified a model of a chimp brain as that of a fossilized human ancestor, and vice versa. Whoops!

But very often the stakes are teeny. In 2001, a *Times* editor conducted intense discussions with an irked source over whether her job was correctly described as "physician assistant" or "physician's assistant." The winner: physician assistant. Time elapsed in debate: about two weeks. The stakes: one letter and one apostrophe.

In 1999, an even shrimpier question landed on the *Times* copy desk. Was Homer Simpson's signature interjection spelled "Doh"? Or was it "D'oh"? The winner: D'oh. The stakes: one apostrophe.

Why this heroic pursuit, at the *Times* and elsewhere, of itsy-bitsy truths? Because of that vertigo thing, yes, because journalism is the first draft of history, yes, and because writers want to be stand-up people, yes. But, without denigrating these very important reasons, we also chase the teensy-weensy questions about truth because the big and hairy ones are devilishly hard to answer. For example: When does an "acquaintance," whom you *can* write about ethically in many cases, transmogrify into a "friend," whom you *can't* write about? We may not be able to respond to that question, we writers say subconsciously, but, partly as penance for that failure and partly for the relief of addressing something doable, we will move heaven and earth to find out if, say, the Mazda in that accident story was slate blue or navy blue.

When the big truths fracture into uncertainty, it all becomes very postmodern. Do my gender and race and class, not to men-

tion such psychological reflexes as projection and denial, make journalistic objectivity impossible? And even if they don't, how do we know what's true? Or what's good? Or what's fair?

Or even, what's funny? Only once as Sunday Business Op-Ed editor did I want to devote my entire space of about 1,800 words to one article. Usually I ran three articles, sometimes two, but never one. I never had the urge to—until I roared over a sendup of a stockholders' meeting by Edward Stephens, a former journalism dean at Syracuse University. The piece was hilarious. It was Charlie Chaplin in print. It was deft and droll.

But I needed my entire space for the piece. To run it shorter would be misguided, I told Glenn Kramon, then the Sunday Business editor and my boss. This style of understated humor needs room to bloom, I pointed out. I can trim anything, I said, but with this one I'll hit bone at any space less than all I've got.

Kramon was sympathetic but not entirely in agreement. You can run it in two-thirds of the space, he said, but you need to run one more essay. Don't give the reader a choice of just one article.

Well. Let's just skip my dark thoughts about Kramon at that juncture. But here's the funny thing. I reread the Stephens piece 15 years later, and it *is* amusing. But stomach-shaking laughter? Well, no. Back in 1993, though, I would have judged you daft not to see the hilarity.

Words stay constant, but how we see them is tricky business, the sum of the words, our age, our life experience, the gestalt of the era, our mood that day, all vectored according to some unknown calculus. As a result, getting a bead on some truths is like nailing jelly to a wall when the wall is made of jelly, too.

We'll keep trying to uncover the eternal verities, of course, because people are plucky that way. But in the meantime, let's wrestle with that Doh-D'oh thing.

Something There Is
That Doesn't Love a Fence

Writing is an act of assertion and judgment. Do not evade that part of the job by hiding behind bland language or others' words.

BUREAUCRATS LOVE CAPITAL letters. Just look at their titles: Chief Operating Officer, Bureau of Blandishments. Grand Vizier, Division of Arcana. Assistant Undersecretary, Department of Magma Analysis.

O.K., these are not real titles. But they sure are realistic.

Many writers accept such blowhard titles as givens. If that's the man's title—Dean of the School of Anarcho-Syndicalist Thought—then that's his title, right? And if he has two titles, Dean of the School of Anarcho etc. and Rod McKuen Esteemed Professor of Light Verse, then that's how he should be described, no? After all, we wouldn't shorten someone's name just to save space, would we?

Well, yes, we would. Britain's Prince Charles has a long, long

string of names—Diana famously stumbled over them at their 1981 wedding—but to the news media he is often Charles or Chuck or Wales or whatever.

And titles are even more alterable than names. A poetry professor is a poetry professor, and in a story about the current state of poetry that is how you can refer to the scholar with the two long-winded titles. No reason to bring Anarcho-Syndicalism or Rod McKuen into it.

Why shorten titles? Because they are often long, boring and obscure. They can be heavy lumps, and as the reader tries to digest them, the momentum of the story may slow or stop. Consider this made-up lead:

Last week, the Brooklyn Victoriana Society announced the winner of its 2007 Blast From the Past Award for Most Inspiring and Creative Private Residence. Jaws dropped at the announcement because the honoree was none other than John August Florey, an architect who has made his name not in the Victorian style, but in the Modernist one.

"2007 Blast From the Past Award for. . . ." That 13-word lump in the middle of the lead, bristling with capital letters, smothers the point of this opening. If you need to fit this clunky formal title somewhere in an article, and I would vote no, stash it way down in the story and give the reader a more digestible paraphrase in the lead:

Last week, the Brooklyn Victoriana Society announced the winner of its 2007 best Victorian house award—and jaws immediately dropped. The honoree was none other than John August Florey, an architect who has made his name not in the Victorian style but in the Modernist one.

With that 13-word lump out of the way, the point of the story—the surprising identity of the winner—"pops" a little more.

Why do writers who would shun such run-on language in their own prose meekly accept it when the words begin with capital letters? The answer is that many writers assume that proper nouns are sacrosanct—they are "facts," in a way, and everyone knows you can't change facts.

But proper nouns are not facts. The essential, unadorned fact, the only fact, is that the guy is a poetry professor. His long title is just window dressing. Words are not facts. Facts are facts.

Writers extend this undue deference to proper and common nouns everywhere: company and civic group names, head-scratching academic coinages, professional jargon. They even extend it to quotations, as in this exchange heard in countless newsrooms:

EDITOR: "This quote makes no sense."
WRITER: "But that's what he said."

The writer is saying the quote is a fact and that he is simply relaying it. But he is misconstruing his role. A writer is not a recorder; he is a reporter. He must not just skate over the surface of his story, transcribing; he must dive down to its essence. Go back to that silly source, and get him to say something that makes sense. What if he stands by his gibberish? Either leave it out, or quote it and underline its silliness for the reader. "Senator Mugwump would not directly answer the question, offering only 'blahblahblah.'"

A writer, in other words, must take risks, must "dare the lightning," in the phrase of the writing scholar Bill Stott. Why? Because if he includes a quote in his article, he is telling the reader that it's worth his time to read it. But if it's a bonehead remark,

then it is not worth the reader's time, and the writer has not done his job.

If you dare the lightning, might you get burned? Yes. But don't forget that not to decide is to decide, and therefore may also be risky. Say you are a history professor and, for a book on genocide, you are contributing a chapter on the Holocaust. You are a cautious thinker and to be absolutely fair you are tempted to devote some space to people who deny that the Holocaust happened. Should you? That at least would be playing it safe, you might say. But is it? Depending on the nature of your chapter, such an inclusion may imply that there actually is some uncertainty over the Holocaust's existence. Would you really sign off on such a statement?

"Fairness can be a false refuge," writes the Columbia professor Samuel G. Freedman, who presents the Holocaust and other such examples in his *Letters to a Young Journalist*.

Don't hide behind Authority either, quoting it just to avoid making your own assertions. If you do, you will often look like a dolt: " 'The nation faces an important decision,' said Senator Palaver on the eve of the presidential election." Uh-huh.

Nor should you crouch behind the passive voice in order to avoid saying who did the what that you are writing about. "The passive voice is safe," writes Stephen King. "There is no troublesome action to contend with; the subject just has to close its eyes and think of England, to paraphrase Queen Victoria." Stated less snickeringly: The writer's loyalty is to the reader, to convey the truth to him as fully as possible.

In fact, the writer is the only champion the reader has got, and the reader has got lots of enemies. The people who coin glitzy job titles are not thinking about the reader or the truth; they are trying to make a job seem powerful and prestigious. Professional terminology often serves only those in the field, by keeping everybody else in the dark. And some quotations, as any journalist who

has ever gotten an official's nonresponse response will tell you, are composed not to enlighten, but to obscure.

Sometimes, these matters are merely rhetorical. When the *New York Post* campaigned to replace "suicide bomber" with "homicide bomber," there was no real writerly issue; the paper was just playing politics. But in September 2007, Clark Hoyt, the public editor of the *Times*, raised a real question about word choice: Is the structure that Israel built to separate its citizens from the Palestinian territories a "fence" or a "wall"? "Fence" of course has a neighborly feel, and that's the word the Israelis wanted; "wall," the Palestinians' choice, sounds hostile and exclusionary. The *Times* chose "barrier."

Even meatier was this word-choice issue: Given the condition of Iraq in late 2006, were the troubles there best described as an "insurgency," or had they morphed into a full-blown "civil war"? That choice of phrase told, or mistold, the whole story—and journalists who reflexively took a source's word for the right term did not do their job.

In the end, the guy is basically a poetry professor!

..

Those Cantankerous Inhabitants
Of Clinton

A writer must let subjects respond fully to criticism,
must parse his words closely to avoid reader offense and,
in features, must be wary of lapses in reporting.

SOME FAIRNESS QUESTIONS are easy. If a writer calls some-
one a "reformer," it sounds as if that person is on the side of the
angels. If a writer says "fewer than half" of the graduates of a
prison rehab program stay out of jail, it sounds as if the program is
a failure. To be evenhanded, a journalist might change "reformer"
to "advocate" in the first story, and, in the second, might opt for a
more neutral "44 percent."

Other fairness questions are more complex. Consider this ex-
cerpt from a made-up story about union efforts to organize deli
workers:

> Customers pay $9.95 for the tuna melt platter at the Yum Yum
> Coffee Shop in Astoria, but Clara Velez, a Peruvian immigrant

who works in the kitchen there, probably can't afford it. For one week of stacking, washing and shelving dishes, she said, she earns $360.

"My hands are numb when I go home," said Velez, adding that she gets no health insurance and no sick or vacation days. She works eight hours a day, five days a week, putting her pay at just $9 an hour.

This passage becomes much fairer if the reporter includes a response from Velez's boss:

Yum Yum's owner, Michael Faraday, said that the restaurant business was very competitive and that he could not pay Velez any more than he did. "I would pay her a little higher if she worked up front as a waitress," added Faraday, who is himself an immigrant, from Trinidad. "But she speaks only Spanish."

This passage helps readers understand Faraday's point of view. But it does not address Velez's specific claims about wages, benefits, sick days or vacation. So the editor directs the writer to interview the owner again, and they add this sentence to the end of the paragraph:

. . . He did confirm that Velez made $360 for a 40-hour week and that he did not offer health insurance. But, contradicting Velez's claim, he also said his workers got five sick days and five vacation days a year.

The point: Writers must make sure that every sizable criticism is answered. For reasons of fairness, and often of law, it is not enough just to give airtime to the criticized person.

Sometimes, a fairness question pops up not in the facts but in the phrasing. Consider the beginning of this made-up article:

In a rarely seen spirit of compromise and flexibility, a large cast of people in Clinton—the residents, the owners of a new sound studio, local musicians and community board members—have all gotten together to solve the noise problems that have dogged this area of Midtown Manhattan.

Oops. This lead says that those people in Clinton are rarely flexible. But what the writer means is that such "compromise and flexibility" are unusual *in New York City as a whole.*

A clearer lead might say, "In a city fabled for its pugnaciousness, a large cast of people in Clinton have joined together in a spirit of compromise . . ."

The stickiest fairness questions come not with facts or phrases, but with sensitive subjects. An example comes in a report, discussed earlier, that New Yorkers who live near a new gay porno store object to it not so much for the usual reasons—its wares are offensive—but out of dismay over its ugly neon lights and kitschy facade. Here is the lead:

Eighth Avenue in Chelsea does not blush easily. On this predominantly gay strip, images of chiseled hard-bodies stare down from storefront windows and flesh-toned billboards. No fewer than six shops carry pornographic movies and bawdy accoutrements.

This is a vivid scene-setter, but some readers may bridle at it. They may think the writer is saying that the area is porn-heavy *because* it is gay. The sentence does not expressly say this, and some readers may dismiss these critics as overly sensitive. But sexual orientation is one of those tender topics where writers often strive mightily not to offend.

How about this rephrasing: "Eighth Avenue in Chelsea does

not blush easily. On this strip, which is predominantly gay, images of chiseled hard-bodies. . . ."

Would using this "which" clause mollify offended readers? Maybe, but maybe not. Perhaps the street's gay character should not be revealed until further down in the story. If that is your choice, however, be ready to defend keeping the reader in the dark for several paragraphs about a pretty basic fact in the story—that this is not a straight street with a porno store, but a gay street with a porno store.

Others might say that any mention of the gayness of the street is out of line. The idea of the story is that, in this urbane, edgy part of New York, people are objecting to an XXX shop for reasons very different from those that would arise in, say, Peoria. What's gay got to do with it?

At the *Times*, editors apply strict scrutiny to any mention of gays, women, minorities and other historically maltreated groups. Is this material clearly relevant? the editors ask. If a motorist in an accident story is described as "a young Jewish doctor," for example, and religion played no role in the mishap, "Jewish" would be escorted right out of the report. Other bits of color—"ponytailed," say—might be fine, but racial, religious or other trigger words get "show me" treatment. Show me they are central to the tale.

These tender topics are not just about fairness; they are about the perception of fairness. Writers tread cautiously on sensitive subjects because the text in such cases often blurs in a rush of high reader emotion.

To make matters muzzier, the nature of feature writing can make fairness issues—whether on sensitive subjects or less sensitive ones—very hard to discern. The feature writer, you see, is in the business of weaving beautiful tales, and sometimes as he does so he pricks himself.

A case in point comes from a poor Latino neighborhood in

New York City that is baseball crazy. Despite the long odds and their deep poverty, the teenage boys who live there try valiantly to make it to the majors. It's "Hoop Dreams," only for baseball.

Sara Rimer, the writer of a 2005 *Times* article about these boys, wants to make artful contrasts between their golden aspirations—fame, glory, head-spinning salaries—and their humble present. Their uniforms are ragtag, she writes. Their exercise weights are Gatorade bottles filled with dirt. Their field is not some private-school greensward but a forlorn part of an overused public park. Keen to drive home their struggles, Rimer makes especially much of the decrepit diamond, where boulders jut up in the outfield and an asphalt path cuts across it.

Wonderful story. But something nags at the writer, and then she realizes something that her editor (me) had not: We have been so bewitched by Field as Symbol of a Hardscrabble Life that we have not addressed another aspect of its reality: Field as Public Amenity. The field is maintained by the city Parks Department, and we realize that basic journalistic fairness demands that the writer call the agency for comment on the sad state of the diamond and the agency's plans, if any, for repairing it.

The department responded promptly, and its response went right into the piece.

If the article had been mainly a news story about the poor state of the field, the need to call parks officials would have been obvious. But we were wearing a different pair of glasses for the baseball story. The dog that nips you is the one you're not watching for.

Chapter 33

The Rose of Spanish Harlem

Feature articles are often about mood and other gauzy matters, but they must rest on a hard nut of logic and proof.

HERE'S A STORY. It's imaginary, but every feature writer can testify that the problems it presents are real.

Johnny Malouk, the Arab-American president of the borough of Manhattan, wants to become the mayor of all New York City, and a reporter thinks she has a very smart story about him. "Everybody knows Malouk is popular throughout Manhattan," she tells her editor. "But it turns out that Spanish Harlem absolutely *loves* him!" She is eager to suss out this sweet tale, and uncover why a Manhattan neighborhood of Latinos has so embraced an Arab man. Tacos and falafel! Off she goes with her editor's blessing to report on this odd political love song, and when she does it's fascinating. An excerpt:

> "Malouk? He's my man," said Ernesto Robles, a shoe store owner who lives on East 129th Street. "After I close my shop, I hand

out his brochure on the street and then work the phones at his campaign headquarters. The guy's gonna be a primo mayor."

The article offers thumbs-way-up testimonials from other Spanish Harlem residents about Malouk, and these fans come from all walks of life—a thirtysomething mother of three, a retired school principal, a young Wall Street lawyer whom Malouk helped get his job. The reporter then trots out the reasons for Malouk's popularity with the local Latinos: his energy, his skill at getting potholes fixed and, oh, he's not too shabby-looking.

It's a spirited account, but as the editor reads the story, he grows uneasy. The premise of the article, the editor remembers, is that Malouk has *special* appeal in Spanish Harlem. But a cold appraisal of the story reveals that it falls short of proving this proposition. Yes, some Spanish Harlemites are agog over Malouk, but so are some residents of SoHo, Chelsea and other Manhattan neighborhoods. Moreover, the reasons the reporter puts forth for Malouk's popularity in Spanish Harlem—youthful zest, constituent responsiveness, good looks—are equally applicable in other places.

In other words, the reporter's basic assertion was comparative: Malouk is particularly popular in Spanish Harlem. But there is nothing comparative in his article.

What proofs would show that Malouk has special appeal in Spanish Harlem? Here are a few:

- A "yes" vote for Malouk in the last election that, at 65 percent, puts Spanish Harlem 10 points higher than the city average.
- A declaration of Malouk's special local appeal by a respected, neutral political expert or a political rival. ("For some reason, Malouk's got Spanish Harlem in his vest pocket—it may be his biggest stronghold in the city," said Paddy Denahan, a chagrined opponent.)

• A list of *specific* reasons that Spanish Harlem would love Malouk—reasons that would not apply to other areas. Maybe Malouk wheeled and dealed and got a big retail complex built in Spanish Harlem that provided 300 jobs for the community. Maybe he got the Department of Education to triple the bilingual classes in the neighborhood's schools. Maybe he's married to a Latina whose family is beloved in Spanish Harlem.

What if the reporter has no such proofs? Then her whole story is a wobbly chair.

Some proofs prove more than others:

WHO Writers must "consider the source." A strong proof in one man's mouth is weak in another's. The claim of an expert outweighs that of an amateur, and a neutral person's outweighs that of someone with a vested interest. Most credible is a statement that hurts its maker, as with the fictional Paddy Denahan, Malouk's political rival. No one ever got ahead by admitting the strength of his opponent.

WHAT Types of proof also vary in persuasiveness. In proving Malouk's popularity, hard numbers from a properly done poll of significant size outweigh personal testimonials ("Malouk? He's my man") no matter how enthusiastic those individual declarations are.

Also, causation outweighs correlation. Imagine that a neighborhood has high asthma rates and also has heavy truck traffic. A reporter learns that some other neighborhoods with high asthma rates also have heavy truck traffic. This correlation *suggests* a link between asthma and diesel-fuel pollution, but the pattern may be a coincidence. A study that *proves* diesel fuel emissions biologically trigger asthma—causation—is stronger evidence.

Correlations are easy to trip over. It sure looks as if truck pollution causes asthma if the ten New York neighborhoods with the highest asthma rates are also the ten with the most truck traffic. But it may be that these ten places are also the ten poorest areas in the city, and that bad diet and unhygienic tenements—two other traits of poverty—are the real asthma villains.

The Rose of Spanish Harlem II

To strengthen her article, a nonfiction writer will often be tempted to twist the truth. She must suppress this urge, for distortion is a slippery slope, and facts are all the nonfiction writer has.

IMAGINE THAT THE writer of the Johnny Malouk story, discussed above, has some wonderful anecdotes about the affection that Spanish Harlemites have for this Arab-American politician. There is Malouk dancing the samba with a sweet old Puerto Rican lady, for instance, or donning a Mexican man's sombrero. So charming, so melting pot!

Meanwhile, the editor who detected the gap between the stated idea of the story—that Malouk has *special* appeal in Spanish Harlem —and its proof, asked the reporter to fill that gap. She could not. Basically, she learned that Malouk is popular throughout Manhattan's many neighborhoods, including Spanish Harlem, but that there is no special bond between him and that particular area.

But the editor, with those alluring samba and sombrero scenes

looping through his head, proposes a simple one-sentence addition to the story to try and preserve the original concept: "Malouk is popular throughout Manhattan, but his relationship with Spanish Harlem seems to have particular resonance."

Is that O.K.? No, it's not O.K. That sentence—meaningless and misleading—is the work of the Story Devil, who sits perched on the editor's shoulder. Dangling that tempting sombrero before the editor, the Devil has lured him into presenting a tale that still is not there. "Particular resonance" is just a blurrier way to say that Spanish Harlem is "special" or "different" when it comes to Malouk, and the editor knows he's got no numbers or quotes or facts that prove that proposition. Malouk may dance the samba engagingly in Spanish Harlem, but he also dances the mazurka on the Lower East Side and the Charleston in Stuyvesant Town.

The Story Devil has other schemes to seduce writers and editors. A major one rests on the fact that somebody can be found to say anything. In the Malouk story, for example, a Malouk loyalist or a publicity-hungry political consultant can be steered by the reporter to say, "Oh, absolutely, Malouk has a very special relationship with Spanish Harlem." But this tack is no more true than the editor's "special resonance" sentence. Saying doesn't make it so, especially when the writer inserted the word "special" into her question just so the source would parrot it back to her. This is not journalism. It's quote as magic.

What then to do with the Malouk story? Tell the truth. If Spanish Harlem's affection for Malouk is typical rather than special, play it that way. Turn that neighborhood into a case study, an example of this man's great cross-cultural, Manhattan-wide appeal. Another option is to expand the story, to paint for the readers the ecumenical charm of Malouk in a heterogeneous city—at a dinner in Spanish Harlem, at a school board meeting

in Chinatown, at a church service in Little Italy. This second approach will require more retooling of the story than the first, but, either way, the samba and sombrero stories will see the light of day and they will do so in a story that is true, not trumped up.

Does this whole ethical tussle seem silly to you? No big whoop? Do you feel that, obviously, the story just needs to be tweaked a bit? My answer is that, from the inside, things are not so easy. For those involved in nonfiction, there are strong forces at work that make it hard to stay true: deadline pressures, competition, pride of authorship, loyalty to an idea, emotional investment, the reluctance to redo something, and the human ability to believe something even in the face of contrary fact.

These devilish temptations pop up all over. Sometimes, the temptation is to engage in deception by selection—quote only those people who pump up your story. Sometimes, the temptation is a single word. In a report about discontent in Greenwich Village over noisy late-night revelers, for example, are there "many" people who are upset, or "some," or just "a few"? Usually, no one has done a survey on the matter; all that the writer has to work with are the impressions of a few locals—some of whom are among the complainers—and a politician or two. But whichever of the three words the frequently scanty evidence may point toward, the writer will most strongly feel the tug of "many"—the more inclusive term.

I face these sorts of questions all the time. In a story about a poor family, is it going too far to call their couch "shabby," an adjective that will strengthen the themes of the story? In a profile of a disciplinarian principal, is his demeanor really "military"? Or are we just wishing it were so for thematic reasons?

In all these situations, the Story Devil has power over you because he knows your weakness. *You want a good story*. For the

Malouk writer, a story that says, "This Arab charmer has some mysterious and powerful bond with Spanish people" is much more unusual, much more exotic, much more attention-getting, than one that says, "Here's a popular pol. Let's hear people sing his praises in Spanish Harlem."

The Story Devil has another hold on writers. He knows that all storytellers, and that most especially includes feature writers, are liars. They take life, and then they distort it, all for the sake of the yarn. Here's how.

Real life is pell-mell; it pings all around. The doorbell rings as you stub your toe and that is just after you shucked the sweet corn and just before you noticed a gust of wind flapping the patio awning.

But that is not what the writer writes about. To make a story, he *shapes* life. He filters and tames all the random unprioritized stuff that is life. And this is fine. We grant the nonfiction writer great leeway, in the words of Samuel G. Freedman, to turn "chaos into cosmos."

There are limits, however. We do not allow the writer to erase what matters for his theme, because that would be false. Art is the selection of a few of the pings of life—maybe the flapping awning, maybe the ringing doorbell—but that selection must be sound and true. Nonfiction writers can edit out the irrelevant; they cannot edit out something that is inconvenient for or undermining of their theme.

It's hard to say more. There are plenty of gray patches in this field. How do the rules for truth differ for literary journalism, creative nonfiction, opinion essays and shoot-from-the-hip blogs? Is it ethical to "clean up" quotations, and what does "clean up" mean? To what extent is the use of composites and other truth-bending practices excused by disclosing them?

I don't know all the answers. But I do know it is good to be strict about truth because it is easy to get out of the habit of truth, and because, for the nonfiction writer, truth is all you've got. "[F]udging memoir details," warns writer Carol Bly, "is like dipping a computer into a river to make it shine." And so it is for all types of nonfiction.

CODA

A test: You put a bullet in a gun and you pull the trigger and you shoot the bullet out, right? No, not right. The thing that comes out of the gun is indeed called a bullet, but the thing that goes *into* the gun is called a "cartridge" or "round," and it consists not just of the bullet, but also of the casing, the powder and something called the primer. So instructs the *Times* style manual.

Another test: "During World War I, E.E. Cummings drove an ambulance." Is this sentence right or wrong? Wrong, you say quickly, because you know the poet is famous for writing his name "e. e. cummings." Not so fast, cautions the *Times* manual. Yes, the poet did use all lower-case letters for his poetry, but in other contexts, it says, "he used conventional capitalization." Spend some time on Google, and you'll find the question gets even more tangled. Some say the poet didn't put periods after the two little "e's," for example, and some say the lower-case name was a personal gesture of humility that he did not intend others to follow in any context.

My point: In most of the world, the truth is a matter of not lying. But in writing, because it's got to be "bullet" or "cartridge,"

because it's got to be "cummings" or "Cummings," because to write is to assert, the truth takes sweat. Writers must chase the truth, Google it, make that phone call, think hard, deduce, research, make distinctions. They must catch the truth, not just skirt the false.

Part VI

LEADS AND OTHER ARTICLE PARTS

*Leads and settings, transitions and kickers:
Each part of an article demands its own
peculiar art.*

Friday Came the Hazmat Suits

They call the *Times* a hard-driving place, but it can chill out now and then. There are memorable diversions, like the day in 1995 when Fidel Castro visited us in the old *Times* newsroom, on 43rd Street. He was tall, dressed in his signature green fatigues, and after we gathered around him he announced that we should get paid more. Viva Fidel!

There are also those fine ironies and sitcoms. The reporter with the breathtakingly messy desk who writes in the sparest of prose. The gorgeous Russian-born clerk who could charm even the grumpiest printer. The waggish editor who said of a famous writer . . .

But enough gossip! What I most loved about the old newsroom was that the Styles Department was next to the Sports Department. I never got there much, but in my mind's eye I saw beefy guys in flannel, belching, and a few yards away, bony fashionistas, glaring. I saw paper basketballs missing the trash can, and bouncing off $400 pixie haircuts instead. I hope these things were true, but I don't really know. They were too good to check.

There were tense, dark days in the newsroom, too, and one of

them arrived a month after that darkest of days, 9/11. It was an anthrax scare. For days the police weren't sure what the white, sweet-smelling stuff was that spilled out of an envelope that Judith Miller, a former *Times* reporter, had opened that Friday morning. That night, before I went into the house, I changed into a set of clothes my wife had left for me on the stoop, in order to protect her and the kids. Just in case, she also prevailed upon a doctor friend to order up some Cipro for us, the anthrax antidote. We still have it, somewhere.

Miller's mail, it turned out, was just some harmless white powder.

My sharpest memory of the anthrax hoax was the gathering, on the day of the scare, of 100 or 200 *Times*ians in the paper's green and white marble lobby. The police stood guard outside.

Journalists cover scary news all the time, but they are just as shocked as anybody else when Fate pays a personal visit. We assembled journalists were anxious. We were testy. The lobby was too small; the excess had to scrunch together on the stairs, the brass motto, "All the News That's Fit to Print," on the wall a few feet above their heads. The only people moving freely about were wearing hazmat suits. As a friend of mine once said in another context, when you are standing next to a guy who is wearing a hazmat suit, and you are *not* wearing a hazmat suit, you are not happy.

A city medical examiner was there, and we cramped and antsy journalists peppered him with questions. What were the odds it was anthrax? Did it look like anthrax? When would he know the lab's preliminary findings? When would he know the final findings? How often do final findings differ from preliminary findings?

All good questions. But that poor examiner! He was

hemmed in by freaked-out people whose profession was finding stuff out, and many of whom—editors—were accustomed to getting answers pronto. It was the Mother of All Nightmare Press Conferences.

Yes, the anthrax did turn out to be fake. As time passed normalcy returned, including that lighthearted preoccupation with words that characterizes word people. Looking at an envelope and alluding to the anti-anthrax guidelines handed out by our mailroom, someone would occasionally joke, "Is this *suspicious* handwriting? Or just *bad* handwriting?"

But the scene in the lobby stuck in the mind. All that readers ever see of the *Times* are its cool neutral columns, smooth dispatches without any stutters or false starts. But in that lobby on that day were the people who produced those unflappable pages, and they were seething with emotion.

Seldom does a newsroom get as anxious as ours did during the anthrax episode, but it is hardly a stranger to sweating of the smaller kind. In the realm of writing and editing, that day-to-day unease most often pops up around the lead, the kicker and the billboard paragraph—three of the topics of this section. Why this pattern? Because those passages are standard components of most articles, because they demand the practice of certain dark, peculiar and difficult arts, and because they are the places where, even for people who tap on their keyboards every day, writing becomes Writing.

This everyday tension explains certain newsroom rituals. Some people write their whole article and, only then, compose the lead—like a sculptor who makes a statue, stands back to look, then fashions the head. One reporter, a former comedy writer, is in the habit of giving editors two or three different kickers to choose from—she had a million of 'em. And nothing grabs newsroom attention more than a declaration like this: "I think your

lead is in the 17th paragraph." Nosy listeners know that line means the basic idea of the article is in play—and pyrotechnics may not be far behind.

Of course, fixing these problems takes nowhere near the heroism of those guys in the hazmat suits. But sometimes it does take a dash of grace under pressure.

Colonel Foster, Commanding

It is easy to write a defective lead and just as hard to write an artful one.

ONE REASON THAT writers fill up the top of an article—the prime real estate—with something other than the central theme is uncertainty over what that theme is. They often spend the initial paragraphs clearing their throats—much as in conversation a person may say, "Um, you know, it was like this." What the writer is doing is collecting his thoughts so he can *really* write the lead.

The Um lead is not useless. The very act of writing helps a person sharpen her thoughts. But when she does arrive at the actual heart of the story, she must be sure to scroll up to the top and lop off those two and a half paragraphs of "Um."

Another reason a writer buries the lead is the "feather duster." In the theater, a "feather duster" is an opening scene in which an actor putters around, perhaps dusting the furniture (hence the name). Her real job, however, is to summarize the plot for the audience, chatting as she dusts. An audience can better appreciate

a play if it knows, straight off in Act I, Scene 1, that the maid, scorned by the master of the house after a furtive love affair, is bent on bloody revenge.

Feather dusters are a common prop of ordinary conversation. Imagine that you are writing a story about drug crimes, and a dinner guest asks you about it. You might say something like this: "Well, back in the mid-60's, New York State enacted the Rockefeller Drug Laws. These laws were really severe. People caught with just a tiny amount of a drug could be sentenced to really long prison terms. Now some politicians want to toss those laws out. So I'm doing a story about one woman who was jailed under them."

But while you the partygoer might explain your drug story as above, you the writer might start with something much grabbier.

The problem, though, is that good leads must fill two contradictory roles. They must paint with a "broad brush"—that is, state the essential point of the story—*and* they must be vivid and specific.

How can they do both these things? The secret is this. While good leads are specific, the specifics they cite must sound the central chord of the tale. A *Times* article discussed earlier, about investors who missed out on the market in a year when the Dow gained 26 percent, began this way:

> They are on the outside looking in, noses pressed against the glass, stamping their feet in the chill, watching the festivities within.
>
> Yep, that's right. These are investors who did not attend the Wall Street Revels of 1996 . . .

These chagrined investors avoided the market for many different reasons, and these different reasons play a very big role in

the body of the story. But those specifics are not expressed in the lead because they have no place there. In the lead, the writer must sound the common element among all these folks: that they lost out on a marvelous market year.

Yet, at the same time that this lead paints with a broad brush, it offers plenty of specific vividness: sad little investor-urchins with frozen feet and noses squished against frosty window panes.

Here's another example of how a lead can play its two warring roles.

Imagine a painting of the U.S. Cavalry pursuing a band of Indians across a river. A writer should *not* begin his description of the scene by saying, "On the left side of the painting are some troops from the 17th Ohio Regiment and some from the 21st Louisiana Regiment, all under the command of Col. Joseph Edward Foster, of the 17th." If the writer does start this way, he has been specific but he has let minor distinctions crowd out his larger point—which is, who won?

At the same time, the writer must not go too far in the other direction, allowing his larger point to crowd out all the vividness: "In 1878, the U.S. Cavalry defeated a war party of Comanches."

Instead, the writer must seek a paradoxical balance of vividness and broadness: "Despite a desperate attempt to flee across the Colorado River on fatigued horses straining against the currents, a war party of Comanches succumbed in 1878 to a well-rested and better-armed detachment of the U.S. Cavalry."

The top of the story is for the forest, not the trees. But, as with the Wall Street waifs, this forest needn't be blurry and unvivid.

The Heirs of Dr. Cadwalader

*Good leads come in many shapes. But the common
measure of their worth is their power to provoke
curiosity.*

WHY IS THE top of a text so critical? Simply because first impressions are important. The precise value of the opening depends on the form, of course. The first few paragraphs of a book may not be do or die, because book readers know the power of a book is cumulative; they are in it for the long haul. A blog lead is not critical either; its readers know that highly wrought openings are alien to that conversational genre. But the lead is absolutely crucial in feature articles and essays and, whatever the form, no writer should stint on his start. As they say, the fish stinks from the head, and wary readers know that.

In other words, the lead is the doorway into every text. Its job, never a minor one, is to draw the reader over the threshold.

This is a tough task, because as he considers the lead the reader is still on the outside of the story, still uncommitted. If, from a quick glance at the doorway, he sees nothing of quickly absorb-

able interest, he will proceed on his way, nothing lost. There will be another doorway to scope out soon enough.

Given the fragility of this moment, much ink has been devoted to the art of the lead, and most of it is worthwhile: Leads must make every word count. Leads must charm, even rivet. Leads must be true to the essence of the story. Leads must never promise something the story will not deliver.

To make a hard job harder, leads are not logical. Reasoning can help a writer to organize a story, trim quotes or decide what to omit. But with the lead, the writer is at the mercy of the intuitive, artistic, right side of the brain.

The good news about leads is that there are many ways to hook the reader, from humor to masterful writing. Plus, there is one guideline that, while not overarching, may simplify this teeth-grinding chore.

That guideline is this: The lead writer must be a riddler, a teaser, a provoker. In other words, as he grapples with possible leads, he should always ask, What lead will prompt in the reader the most irresistible questions, questions powerful enough to propel him through that doorway and into the story?

There will not be one clear answer; writing leads will always be murky. But this "riddle" principle, and such writing scholars as James B. Stewart and William E. Blundell agree, is a handy guide for the lead writer. "Fact" leads, for example, are often spurned in feature writing, but if it is a fact that prompts the most reader curiosity, the feature writer should try it.

An imaginary illustration of the riddle principle:

The doctors-to-be walked purposely down the hallway toward the lecture room. They strode past somber portraits of the giants of the school's past, from Dr. William Cadwalader, at one time the nation's foremost expert on the small intestine, to Dr. Rufus

McGoldrick, a surgical pioneer during the Civil War. The students looked much younger than these eminences, of course, and there was another, striking, difference. The students in this class were all women; the portraits were all of men.

This lead will prompt many questions from the reader. Is this class taking a course that only women students tend to take? If so, what subject is it? Or is this an all-women medical school? If so, is that legal? If not, do lots of medical schools have classes that are largely, or entirely, female? Is the profession becoming feminized? If so, what are people saying about that?

To get the answers, the reader will read on.

No genius has yet put forth a Grand Unified Theory of leads. And without any prioritizing of the daunting number of guidelines about leads—No crammed "fruit salad" writing! No rambling anecdotes!—the whole subject is swathed in yellow police tape and writers freeze at the scene. In such circumstances, I think the best approach is to put this too-abundant advice in a pecking order. For me, Rule No. 1 is to raise questions in readers' minds. Intrigue them.

Look at it this way: Much of the advice about leads sounds like general writing advice, just more shrill. (Avoid clutter!) Better to focus on what makes leads different from the rest of writing, not on what makes them the same. And what is different about leads? Leads raise questions; the rest of writing answers them. So let that be the star you steer by.

Chapter 37

..

The Artist and the Old Socks

*By linking unlikely items, the "double take" lead can
lure in the puzzled reader.*

WHEN TWO THINGS that don't go together—let's say monks
and punk music—are somehow put together, you want to know
more. Who are these monks who play punk? Are they recording
their music? Are people listening to it?

Your reaction, of course, is a double take—that second, harder
look that a person gives to a scene that does not conform to ex-
pectations. A person reading a story about monks expects to see
certain items—rosaries, sandals, brandy-making, tonsured heads.
If he sees something different, questions arise, and a potential
reader of the monks-who-play-punk story is born.

There are enough double-take leads out there to give you a crick
in the neck, and the reason is that double-take situations are often
what inspire stories in the first place. A reporter tells her editor,
"I have a great story. It's about this artist in Brooklyn who does
paintings of this dirty, rubbish-filled lot over and over! He says it's
'haunting and beautiful in its way.' He's totally obsessed!"

Why is this a worthwhile story? Because many artists paint lovely scenes of rivers or mountains, or portraits of the famous. But, just as "man bites dog" is newsworthy and "dog bites man" is not, few artists paint scenes of garbage-strewn lots, and fewer still paint them over and over.

The lead to a 2001 *Times* story about this artist, by Erika Kinetz, reflects its double-take inspiration:

> Nicholas Evans-Cato has been painting pictures of the same triangle of dirt for five years. Today the object of his affection—an awkward lot at Hudson Avenue and Front Street in the Vinegar Hill section of Brooklyn—is filled with sickly grass, robust weeds, automobiles, old socks and a deflated Wilson football.

By ticking off the litter, from socks to a football, Kinetz highlights just how unusual this painter's "object of affection" is. By maximizing the oddness, she also prompts much reader curiosity: Who is this painter? Why is he painting this unpicturesque scene? What does he do with the paintings? Is anyone buying them? Do the paintings differ from one another?

When the question marks pop up, the lead has done its job.

Chapter 38

The Secret Taxi Signal

The mystery lead can be a brief and powerful way to engage the reader. But used too freely, it sounds cheesy.

UNLIKE A DOUBLE-TAKE lead, a "mystery" lead does not pair incongruous elements. It makes a more blunt bid to provoke reader curiosity.

At its simplest, a mystery lead dangles one word before the reader to raise questions. Seth Kugel begins his 2003 *Times* story about a Filipino boy band visiting the United States this way: "For fans of 'Nanghihinayang,' it was the place to be." If this story ran in a Manila newspaper, that lead would be humdrum. But the reporter knows that most New Yorkers have never heard of the band and will read on to find out what Nanghihinayang is—martial art? pastry? clothing label?—and why it has so many fans.

Sometimes, as in another 2003 *Times* story, the mystery lead is spiced with a little joke: "There's a hand gesture on the streets of New York that's directed at off-duty cabbies," writes the author, Judy D'Mello. "But it's not what you think." The reader, interest piqued, reads more, learning that some wannabe riders are now

raising thumb and forefinger, slightly apart, to signal to off-duty cabbies, who are generally on their way back to base, that the rider is traveling just a short distance. The implication is that the cabbies can grab the fare and still not be late for the taxi drivers starting the next shift.

Some mystery leads, particularly in adventure stories, tease readers by promising great drama further on in the tale: "Many people had warned Bryan McDuff that sea-kayaking was no sport for a 70-year-old. He was about to learn they were right."

This kayak lead leaves out the climax, the end, of the story. A more subtle mystery lead is the "in media res" variety, which omits the beginning or middle. Maureen Dowd begins a 2008 *Times* column about Hillary Clinton this way: "A huge Ellen suddenly materialized behind Hillary on a giant screen, interrupting her speech Monday night at a fund-raiser at George Washington University."

The reader immediately wants to know the start and end of the story. Was this on-screen appearance of Ellen DeGeneres, the comedian, a gaffe? If so, how'd it happen, and did Clinton recover her composure, and did heads roll later? Or was it on purpose, and if so, why was Clinton recruiting comedians to help in her campaign? Were the other presidential contenders doing it, too?

But whether the writer of a mystery lead leaves out the start or middle or end, or uses a word a reader doesn't know, he is posing a question that will nudge the reader further into the story. What will happen to Bryan McDuff?

Mysteriousness is a potent reader draw and, like double-take leads and often unlike anecdote leads, mystery leads are frequently brief. But used too nakedly, they come off like a promo for a bad sitcom ("Tune in next week, when Brad gets a new girlfriend—or so he thinks.").

Chapter 39

Norma Rae Comes to Brooklyn

*The anecdote lead is much maligned, but its low
reputation stems more from bad execution than from
inherent flaws.*

ANECDOTE LEADS CAN be gripping and concrete, and confer
on a story a human face with which readers can immediately con-
nect. Consider this lead to a 2001 *Times* article by Adam Fifield:

> Hands clasped behind his back, a copy of *El Diario* tucked
> under his arm, Manuel Escobar stood on a crumbling, weed-
> tufted sidewalk in East Williamsburg, Brooklyn, in April, star-
> ing across the street at a sprawling green building. Through the
> dark, yawning entrance, payloaders and backhoes could be dimly
> seen, lurching and digging amid 15-foot-high dunes of garbage
> as though searching for prey. Every so often, a seagull fluttered
> out of a swirl of paper scraps, shrieking.
>
> This is Varick I, a waste transfer station and recycling center
> on Varick Avenue operated by Waste Management, the nation's

largest trash company. Inside are 100 workers who haul, sort and
bale tons of the city's garbage every day.

Squinting in the sun, a few beads of sweat standing on his
tanned brow, Mr. Escobar, 36, glanced furtively toward a secu-
rity booth. The guard, who watched him carefully, had called
the police on previous occasions when Mr. Escobar, a labor or-
ganizer, had crossed the street onto company property.

Just after 2 p.m., the end of the day's first shift, a few rumpled
figures emerged from the building into the blinding sun.

"Buenos días!" shouted Mr. Escobar, shooting a hand into
the air. Heads down, the men ignored him and plodded de-
terminedly away. Others soon followed, though Mr. Escobar
waved to all.

Finally, one acknowledged him with a nod, and as if tugged
by a magnet, the organizer strode swiftly across the street.
Grinning, he gripped the man's hand and pumped vigorously.
The man, in his mid-20's and paunchy, smiled, looking around
nervously. They walked together down the street, Mr. Escobar's
hand planted on the man's shoulder, talking and nodding. At
the corner, Mr. Escobar fished a 3-by-5-inch union pledge card
out of his pocket. The man took it reluctantly, like a child who
accepts something he knows he shouldn't from a stranger.

Mr. Escobar is the senior field representative for the Waste Ma-
terial, Recycling and General Industrial Laborers Local 108, . . .

This vivid scene—the screeching seagulls, the nervous
worker—pulls the reader right into this profile of a union orga-
nizer. Like all anecdote leads, this one zooms immediately into
its subject, plopping the reader onto a Brooklyn street, and only
afterward does it pan back, explaining to the reader the broader
context of what he just saw up close.

Over all, this is a gripping start, but to reach such success anecdote writers must skirt several common pitfalls:

THE UNNEEDED DETAIL Imagine that the Escobar lead contained this sentence: "A recent immigrant from Peru, the nervous worker was a baler at Varick I, one of the 25 men there who did that type of work." These less central details should be pushed down further in the piece; they are not needed to paint the opening scene. Even a long lead must be spare.

THE FLAT STORY THAT NEVER ENDS Imagine a lead that just showed the union organizer driving past the waste plant, talking about his job and about the prospects for organizing that particular facility. Such a story lacks the drama of the published lead, and if you use it, write it short. In other words, if you lack a wow anecdote, do not write it at wow length.

THE NEAR MISS Fifield's lead goes to the heart of his story. It's a profile of a union organizer, and in the lead we see him trying to . . . organize a union. If the opening scene showed the organizer at home with his family, talking about the union but eating dinner and tousling his son's hair, the anecdote would be sitting on the margin of the article.

If these and other dangers can be avoided, a strong anecdote lead can be like a good film trailer, showing off the subject in its most alluring light.

Like other kinds of leads, anecdotes provoke reader questions, both specific to the scene and more general. A reader of the Escobar lead might ask: Did the man succeed in unionizing those skittish recycling workers? What other workers has he organized?

How often does he succeed? Are most workers too nervous to talk to him? How much are the workers paid? And what motivates Escobar, who seems so upbeat, to do this tough job?

Of course, the reader forges ahead for another reason: This lead is fun and dramatic, and the reader says, Give me more of that.

The Escobar anecdote is long, but so is the article—3,000 words. Shorter stories should take shorter leads, like this one in Jennifer Bleyer's 400-word *Times* report about an overcrowded playground:

> The little blond boy in the camouflage jacket looked longingly at the swings. He was fifth in line, behind a girl in a pink head-band and another in Converse sneakers, all of them fidgeting. It looked as if it was going to be a long afternoon.
>
> The wait was at the Bleecker Playground . . .

This is just a baby anecdote compared with Escobar's, but it, too, parachutes the reader right into its subject, and then backs out to furnish the broader context.

···

Long Lines at Buckingham Palace

Of the dozens of lead varieties, three that deserve more attention are the scene lead, the fact lead and the Harry Truman lead.

A TOURIST POPS out of a cab in Times Square, and what does she do? She scopes it out, of course. Her eyes dart from the ESPN Zone to the Target billboard to the men in red vests hawking tour bus tickets.

Like that tourist, the reader of a story is basically laying eyes on a new place. For that reason, many writers compose leads that give the reader what he naturally wants—a quick scoping out of the scene.

But while the tourist, guileless, is open to all sights, swiveling her head this way and that, a writer often has an agenda. In his 2008 *Times* article about an effort to rename a Brooklyn park, for example, Alex Mindlin allows his readers a quick view of the whole arena of his story. But he also trains their eyes on the topic he plans to highlight:

The official name of the two-square-block collection of grass, asphalt, swings and jungle gyms at Fifth Avenue and Third Street in Park Slope is J. J. Byrne Park. But to the old men playing dominoes there and the nannies keeping an eye on strollers, that name means little.

"It's always 'Who was J. J. Byrne?'" said Kimberly Maier. . . .

This opening—call it a scene lead—is not as immediately intense and up-close as an anecdote lead. Rather than hurtle the reader into an ongoing drama, as the anecdote writer would, the scene writer strolls up more slowly, describing the full view while also stressing a thematically advantageous aspect. The scene lead is also usually shorter than an anecdote lead, and it can be even shorter if the writer dispenses with some of the "scene" part and heads more quickly to the thematic detail.

The scene lead should be used more, but it is not uncommon. The fact lead, though, is positively rare in feature articles. Consider these made-up fact leads:

Margie and Bill Feinman are busy, and getting busier. They make superlarge coffins at their Iowa factory, and their orders have quintupled over the last five years.

and

Prince Harry will have no problem when the prom arrives, if princes have proms. According to the British royal family, Harry receives 150 e-mails a day from love-struck teenage girls around the globe—even more than William, his blond, first-in-line-for-the-throne older brother.

Like all good leads, these fact leads prompt powerful questions in the reader's mind. A reader of the first fact lead, for example, might wonder: Why is the coffin company so busy? Did they just get really successful in a niche market? If so, how? Or are people getting fatter? If so, how fat? Are they dying because they're fat? What are these superwide coffins made of? And does their design account for the presumably larger number of pallbearers needed?

If fact leads can work nicely, why do feature writers reject them? Probably because they feel such leads are for news stories, and that they owe the reader something more artful. But that's the wrong yardstick; the right one is the power of the fact lead to prompt reader curiosity. Anyway, the feature writer can always get arty elsewhere.

Speaking of artfulness: Many kinds of leads, from the double-take to the anecdote, are at root artful schemes to seduce the reader. With so much wiliness around, the plain-speaking lead can be refreshing (and, ahem, still seduce the reader with its contrarian charm). Here is the start of a 2008 *Times* story by James Angelos:

> A city street tree has a rough life. Plumes of vehicular exhaust cloud trees' spring blossoms, teenagers carve their trunks with the musings of adolescent love and trucks barrel into their branches. And so at 8:30 on a recent morning, two citizen pruners, Peter Arndtsen and Bruce James, set out to care for some of the afflicted street trees in their Upper West Side neighborhood.

This is the honest man's opening, a lead Harry Truman would approve: "Here's what my story's about. If you like it, keep on reading. If not, I'll see ya."

Death of a Banker

No words are more important than the lead. Invest the
time to compose, and compare, several possibilities.

HERE ARE A fact lead and an anecdote lead for each of three
imaginary stories. Pick your favorites.

DOCTORS

On an otherwise ordinary day in October, for the first time since
the United States has had doctors, the number of women ap-
plicants to medical school exceeded the number of men. This
statistical milestone comes barely a century after some medical
schools discarded their male-only admissions policies.

or

The doctors-to-be walked purposely down the hallway toward
the lecture room. They strode past somber portraits of the giants

of the school's past, from Dr. William Cadwalader, at one time
the nation's foremost expert on the small intestine, to Dr. Rufus
McGoldrick, a surgical pioneer during the Civil War. The stu-
dents looked much younger than these eminences, of course,
and there was another, striking, difference. The students in this
class were all women; the portraits were all of men.

The fact is, such scenes are becoming more and more
common. The number of women applicants to medical school . . .

COFFINS

Margie and Bill Feinman are busy, and getting busier. They
make superlarge coffins at their Iowa factory, and their orders
have quintupled over the last five years.

or

When Glenda Burton's husband died of heart failure last Sep-
tember, she faced all the usual, sad tasks of arranging for the
burial of a loved one. But for her the job was especially arduous.

"The local funeral parlor did not carry coffins big enough
for my Tom," said Ms. Burton, whose husband, a bank execu-
tive in Tulsa, Okla., weighed 450 pounds. She first thought to
have a custom coffin built, but the expense was daunting. So
she searched the Internet and, finally, found Margie and Bill
Feinman. . . .

HARRY

Prince Harry will have no problem when the prom arrives, if
princes have proms. According to the British royal family, Harry
receives 150 e-mails a day from love-struck teenage girls around

the globe—even more than William, his blond, first-in-line-for-the-throne older brother.

or

"I am so exactly the same as you!" gushed Kayleen Carson, in her long, adoring letter to Britain's Prince Harry. "I have red hair. I love horses. I like the Strokes and the White Stripes, and I think you are TOTALLY gorgeous! Would you like to visit our ranch in Wyoming? I could show you tons of stuff! Have you ever seen a bison?"

Kayleen, a tall, thin sophomore at Laramie Central High School, will have to get in line behind Lynn Lamanno of Milan, Maria Jimenez of Mexico City and Annie Lutefisk of Oslo. According to the royal family, Prince Harry receives . . .

Which leads work better? They all get high marks for sparking questions in readers' minds; there is no clearly right choice. The anecdote leads are touching and vivid; the fact leads are short and address quickly the reason for the story. In the real world, of course, the choices may be different. If Buckingham Palace denied reporters access to the love notes, for instance, there would be no gushing Kayleen Carson. The fact lead may be all the reporter has.

Choosing the better lead is an attempt to divine readers' druthers. Do they want to know fast why they're reading about Prince Harry? Maybe. Some readers get antsy when they are not quickly supplied with the point of a story. But others will enjoy Kayleen's sweet note, and be willing to wait.

If the choice is tough, that may simply mean the options are equally good. So just pick one, and remember that the unchosen lead will probably not be lost; if it was solid enough to be a close contender for the lead, it will probably stay in the story. If you

choose the shorter lead for the coffin tale, for instance, the reader will probably still get to meet Burton and learn about her sad search.

For the record, I would pick the "statistical milestone" lead in the medical school story, on the strength of its historic sweep. For the coffin article I prefer the short fact lead, too, but only narrowly; Burton's tale confers a real sense of the human side of this business trend. I favor the anecdote lead in the Prince Harry story, though; data about e-mails pale compared with teenage hysteria.

How do these choices measure up by my yardstick of lead quality—the ability to raise questions in readers' minds? Use the coffin story as an example: I felt pretty sure that Burton would make out adequately well, so that anecdote lead did not prompt in me as many pressing questions as did the fact lead about the striking quintupling of coffin sales. The lead that intrigues the most, wins.

Why Snuffy Stirnweiss Matters

Like a diamond, a story needs a setting.

YOU ARE WATCHING a film. The scene is of a beautiful lime-stone home on a city street. A man and a woman sit on the stoop, talking. Their conversation, about a friend and his new job as a D.J., is engaging, but soon you start to wonder: Where are we, anyway? Boston? New York? Georgetown?

"Setting" paragraphs answer such questions. They furnish a context, which can be geographical, but can also be historical, statistical, intellectual or even emotional.

These paragraphs are important because a reader soon feels skittish in an unplaced tale, like a horse with blinders. If you think of a story as a room, then no matter how fascinating its furniture or its occupant, the reader will eventually want to gaze out the window.

And so a writer, like a filmmaker, makes sure to pan back at some point, usually early in the article. The setting may be just the background, the wallpaper, for the tale, but often it may also flavor the story.

Consider this lead to a 2002 *Times* story, by Peter Duffy, about a famous 1945 incident:

> Every evening at 7, Joseph Vitolo walks out the back door of his boyhood home in the Bronx and ascends a long stairway to a shrine that overlooks the northern tip of the Grand Concourse. He then leads the few people who have gathered in the recitation of the rosary. On some nights, no one shows up and he performs the service alone. Other nights, Mr. Vitolo is himself absent, having fallen asleep in front of the television set or lost track of the time.
>
> Mr. Vitolo, a slow-moving 66-year-old with a gravelly voice and sandy hair flecked with gray, has sought to carry out this nightly act of devotion since Oct. 29, 1945. That is when, at 9, he said he witnessed the Virgin Mary hovering over the spot where the shrine is now. The sighting catapulted Mr. Vitolo, a child of Italian immigrants, to news media celebrity. Spurred by extensive newspaper coverage, more than 30,000 people eventually crowded the spot, just south of Van Cortlandt Park, hoping to be touched by the heavenly presence that, it was said, had been communicated to the child.

Gripping, no? But the curious reader also soon wants to know what New York City was like in 1945. The next paragraph enlightens us:

> The vision arrived just a few months after the end of World War II. Boatloads of joyous servicemen were returning to the city from overseas. New York was unassailably confident. "All the signs were that it would be the supreme city of the Western world, or even the world as a whole," Jan Morris wrote in her book *Manhattan '45*.

This atmosphere plays no direct role in the tale of Vitolo. It might have. The writer might have cited a sociologist, say, who believes that such incidents as the Vitolo sighting sprang from the optimism of that postwar age. But there was no such sociologist in this story. The description of the can-do climate of New York back then just adds seasoning to the tale, which is mostly a profile of Vitolo and his vision.

In later sections of the story, the writer gives us still more glimpses of New York City in 1945. "William O'Dwyer, an Irish-born former Brooklyn district attorney, was days away from being elected mayor" at the time of the vision, the reporter writes. And, "Yankee fans were lamenting their team's fourth-place finish that season; its top hitter had been second baseman Snuffy Stirnweiss, not exactly Ruth or Mantle."

In Adam Fifield's 2003 story about the digging of the Manhattan segment of New York's Third Water Tunnel, there are two settings. One is a statistical portrait of the overall tunnel project ("When completed in 2020, half a century after work began, the tunnel will stretch 60 miles and ferry one billion gallons of water to the city each day. . . ."). The other describes the history, wages and achievements of the specialized underground construction workers, known as "sandhogs," who are digging the tunnel (sandhogs "dug all the city's subway, sewer, water and train tunnels . . . They helped build foundations for the Brooklyn Bridge, the Woolworth Building. . . .").

These setting passages, laying out information that is basic to the tunnel story, are more intertwined with it than are their counterparts in the Vitolo profile. But both sets of settings enable the reader to step back, scan a wider horizon, and then, comforted by the knowledge of where he is, refocus on the close-in action.

Chapter 43

--

The Man Who Met Lincoln

Besides furnishing the atmosphere of an article, the setting often answers that vital reader question, "Why should I read this?"

A MAN NAMED Danforth Houle labored day and night for months to open a French restaurant in Brooklyn. In a *Times* article in 2000, Chris Erikson described the construction and opening of Houle's dream business, as well as the zillions of details he had to grapple with, from where to buy a mop bucket, to what to charge for steak frîtes, to what to name the place.

But the time-pressed reader may say, Who cares? Hats off to Houle, and, yes, it's mildly interesting to sample the ins and outs of the restaurant field. But I have this stack of magazines to go through and do I really want to read 3,000 words about one guy pricing espresso machines?

The writer's answer comes in the fourth paragraph: "The 2000 Zagat Survey, which tracks only a small fraction of the city's restaurants, noted 274 openings in 1999, more than 5 a week. If

industry averages hold true, at least two-thirds of those will close or change hands within two years."

Notice that this setting not only gives readers their bearings, it also justifies the story and bolsters its importance. Erikson is saying that this story about Houle is not just about Houle. This man stands for a whole set of wannabe restaurateurs who themselves are part of a big, and chancy, New York industry.

Numbers frequently figure in such justificatory settings. Picture this: A browser at Barnes & Noble picks up *Shadow Cities*, by Robert Neuwirth. It's about squatters, people who live in empty buildings they don't own or rent. The browser might be interested in the book, but he balks. Is there any more to this topic, he wonders, than the occasional groups of disaffected youth taking over abandoned tenements? Neuwirth answers this waffling reader real fast, right in the prologue:

> Estimates are that there are about a billion squatters in the world today—one of every six humans on the planet. And the density is on the rise. Every day, close to two hundred thousand people leave their ancestral homes in the rural regions and move to the cities. Almost a million and a half people a week, seventy million a year. Within 25 years, the number of squatters is expected to double. The best guess is that by 2030, there will be two billion squatters, one in four people on earth.

Sometimes, the justifying takes a little explaining, as in a 2003 *Times* article by Jim Rasenberger.

In the article, Rasenberger describes some of the colorful people who lived in his Manhattan apartment house 50 and even 150 years ago. Readers meet Robert F. Heilferty, a teenage soldier who met President Lincoln on a Civil War battlefield, and Emma Vidder, who jumped to her death from the eighth floor of the

Narragansett Hotel and nearly landed on a blind woman in the process.

Interesting, but few New Yorkers live in Rasenberger's building on West 106th Street. Why should others care about this story? Rasenberger's answer: Because, like the author, many New Yorkers live in fairly old buildings. That means they, too, may have had colorful predecessors like Heilferty and Vidder, maybe even residing in their own apartments.

Here is the setting paragraph in which Rasenberger makes this case for broad interest in his tale:

> For all the development this city has sustained over the last several hundred years, much of New York remains old, by American standards anyway. Half our compatriots live in homes built since 1970, but 90 percent of New Yorkers live in homes built before that year, according to the Census Bureau's New York housing survey. More remarkable, more than 40 percent of us live in homes constructed before 1930, and nearly 18 percent in homes built before 1920.

On the surface in this paragraph, Rasenberger is talking about regional patterns in housing stock. But what he is really saying is, the story of my building may be the story of your building, too.

Yellow Ribbons and Honeylocusts

The nut paragraph is both a map and an ad.

IT GOES BY names like billboard paragraph, nut paragraph and focusing paragraph. It is a staple of longer stories, appearing high up in an article, and it is a familiar feature of books, too, in the foreword or preface or maybe on the flap. Wherever it is and whatever it's called, it's basically a guide for the reader to the major areas he will visit in the balance of the work.

But for all its importance, even in the work of excellent writers, the billboard paragraph is often missing, or missing in part, or needs improvement. Why?

For one, such a paragraph is hard to write. To do so, the writer must hover above her whole work—the very thing she is smack in the middle of composing—and give a bird's-eye view of it. It isn't easy to draw a map when the landscape is morphing. As a result, such a paragraph can be made final only after the rest of the story is written and edited.

Also, the top of a story demands a complex choreography, and in close quarters to boot. This small space contains many impor-

tant story parts—the lead, the setting, the peg, the "to be sures"—
and all of them are jostling for room. The billboard paragraph
is perhaps the most intricate, and so the least nimble, of these
cheek-by-jowl elements.

Finally, this paragraph has not one but two jobs. It must be
a map to the story, yes, but it also must be an advertisement for
it—a billboard. Like the lead, this paragraph must sell the article
by setting forth some of the tantalizing facts to come. Think of
it as a circus poster: Human cannonballs! Fire-eaters! Bearded
ladies!

This selling is serious business. The reader may have been lured
to read past the lead, but that does not mean he is convinced he
should trudge further on. To keep him from turning back, the
writer must avoid the arid abstractions that come naturally to
mind when writing summaries. After all, no one would spring
for circus tickets if the poster said, "Sleight of hand! People with
bodily anomalies! Acts of physical dexterity!"

In the early days of the Iraq war, the *Times* reported on reac-
tion to it from the residents of one block of Guernsey Street, in
Brooklyn. Imagine that the author of the story had written this as
her billboard paragraph:

> The people of Guernsey Street gather in the evening to
> discuss the day's events, and these days that means Iraq.
> Sometimes they agree and sometimes they argue; they talk
> of honoring our soldiers, and they cheer themselves up with
> humor. Their children grapple at school with the issues raised
> by the war, and everyone worries about a soldier stationed in
> Kuwait whom they all know.

This paragraph is a true map to the story. No reader would
complain that it does not faithfully lay out the terrain of the tale.

But it is abstract and boring. Contrast it with this, the billboard paragraph that the writer, Tara Bahrampour, actually used:

> On this block, the war in Iraq plays out in neighborhood-size ways. A woman sits on her stoop and dreams of tying yellow ribbons around all the honeylocusts, to honor American soldiers. A teenager groans about an essay on the war she has to write for school. Neighbors giggle at a living-room skit about Mr. Bush and Mr. Hussein—props include a kitchen knife, a meat cleaver and some talcum powder—and family members wait for an e-mail from Felix, a marine who is in Kuwait and who is married to a resident's daughter.

This much richer billboard paragraph is both a true map of the story *and* a sales pitch for it. Don't divulge all your goodies to come; the reader will have no reason to read on. But a little whetting goes a long way.

Two-headed calf! The tiniest man in the world!

Chapter 45

The Soccer Girls

The best transitions are the ones avoided.

WHEN A DRIVER takes a turn startlingly fast, his passenger braces himself against the dashboard, his knuckles whiten and, afterwards, he needs a moment to get his bearings. When a writer changes direction abruptly, the reader gets similarly discombobulated.

How to smoothen the ride? One standard answer is to use a transition, a bridge connecting one section of an article to the next.

Another is typographical devices—subheads, bullets, skipped lines, chapter breaks. These devices are road signs that say, "Sharp Curve Ahead," giving the reader a chance to get an anticipatory grip on the dash.

But the best way for the writer to avoid swervy trips is to lay out his story—plan his route—so that the curves are gentle, not sharp. Such planning doesn't erase the need for transitions, but it makes erecting these word bridges far easier.

A 2000 *Times* article describes a long-running soccer game

played every Sunday in Brooklyn's Prospect Park. The writer, Tara Bahrampour, explores the origins of the game (a pickup affair that began in 1976 and just kept going), its informality (no referees, knapsacks for goalposts), the players (many nationalities), and the role of women (the girlfriends who watch, the handful of women who play). Bahrampour might have had to haul out a trunkful of transitions for this multithemed, 3,100-word report, but she lightened her load with a simple technique—packaging similar ideas together.

In a 20-paragraph, 700-word section of the article, for example, Bahrampour groups together her seven women-related topics. Here are those seven items, and the sequence in which she discusses them (emphasis added):

1. For some of the soccer players, participation in the game predates their jobs or **spouses**.
2. Sometimes the game dictates home life. The parents of one player's **girlfriend**, for instance, never schedule family gatherings for Sunday afternoon—because that's game time.
3. Some **girlfriends and wives** come and watch the games.
4. In fact, although most players are men, some **women** even play.
5. Sometimes, the **women** who do play feel resented by the male players.
6. But often the **women players** feel welcome.
7. One **woman** even found romance, and marriage, on the field.

Had Bahrampour scattered these seven topics throughout the piece, she would have had to construct big word bridges to enter into and exit from them. In the section on the players' varied backgrounds, for example, she might have had to hammer together a clunker like this: "Although there are many nationalities on the playing field, one type of person is in short supply: women." And

in the section on fights, she might have had to write: "Besides disputing fouls and goals, some men occasionally bridle at the presence of the women players, of whom there are a few."

But with the women-related topics packaged together, readers need just a footbridge to get from one idea to the next, not something the size of the Golden Gate. From "Some women watch the game" to "Some women play the game," for instance, is hardly any distance at all.

Grouping the seven ideas together is not the end of the job; these ideas must themselves be smartly arranged. If Bahrampour went directly from Point 2 to Point 5, above, for instance, she would need a long and ungainly span to link them, even though both deal with women. ("But if one girlfriend's parents have found a peaceful coexistence with the game, war sometimes erupts on the playing field for those women who participate in it. . . ." Yecch.)

Bahrampour thoroughly planned not just the women-related items but all parts of her tale, and the result is that her readers can enjoy the ride and not gasp at, or even notice, the turns. Here's an analogy: You're at a cocktail party, and you have your eye on someone at the far end of the room. If you take slow baby steps, pausing to speak here and there with this guest or that, then, apparently all of a sudden, you will be clinking glasses with the object of your desire. No one will have noticed your migration. But if you stride all the way across the room to talk to your target, your movements will be neon.

Smart story planning minimizes the need for transitions, but you still need them. What are the basics of their construction?

Since transitions are stitches, make them short; the more seamless a story is, the better. Fortunately, English has a bunch of brief words—"but," "moreover," "yet," "meanwhile" —that do the job. Sure they're plain vanilla and we take them for granted, but to me they are a glory of the language. "But"—three little letters that

convey the abstract notion that an idea just presented will now be tempered. "Moreover"—one word for the equally abstract idea that the concept just presented will be reinforced. Not bad.

Word repetition is another way to make a neat stitch. In an imaginary profile of a novelist who has just sold his first book, for example, the writer ends a paragraph like this: "And with a book contract in hand, Jesse Burns has realized his lifelong **dream.**"

But in the next paragraph, the writer wants to pan back and discuss the many other aspiring novelists out there, of whom Burns is just one. How to link the two sentences? Just repeat the word "dream."

"This **dream** is what galvanizes 5,000 novelist wannabes to FedEx their jottings to America's major publishers each year. And that's just the wannabes who have agents. . . ."

Some editors yank out all the transitions that they consider unneeded, but I'm looser. Transitions do an important job and take up little space, so I can tolerate a smidgen of repetition with them. After all, the nation's highways furnish more than one sign to warn drivers that, say, I–95 is approaching. We don't want readers to miss the turn, either.

For example, one part of Bahrampour's soccer story focuses on the "one world" aspect of the game. The players may hail from all over the globe, she reports, but, at least for four quarters, they are engaged in a common, harmonious pursuit. The next few paragraphs, however, qualify that view, maintaining that some ethnic differences remain. The writer introduces that next part this way: "Even as nationalities blend together on the field, cultural variations are not lost."

The phrase "Even as nationalities blend together on the field" is, strictly speaking, unnecessary; it merely summarizes the prior section. The sentence "Still, cultural variations are not lost" would do the transition job fine by itself. But I like the "nationalities

blend" phrase because it nicely sums up the prior, detailed paragraphs, and because those prior paragraphs lay out a major story theme. There are plenty of other ways to trim a story than to snip a few words that convey a basic story line.

But do not be too wordy with transitions; some writers make them sound like heralds lined up on a castle parapet. Imagine that, in an article about Newark history, there is a large section on the looting that plagued that city in the summer of 1967. Now imagine that the very next section of the article, about the police response to the crimes, begins this way:

> This looting presented a pressing law-enforcement problem. The Newark Police Department reacted gingerly at first . . .

The transitional sentence, "This looting presented a pressing law enforcement problem," is clunky and obvious. Just send the heralds back into the castle keep, and forge on with the second sentence.

The White Tiger at the Garden

The end of a story can be the bow on the package. It can also be something more substantial.

WRITERS MOSTLY AGREE that a "summary" kicker is unwise. Such a kicker, snappily writes William Zinsser in his classic *On Writing Well*, "signals to the reader that you are about to repeat in compressed form what you have already said in detail."

True, a summary kicker may fit comfortably in academic essays, in a "here's what we learned today" kind of way. But in most journalistic or literary writing such a kicker sounds like a lecture by a blowhard, beetle-browed professor.

Yet, if the kicker is not a summary, what is it? Writing scholars say a kicker should sound an important note in a story, preferably in a striking way. The word kicker itself, meaning a surprise, a twist, a flourish, hints at these high ambitions. As Jacques Barzun has written, "Nobody wants merely to stop, but rather to end."

Why such grand aspirations? Because, like a poem's final stanza, the end of a story can linger in memory. The last can be lasting.

Writers build these memorable endings in different ways. Sometimes they choose a compelling quote to do the job, sometimes a spellbinding image, and sometimes they revisit the person or scene that started the piece, a nice bit of story symmetry known as a bookend kicker. But all these high-stepping kickers perform basically the same function, which is to tie a pretty ribbon on the tale. Consider this ending to David Critchell's 2000 *Times* story about a Bronx teen's dream of becoming a champion boxer:

> He dreams of the day he is fighting for a title on TV, before a crowd like the one for the Sanchez fight: 20,000 fans in Madison Square Garden. On that day, he said, he plans to enter the ring dressed as a white tiger, his ring nickname. "I'll have my face painted like a tiger, and I'll wear fur, and it'll be like I'm the animal, and I'm crawling to the ring, just ready to pounce. Then I'll knock the guy out in the first round. I can't wait."

Such kickers are great, but I think the conventional wisdom about kickers needs to catch up to actual practice. Yes, kickers often do serve as decorative and dramatic touches, as in this boxer's story, but they can and do serve other, more structural functions, especially in stories where space is tight and the topics are many.

Here are some of those roles:

THE VOICE UNHEARD, THE TOPIC UNTOUCHED An article reports that a troubling number of New York schoolchildren are playing hooky. But these truants aren't heading to the proverbial fishing hole; they're slipping into Internet cafes to play video games.

Most of the story—stuffed into just 400 words—is a complex

debate among principals, parents, cafe owners and other adults about the truancy problem. The writer, Jim O'Grady, then wisely devotes the only room left, the kicker, to a voice that certainly belongs in a hooky story: a kid's.

> Henn Tan, a ninth grader at I.S. 237 who was hanging out at the cafe that afternoon, turned from his computer and volunteered that he never cut class to go to Internet cafes. But, he added, he knew students who did. "Most of them are lazy," he said. "Or get addicted to games."

This story would not have been wrong without kids. Space was tight and the article needed to fully air the educational issues. But the boy's voice certainly enriched it.

Good writing often demands choosing one dominant theme and forsaking others. By allowing the writer to at least nod briefly toward an untreated aspect of a story, a technique William E. Blundell calls "spreading out," a "voice unheard" kicker can temper this harsh principle.

THE HUMAN NOTE Some residents of Chinatown collect a colorful fish called a flower horn. "They're like prized orchids except they swim," one person says. The bulk of this story discusses the collectors, the companies that sell the fish, the breathtaking prices the fish command, and the variations that affect the price (if the spots on the fish form a Chinese character, especially a lucky character, the price soars).

But Denny Lee's story is also about the joy that collectors take in these swimming bits of beauty. The lovely, low-key ending focuses on that happiness:

Mr. Choi scooped them gently into their new homes, and pulled up a chair. "Sit, enjoy," Mr. Choi said, like a proud father. "This is my collection."

BALANCE Consider an imaginary story about a Postal Service supervisor. Deservedly or not, postal workers have a reputation as nail-filing malingerers. But this supervisor, let's call her Eleanor Queensberry, is a boss full of spit and polish who has her subordinates jumping, her customers smiling and the floors gleaming. By the end of the story, Queensberry seems like a robot—so the kicker acts as a counterweight, revealing her softer side.

> After work, in the spacious apartment she shares with her husband, two children and three parakeets, Ms. Queensberry sometimes sits and knits. "I'm making baby booties for my sister's twins," she said. "They're due in a month!"

SHIFT A lawyer named Charles Dufresne was so upset by his girlfriend's mugging that he campaigned to have streetlights installed in all the dark, mugger-friendly side streets of his neighborhood. A 2003 *Times* story by Erika Kinetz describes his meetings with the police and local groups, and all the other details of his mission. He did it all for love, of course, but the lighthearted (and ironic) kicker offers a different slant on his quest:

> "It is very flattering," Mr. Dufresne's girlfriend said. "But when are you going to fit me in? You have all these meetings."

DOTDOTDOT (That is, " . . .") After 15 years of dueling with city officials, Harlemites finally secure the money needed to overhaul Frederick Douglass Circle, a picturesque area near Central Park. A 2003 *Times* story by Kelly Crow describes the funding, the resi-

dents' relief and the dispute's long and tempestuous history. But while the money is finally in hand, the actual design is not yet done—and the kicker makes clear that another chapter of this story has yet to be written.

> "We're really excited that finally, the circle is going to happen," Ms. Caron said. "But the devil is in the details, and we need to be sure it's the best plan we can get. People have waited too long to get anything less."

The end of the story, the dotdotdot kicker says, is not the end of the story.

Whatever the purpose of the kicker, to render it is an art:

- A kicker, like a lead, is short and shorn of all but the essentials. Some writers prattle on and on in their kickers—like a hammy actor who staggers about for far too long in his death scene.
- Kickers love commas, periods and other braking devices. An artful kicker reads in a stately way, coaxing the reader to dwell on the dramatic, meaningful words, and guiding the story to a graceful, not screeching, halt.
- Kickers are powerful because they are the end. To exploit that power, the central dramatic words should literally be the last words.

As to the last point, this made-up kicker:

> But there have been many tirades directed toward the accused killer and everyone allied with him. "There's a big red circle painted on my backside," said Malvolio Smith, one of the defendant's lawyers.

is weaker than its rephrased cousin:

But there have been many tirades directed toward the accused killer and everyone allied with him. As Malvolio Smith, one of the defendant's lawyers, said, "There's a big red circle painted on my backside."

CODA

Leads, transitions and the other topics of this section are mainstays of the writing curriculum—the three R's, so to speak. But there are plenty of other disciplines for writers to master.

One is numbers, which arise in so many areas—size, time, distance, dimension, volume, weight, density and more—that no writer can skimp on their presentation. First of all, always strive to be reader-friendly in matters of numbers. (Say "One of every five people on earth is Chinese" rather than "The Chinese represent 1.3 billion of the world's 6.7 billion people.") Find smart ways to compare numerical magnitudes, too. ("A million is to a billion as 11 days is to 31 years.") Work familiar referents into your numerical descriptions. ("How much does a rhino weigh? As much as 20 Michael Phelpses.") Most important, treat numbers, like any subject matter, as a chance to tout your theme. ("Mr. Kovener's room at Silver Acres Nursing Home is a squarish affair, about half the size of the shuffleboard court outside his window.")

Paragraphing and quotation are other significant writerly subjects. So are dialogue, and revision, and description of the human body, which may be the hardest of all.

But the most central of these second-tier disciplines is punc-

tuation, and in that field false notes are just a jot away. A writer overfond of the colon sounds like a drama queen; a weakness for semicolons, and he's a bewhiskered Edwardian; a yen for short sentences, he's a Hemingway wannabe or a refugee from *See Spot Run*. And because punctuation sets a text's pace—the British call the period a "full stop"—the misplacement of periods and commas can unbalance a whole piece, as if it were an orchestra whose brass and string sections are cued by different conductors.

Part VII

THE BIG TYPE

Titles and subtitles are turbocharged text.
They are your work distilled.

The Red Phone

In the late 1990's I filched a phone from a trash can at the *Times*. It's a red phone, an old one in the rotary style. Only there is no dial on this dial phone, and no numbers except in the center, where, in the spot that usually has the phone number, it says, "Hotline 27." When that phone rang—and similar ones sat in various departments throughout the paper—it meant that something major had happened, major even by the standards of a newsroom where "major" is daily fare.

Sam Roberts, a veteran *Times* reporter, can remember only one time when he saw the red phone in use. It was the 1960's, a major airline strike had just ended, and legendary news editor Lewis Jordan picked up the phone and said, yes he did, "Stop the presses." Roberts, who also worked at *The Daily News* in New York, remembers someone yelling "Stop the presses" there once too, only someone yelled back something like, "The presses haven't started yet, you jerk."

"That," Roberts says, "summed up the difference between the *Times* and the *News*."

My red phone sits in my home office, unconnected and propped on a shelf right below *The Dictionary of Anagrams*. I never did see

it in use myself, but it's one of those relics from the *Times* that murmurs "witness to history" or something button-bursting like that. I get a little shiver looking at it, even though my witnessing has taken place mostly in the metaphor-promotion department. It's a nice sum-up of my affection for the *Times*.

Savvy writers know that it is always things, like phones, that best convey abstractions, like institutional loyalty. And it is the writers of titles, headlines, dust-jacket copy and other "display" type—the subjects of this section—who know it best. Just scan some story titles to see. Call an article about up-and-coming politicians "Peach-Fuzz Pols" and readers may well start reading. Call it "New York's New Crop of Young Officials" and they well may not. "The Good Samaritan of Queens" is a blah headline for a piece about a man who feeds the hungry. Say "The Chicken and Rice Man" instead, and readers will show more interest.

And so it is with the *Times*. I love the paper, but it sure isn't the abstract corporation that makes me fond. It's "Lorem Ipsum," the first two Latin words that appear in the dummy text that the newspaper's designers use to lay out a page. It's *A Field Guide to Germs*, one of the many castaway books that I've snatched from the newsroom's generous, laden credenzas. And it's that dialless red phone, Hotline 27.

Why Change an Apple?

The large type presents the first words that a reader encounters. With a big mission and little room, these titles and subtitles are a boot camp for sharp writing.

THE LEAD IS the gateway to a story, the pivotal place where readers decide whether to enter the writer's world. What could be more critical? Well, the title could be, and so could the subtitle. Whether the text at hand is a book, an article or a blog post, readers encounter this "display type" even before the lead—it is the lead to the lead.

As with leads, a title, like the following three from the *Times*, can use a riddle, an image or a play on words to stir reader curiosity. What is the story behind "How My Mother Saved New York"? (She wandered around Manhattan, kids in tow, collecting gargoyles and spandrels from doomed buildings.) What is "The Tour That Never Was" and why was it never conducted? (It was a guided audio tour of the World Trade Center that was not quite ready for its debut on Sept. 11, 2001.) What place is "Where Extra Large Is Way Too Small"? (It's the Bronx, where the fashion

among boys and teens is superhuge T-shirts—XXXL and more— that end at mid-shin.)

Usually, the subtitle, also called the bank or deck, elaborates upon the title. The basic conclusion of a 2005 *Times* article about the New York Health Department was that its philosophy had been shaped by the crises it had confronted through the years, from cholera to diphtheria to AIDS. The headline was a nice, broad-brush statement of this theme: "Forged by Fire." But those three words hardly served to make the full point, so the two-sentence bank did: "New York's Health Department was born 200 years ago to battle outbreaks of yellow fever. Ever since, it has been the big threats, from smallpox to bioterrorism, that have fueled the agency's growth."

Every writer, from student to diarist to novelist to blogger, should compose titles and subtitles whether she has to or not. They are the calisthenics of composition, the one-handed pushups that make writing ordinary text easy by comparison. They make regular writing easy because they're so hard: This title fits the space, but the idea is wrong. This title has the right idea, but it doesn't fit. This title has the right concept and it fits, but the image is bland.

The sun may rise and set and rise again before you get these devilish bits right in thought and in art.

And yet, it's the hard work that makes you happy. When you finally capture the essence of a 2,500-word essay or a 50,000-word book in four or eight words that are specific, vivid and faithful to the text, a smile blossoms on your face. Why? Because you've reached the summit of writing, the peak of prose.

No words are that powerful, that capacious, you scoff. Wrong. In *The Cat in the Hat*, Dr. Seuss created an entire, and enduring, world of fantasy. How many words did he need to do that? Just 1,626—the length of a chatty e-mail. The right words can make worlds.

That smile on the summit reminds me of Tony Bennett's plan to switch from his successful torch-song style to rock 'n' roll. When Count Basie heard of the idea, he reportedly dismissed it with, "Why change an apple?" I think the smiling writer, after snaring those four or eight vivid and exactly right title words, has the same feeling. That writer is Fonzi in "Happy Days," comb poised, ready to go, but then, a satisfied shrug. Hair's perfect. Why change an apple?

It is not just the word freaks out there who like such distilled writing. When Smithmag.net, a storytelling magazine, asked readers to submit six-word biographies, thousands did. The entries ranged from the funny ("One tooth, one cavity, life's cruel.") to the witty ("Boy, if I had a hammer.") to the bawdy ("Catholic girl. Jersey. It's all true.") to the poignant ("I still make coffee for two.").

My favorite, though, was one that bent the contest rules: "Editor. Get it?"

Part of the joy—and for me, it is joy—of concentrated writing derives from its victory over form. Titles and subtitles, with their absurdly tight space, are a severe form. Think of haiku, or sonnets. To face strict limits, by mandate or by choice, and still prevail, that is a vastly satisfying victory. You have used one hammer to build a house. You have used one scythe to harvest a hundred acres. You have taken the old stuff from the fridge, and whipped up a feast worthy of the Iron Chef.

In *Old School*, Tobias Wolff's 2003 novel, a fictional Robert Frost compares formal poetry to more relaxed styles. Referring to Achilles' "famous, terrible" grief over the death of his friend Patroclus, Frost says to his prep-school audience: "Let me tell you boys something. Such grief can *only* be told in form. Maybe it only really exists in form. Form is everything. Without it you've got nothing but a stubbed-toe cry—sincere, maybe, for what it's

worth, but with no depth or carry." (The real Frost concurred. He dismissed free verse as "tennis without a net.")

This topic may sound overblown in a section on titles and sub-titles, but the fact is that I am not discussing just titles and sub-titles. I'm talking about all writing. Breathing life into the dead blips and dots we call words, and doing so in limited space, is the writer's fundamental victory over form. It's a long-odds bet, and when we win we smile. But when the word count is particularly short and the message particularly important—as it is in the big type—this long-odds bet grows longer still. We like that even more.

Why do we like that so much? That question is beyond this book, but here's my personal answer: because life is stacked against us—we all die, yet we all comprehend eternity—and we like to mimic that sucky situation, but end up winning instead.

Cabs and Cornfields

Composing a title demands a deep understanding of the text and a fine-grained appraisal of different phrasings.

HERE'S A STORY in search of a headline:

In 2005, the *Times* published a funny, self-deprecating essay by a witty writer, Joe Queenan. In that very tongue-in-cheek piece, Queenan describes his young self as an annoying, know-it-all kid, the kind whose hand is in midair when the teacher is still in mid-question. At one point, still young, he leaves home and moves to New York, fully assuming that he can continue to show off, only now on a far bigger stage. But it turns out that in New York he's not even an understudy; the city's glib cognoscenti take him down hard. The reader couldn't be happier.

What headline can capture this smug character (who is not really Queenan, of course) and his delicious demise?

How about "Vengeance on a Braggart"?

That's in the ballpark. But it doesn't sound particularly pretty, and it is hard to absorb and a bit misleading. There is no active vengeance in the tale; our pretentious pup just meets his match and end of story.

O.K. Maybe "The Show-off Gets Shown Up"? That's a possibility; it's catchy and truer to the story. Something similar, "What the Know-It-All Didn't Know," is also a strong candidate. Both these headlines lure readers in with the anticipation of some delicious event.

How about a one-word headline: "Outsmarted." It's nice because it plays on the meaning of that word, given that the boy's smarts are central to the story, and also because one-word headlines give readers a chance to fully savor the chosen word. On the other hand, the cleverness may be lost on readers. They can fully appreciate the "outsmarted" joke only after reading the story, but typically they read the headline first.

Well then, how about this headline: "Smartypants." On the one hand, this is a winner word; it's vivid and nicely captures the disdain we feel for know-it-alls. But, unlike "Outsmarted," this headline is silent on the central event of the story—a know-it-all's *undoing*. A headline should snare the heart of a story.

How about "Mr. Smartypants' Comeuppance"? "Comeuppance" is great, a refreshing word that conveys exactly the joy of watching bad things happen to annoying people. But there's a problem: "Smartypants" and "Comeuppance" are two great words, and that's one great word too many, like two divas at a dinner party. Plus, these two words are a mouthful to say together, and their clunkiness grows when the copy editor gleefully tells us something we should have known all along—that "Smartypants" should be hyphenated, as in "Smarty-Pants." Now we are left with a headline that both sounds awkward and looks awkward.

Maybe the word "Snob" could replace "Smarty-Pants"? "The Snob's Comeuppance." Not bad. It rolls trippingly off the tongue; it zeroes in on the essay's central event, and it offers two lively words that will not collide with each other.

Other possibilities: "Another Big Apple Has-Been" nicely evokes the idea of New York as the graveyard of small-town stars. But it does not reveal the know-it-all at the center of this story; it could mean an aspiring writer or actor or anyone else who gets off the bus with big dreams. Another candidate, "Bright Kid, Big City," is a reasonably appropriate allusion to Jay McInerney's novel. New York, a main site of Queenan's story, is also the locus of that novel, and in both of them something nasty happens to recent arrivals—a comeuppance in one, a descent into drugs in the other. Some may argue that McInerney's book has been way over-alluded to; it's right up there with "Desperately Seeking Susan" as a popular template for the headline writer. But "Bright Kid, Big City" does tell the reader: A Smart Kid Goes to New York City and Probably Something Bad Happens. For four words, that's not too shabby.

Of course, which title works best depends on who's deciding. "Sliced Up in the Big Apple" would be too blunt for the *Times*, but maybe not for the lively, less literary *New York Post*.

But for the *Times*'s sensibility, what's better, "The Snob's Comeuppance" or "Bright Kid, Big City"? I prefer "The Snob's Comeuppance" because it flags the part of the story that is most fun, because "comeuppance" is a fine word, and because the McInerney headline would be lost on readers not familiar with the novel.

Both headlines, however, are clearly superior to "Vengeance on a Braggart," which is misleading and a bit opaque, and to "Another Big Apple Has-Been," which gives no glimpse of the put-a-lid-on-it main character.

In the end the headline we chose was "The Snob's Comeuppance." We may have been right, we may have been wrong, but in the end writing titles is more about the journey than the arrival. Parse the possible headlines closely and, whatever your final

choice, your overall writer's vision will improve. You will be able to spot Blind titles, which perversely require the reader to have already read the story in order to get the point. You'll detect Bland titles, those generic formulations that cast a broad dim beam rather than focus specially on the text at hand. And you'll catch the Bling titles, which trumpet a glittering aspect of a story but are mum on its main point.

The title writer also learns the critical skill of finding vivid, concrete words to stand for abstract, bloodless ones. Call them ding words, after the mouth-watering terms—"smothered with gravy," "encrusted with almonds"—that restaurateurs foxily put on their menus to make diners hungry. A *Times* story about an upper-class Christmas celebration is not called "Night of the Big Ball," for instance; it's called "Night of the Tuxedos." A profile of a couple who commute between Iowa and Manhattan is not called "The Interstate Commuters." It's called "Cabs Today, Cornfields Tomorrow."

Such vivid words can even link up in a coordinated image, helping to stitch a story together tightly. Here is the headline on a report about aggressive preservationists on the well-heeled Upper East Side: "In a Kid-Glove Neighborhood, a Call for Clenched Fists."

Headline writers also learn to pique reader curiosity by linking incongruous words. When three museums that specialize in New York City history plan to merge, the resulting story is called "The Future of the Past." The reader reads those words and cocks his head. How can the past have a future? He reads on.

Even blah words can be used in a pizzazzy way. A post–9/11 *Times* article about the outlook for constructing skyscrapers in Manhattan carried the headline, "The Future of Up." In just two letters, this headline signals that the story is concerned with a very basic direction. After all, there are just six of them—up,

down, north, south, east and west. Has 9/11, the headline asks, stolen our "up"? "The Future of Skyscrapers After 9/11" packs no such punch.

Just as he learns to embrace ding words, the title writer learns to toss out cringe words—terms so clunky they dim otherwise sparkly writing. Sometimes, avoiding them is hard, as in a *Times* article about the online digitizing of a collection of late 19th and early 20th century books. Nearly all the central words in this story—digitize, online, Web—are extremely unpretty. But the headline writer found a rose amid the techno-thorns: "The Past, in Pixels." Avoid the ugly.

But don't avoid writing titles. That struggle puts punch in all your prose.

The Tides of Brooklyn

*A subtitle is an outline to a story. But it is more
concentrated, and written with verve.*

A SUBTITLE, ALSO known as a deck or a bank, has a bit more
room than a headline, which means it can be more analytically
ambitious, fine-tuning and elaborating upon the concept that the
headline can only nod toward. But like headline-writing, bank-
writing is a crucible from which refined writers emerge. Consider
this example:

It is 2005, and some *Times* editors are planning a special issue
about Brooklyn. The editors see lots happening in that borough,
with hipsters and immigrants moving in, yuppies restoring ne-
glected brownstones, and cultural institutions, like the Brooklyn
Academy of Music, thriving.

What is the Big Thought that links these developments? The
editors toy with several possibilities: that Brooklyn is showing
signs of becoming a city unto itself, separate from the rest of New
York; that the legendary Brooklyn of the Dodgers and egg creams
has been supplanted by hip Williamsburg and Arabic Bay Ridge;

and that Brooklyn, with its density, low buildings, large ethnic mix and many telecommuters, is a model for the American city of the future.

Eventually, the editors choose this as their overarching idea: New York City has changed greatly in the last 25 years, but one place within it—Brooklyn—has changed even more so.

Fair enough. Now, the editors need a bank to express this idea elegantly, accurately and vividly. This bank will go under the headline, "The New Brooklyns," and will be the first statement the reader encounters. It is the editors' justification for their special issue.

Like writing a headline, writing a bank demands high style and hard thinking, and there are plenty of ways to flub the job. Here's one flawed candidate: "New York City is evolving greatly, and in no place is that change more pronounced than in Brooklyn." This bank is conceptually solid, but bland as boiled rice.

How about: "Over the last 25 years, New York City has donned a sharp new suit—but Brooklyn has had a complete makeover." This bank offers a mildly interesting metaphor, but it overstates the editors' idea; they believe Brooklyn has changed greatly, not that it is totally transformed.

Then how about: "In the last 25 years, New York has put on a whole new face. But one place that is unrecognizable is Brooklyn." No. This bank has two problems—it overstates the extent of the change in Brooklyn, and it makes no sense because that "whole new face" would make all of New York unrecognizable, too.

Let's keep plugging. How about: "The pace of change is fast all over New York City, but in Brooklyn the trends are at full tilt." That's not bad; it says what the editors believe—that the city is changing and that Brooklyn is changing the most—and the metaphor works. Only thing is, the image is not very visual.

But we're getting closer. Now consider this bank: "Since 1980,

strong winds of change have blown through New York City. But nowhere have the gusts been greater than in Brooklyn." This bank is conceptually accurate, too, and, although the metaphor is a little labored, it is more visual than the "pace of change" one.

The chosen bank had a water image. It read, in part: "Waves of change have washed over New York. But in Brooklyn the transformation seems almost tidal." We thought that this choice, like the two above, was conceptually on target but offered an image that was a bit more vivid and polished.

(As I read it now, though, I realize the word "transformation" overstates the case; "the *trends* seem almost tidal" might have been better. All of which means that sometimes the banks that flub the job include the one you publish.)

As a reward for her hard work, the bank writer will receive a bag of tricks that are valuable in all kinds of writing. Suspense is one such trick. In a 2005 *Times* article called "It Takes Two to Tango," the bank teases: "Alex Spencer, whose passion is competitive ballroom dancing, has been on a frenzied search for a partner. A major championship is looming, and he can't dance alone."

Do you want to know if he found a partner in time? Of course you do. In the same way, serialized novelists like Charles Dickens knew that ending a chapter on a high and tense note would prompt readers to buy the next installment.

Commonly, this suspenseful end note is not a factual question—Did he find a dance partner in time or not?—but the newsworthy, unconventional twist that undergirds the whole story. For example: Most immigrants who flock to New York do so for economic reasons, but one particular group, young, middle-class Japanese women, head there for *cultural* freedom. These women complain that in Japan they are bound by harsh, sexist conventions and told to be demure and submissive. Chafing at this, they move to New York to join punk bands, break-dance, write novels,

open restaurants—all ventures that, by their accounts at least, would be frowned upon back home.

The bank to this story, a 2005 *Times* report by Jiro Adachi, plays this unusual motivation off the conventional one: "Money is what draws most immigrants to New York. But young Japanese, determined to shake off the cultural restraints of their homeland, see the city as a place to dance, to dare, to shine."

Getting the idea right is Job No. 1 for the bank writer. But if she can hit on a striking visual, too, it can pack a particularly big wallop because of the bank's prime location and large type. One of my favorite such images came in a 2004 *Times* article about growing competition among the florists in New York's Midtown Garden District. "From high in the sky," the bank declared in part, "the flower district looks like a giant corsage pinned to the heart of Manhattan."

For me, the beauty of that image deepens because it lives in so small a space, like a feisty daisy in a sidewalk crack.

Pundamentals

*Word games offer a nice sideshow for the reader. They
are never profound, but some efforts are smarter than
others.*

ALLUSIONS, PUNS, WORDPLAY of all sorts: they spice prose
up even if they do not deepen its meaning. It's just fun to call an
article "War of the Roses," especially if the alternative is "Com-
petitive Pressures Dog the Midtown Garden District."

But wordplay, which pops up more often in titles than in text,
usually rings false or worse in works that are serious or somber. I
nearly dropped my remote some years ago when a TV newscast
about the heart troubles of Vice President Dick Cheney was titled,
"The Beat Goes On." The same holds if a story about some or-
phaned kids is called "Home Alone." Insensitivity is not wordplay.

But if "clever" is the most to which sleight-of-word can aspire,
for many purposes that's just fine. A *Times* article about the con-
version of an elegant hotel into a college residence carried this
headline: "From Doorman to Dorm, Man." That's a bonus bit of
wit for the reader.

Word twists come in all guises—rhymes, invented words, inverted phrases, even repetition. In a *Times* article about graffiti insurance, which building owners buy to protect themselves from vandalism, the headline was, "For the Writing on the Wall, the Writing's on the Wall."

Wordplay's biggest danger is staleness; only a short distance separates bright and trite. To avoid the obvious phrase, a writer should always stifle that first thought. In a dispute over a park, for example, a variation of "The Grass Is Always Greener" will quickly pop to mind. Eject it. If you construct a pun based on Clint Eastwood's "Make My Day," blow it up. If you're thinking "Car Wars" for that auto essay, or "Bar Wars" or "Par Wars" for stories on taverns or Tiger Woods, unthink fast.

"Writing is the art of the second thought," Jack Cappon has observed.

Here are some headlines that profited from the wait. For a profile of a Yankees fan who complains ceaselessly no matter the team's success: "Seventh-Inning Kvetch." For a report about a dispute over a sound studio: "Music Studio Is a Den of Din, Neighbors Say." For a piece about how patrons of a Coney Island roller coaster lose their wallets: "The Down Side of Upside Down."

Of course, it's real wordplay only if it works on two levels. There was a real War of the Roses (Level 1), and a story about florists' rivalry can fairly and smoothly be called a War of the Roses (Level 2). One of my favorite bits came in an article about stand-up comedians who work their personal troubles into their acts, turning their performances into funny, onstage psychotherapy sessions. The headline: "Take My Life, Please." By taking the punch line of a joke and twisting it into an allusion to suicide, this headline neatly spears the two subjects of the story, comedy and psychotherapy.

But consider a story about sari fashion that carries the head-

line, "Who's Sari Now?" If there's no "sorry" in this fashion story—if, say, it's not about a sari merchant who sold his store just before the garments got popular—then there's only one level. One-dimensional wordplay is just not wordplay.

To keep their in-house wits from getting too frisky, news outlets have rules about wordplay. The *Times*, for instance, allows no punning on people's names. Remember, too, that wordplay hinges on readers' education, culture and age. Not many punk rockers will appreciate a sly aside about "Turandot." Know your readers.

But if it is fresh and not offensive, wordplay is fun. Like metaphors and other figures of speech, it also lets readers solve a puzzle, read between the lines, interact with the writer, connect the dots. It's the sprinkles on the story.

CODA

"It is my ambition to say in 10 sentences what others say in a whole book." Thus spake Friedrich Nietzsche, and with those words he captured the most profound aspect of "the big type." True, writing in a tight space is artistically satisfying, as this section has argued. But to distill words so powerfully that they become almost pure thought—that is display type's biggest challenge, and biggest promise.

Nietzsche's aspiration, which is of course every writer's aspiration, may in fact be even grander than it seems. For its unspoken corollary is this: If a writer succeeds in saying a book's worth of stuff in 10 sentences, then what if he wrote a whole book of such superdistilled prose? How much wisdom would lie between those covers?

Afterword

THE BRANNOCK DEVICE

So I walk into this empty conference room in the old 43rd Street building one day, and there I find a personalized notepad with a few sheets left. The name on the notes: Arthur Ochs Sulzberger Jr., the publisher of the *Times*.

I take the pad home. "Parakeets need seed," I write on one sheet, taping it onto the remote—where my wife and teens would doubtless see it—and signing "A.O.S. Jr." with what looks to me like a magnate's flourish. "Weeds among the marigolds!" I write on another sheet. "Is this the face we want to present to the public? I think not."

The notes were about as effective as you might guess. I had much greater success with humor in the newspaper, and I put it there often. During the two years I edited the Sunday Business Op-Ed page, for example, I ran three solid months' worth of funny pieces.

One was a meditation on business school by Peter Robinson, a former Reagan speechwriter. "My favorite item in the school library was a wall map called 'The Two Americas,'" Robinson wrote. "I expected the familiar theme that America was divided

between rich and poor. Instead, the map was about purchasing patterns for mayonnaise. Apparently, the nation's North and West buy Miracle Whip, while the South and East go with Hellmann's."

Funny! I also still laugh over an essay we ran in the City Section about a Brooklyn tutoring center that lures kids in by selling capes, grappling hooks and other "superhero supplies." In a logbook by the front door, in keeping with the store theme, visitors are asked to register their superpowers. We ran selections: "Chopstick Man—Can pick up anything." "Senior Citizen Man—Gets into movies half price." "Captain Yankee—Goes to the postseason almost every year."

Also funny! But as I edited and thought about these funny articles, I realized that to write humor well demanded the qualities that writers need for every subject: empathy, vividness, imagination, egolessness, a deft use of indirection and the patience to think beyond the first-blush thought. A humor writer cannot hide behind highfalutin words. He cannot forget about the reader. He must acquire a voice. He must learn pacing and cadence, and know when to stop, and know what to leave out. And the payoff for all these skills is this: When that writer makes a reader laugh— zing!—he has touched his heart. What's writing about if it's not about that?

Moreover, humor conveys the Big Themes well. Several months after 9/11, the *Onion*, the parody newspaper, ran a story I call Plaintive Flag Guy. It was about a man who, in a surge of patriotism right after the terrorist attacks, had raised American flags on his home, garage, everywhere. But time had passed, the fervor had subsided, and he wanted to take one or more down. Of course, he felt sheepish about doing so, he even felt sheepish about *wanting* to do so. "Area Man Not Exactly Sure When to Take Down American Flags," the *Onion* announced.

How great is that conceit? That fake article is so emotionally real! You know that tons of real people were conflicted about the same thing. In Plaintive Flag Guy, the *Onion* wrote about love, sorrow, guilt, practicality—large ideas—and it did so unsentimentally and while getting some yuks.

I have never tried to write humor; I've been a sidelines admirer. But I am determined to try. Here's the twist, though: I don't want to write it only because it seems like a great genre. I want to do it to keep myself fresh.

Why? Because if writing is about anything, it's about seeing things fresh. A longtime book critic once said he feared that eventually he might be able to have only 700-word thoughts—the length of his reviews. He knew that freshness was crucial. A journalism professor I know of lets his students write about any topic they want—as long as it's a topic they don't know. He knows that freshness is crucial, too.

So if you do not want to write humor to keep yourself fresh, turn to some other unfamiliar subject (garage bands? philately?) or genre (aphorisms? one-act plays?). Do it because it will keep you nimble and because the greatest tragedy of all would be to love some aspect of writing *and never find out*. Euell Gibbons, the naturalist, was lucky; he did find out. According to John McPhee, Gibbons wrote "sonnets, light verse, short stories and several kinds of novel, including a Biblical epic," for years and without any real success, when, finally, an insightful literary agent noticed the wealth of wild foods in his works and advised him to do a straight-up book about them. So in 1962 Gibbons wrote *Stalking the Wild Asparagus*, it was a huge hit, and soon he had a bountiful crop of other *Stalking* books.

Happily, there are plenty of new topics to try, because the world is wonderfully varied and, as I said in the Introduction, writing is a big rambling house with lots of rooms. I myself may

check out the room called Book Editing someday, and maybe Monologues. Some people even build their own room. Take Paul Lukas. He has what one observer calls "a Thing jones," meaning that Lukas has a craving for the millions of things produced by our consumer culture. So, in articles, his own magazine, and a book called *Inconspicuous Consumption*, dallying in a field that he founded himself, Lukas writes lovingly about mail chutes, animal crackers and that black-and-silver contraption shoe salesmen use to measure your feet (the Brannock device). He traces the history of these multitudinous things, he profiles their inventors, he dissects their pros and cons, he loves the stuff to death.

Go find the stuff you love to death. When you find it, many wondrous things will happen. Time will fly. Work will become play. You will feel stoked. If you are prey to self-consciousness and general writerly heebie-jeebies, they will fade or vanish. Of course, the room you walk into may be the wrong one. But you can just walk out, nothing lost, and try a different door. If you are in love with writing (and not just with the idea of writing), there is almost certainly such a door, and it is waiting for you.

Acknowledgments

Editing has taught me the most about writing, so my deepest thanks go to the many writers at the *Times* with whom I have collaborated, especially those at the Sunday Business Section and the City Section. Their texts have been my main canvas, but the canvas is of course still more theirs than mine. Thanks to all of them for sharing, and regrets for all my splotches and brush marks.

Thanks, too, to every writer who made me excited about writing, from Malcolm Muggeridge and his curmudgeonly columns in *The New York Journal American* in the 60's, to Edward Hoagland and his knowing observations of nature in "The Courage of Turtles" and other essays; to Raymond Carver, who taught me the power of quiet writing; and to M.F.K. Fisher, who wrote food essays so rich you can almost taste her topics. (Of an intensely sweet cake, she once wrote, "It makes every tooth in my head quiver like a stricken doe.")

Thanks as well to William E. Blundell, Roy Peter Clark, Jon Franklin, Samuel G. Freedman, Francine Prose, James B. Stewart, William Strunk Jr., E.B. White, William Zinsser and other writing scholars. I wrote this book standing on their shoulders.

Thanks to *The New York Times*, which, in these days of fast 'n' loose

'n' self-aggrandizing journalism, is an unflagging standard-bearer for artful, truthful, fair and neutral writing.

Thanks to Connie Rosenblum, who originally suggested I write a writing book; to Larry Weissman, my agent, who believed in the book from the start and was a true warrior on its behalf; to my many present and former *Times* colleagues, many of whose names appear in this book and many of whom unstintingly lent me a hand; to Rob Boynton, Brooke Kroeger and Mary Quigley at New York University, who gave me a place to air my ideas, and to my students there, who helped me refine them; to Susan Shapiro, writer, professor and morale builder nonpareil; to Serena Jones, my editor at Collins, for her valiant efforts to improve this book; to Mitch Keller, who made my prose clear, compelling and correct; to Nina Brown, who designed the jacket; and to Steve Ross, Bruce Nichols and Diane Aronson at Collins.

Thanks finally to my wonderful wife, Jeanette, for ceaselessly encouraging me and for being my own private Google ("Is Manolo Blahnik still alive?" "Yes, dear."); to my son, Patrick, most astute of readers ("That's a little . . . over the top, Dad."); and to my daughter, Clara, steadfast and serene and sensible ("The book's $24.99? That much?").

Sources

Ackerman, Diane. 1991. *A Natural History of the Senses*. New York: Random House.

Allam, Abeer. "What Could Stink This Much? Oh, the Mind Reels," copyright © 2005 by The New York Times Co. Reprinted with permission.

Angelos, James. "Citizen Pruners, on Deadwood Patrol," copyright © 2008 by The New York Times Co. Reprinted with permission.

Angier, Natalie. "Scientists Mull Role of Empathy in Man and Beast," copyright © 1995 by The New York Times Co. Reprinted with permission.

Bahrampour, Tara. "Years Pass. The Game Endures," copyright © 2000 by The New York Times Co. Reprinted with permission.

Bahrampour, Tara. "War Comes to Guernsey Street," copyright © 2003 by The New York Times Co. Reprinted with permission.

Baker, Nicholson. 1990. *The Mezzanine*. New York: Random House.

Barry, Dan. "About New York: Over Asphalt Rivers, the Source of the $3 Umbrella," copyright © 2005 by The New York Times Co. Reprinted with permission.

Barry, Dan. "About New York: The Yankees Strike Out, the Heckling Heats Up," copyright © 2006 by The New York Times Co. Reprinted with permission.

Barzun, Jacques. 2001. *Simple and Direct: A Rhetoric for Writers*. (4th ed.) New York: HarperCollins.

Bleifuss, Joel. "New Angles From the Spin Doctors," copyright © 1994 by The New York Times Co. Reprinted with permission.

Bleyer, Jennifer. "In a Swollen Park, Not a Swing to Spare," copyright © 2008 by The New York Times Co. Reprinted with permission.

Blount, Roy, Jr. "Deficit Lessons: Just Say O," copyright © 1993 by The New York Times Co. Reprinted with permission. (Adapted from Blount's *Camels Are Easy, Comedy's Hard.* New York: Villard.)

Blount, Roy, Jr. 2008. *Alphabet Juice.* New York: Farrar, Straus & Giroux.

Blundell, Wm. E. 1988. *The Art and Craft of Feature Writing.* New York: Penguin.

Bly, Carol. 2001. *Beyond the Writers' Workshop.* New York: Random House.

Brady, John. 1977. *The Craft of Interviewing.* New York: Random House.

Byrne, Josefa Heifetz, and Robert Byrne (eds.). 1974. *Mrs. Byrne's Dictionary of Unusual, Obscure, and Preposterous Words.* New York: Kensington.

Cappon, Rene J. 1982. *The Word: An Associated Press Guide to Good News Writing.* New York: Associated Press.

Clark, Roy Peter. 2006. *Writing Tools.* New York: Little, Brown and Co.

Clark, Roy Peter, and Christopher Scanlan. 2006. *America's Best Newspaper Writing.* (2d ed.) New York: Bedford/St. Martin's.

Critchell, David. "Angel's Dream," copyright © 2000 by The New York Times Co. Reprinted with permission.

Crow, Kelly. "Trying to Make Douglass Circle a Gateway, Not a Roadblock," copyright © 2003 by The New York Times Co. Reprinted with permission.

Cullen, Ed. 2006. *Letter in a Woodpile: Essays From NPR's All Things Considered.* Franklin, Tenn.: Cool Springs Press.

de Boinot, Adam Jacot. 2005. *The Meaning of Tingo.* New York: Penguin.

Diaz, Junot. 2007. *The Brief Wondrous Life of Oscar Wao.* New York: Riverhead.

Dillard, Annie. 1989. *The Writing Life.* New York: Harper Perennial.

D'Mello, Judy. "When Cabs Won't Stop, a Little Pinch May Help," copyright © 2003 by The New York Times Co. Reprinted with permission.

Dowd, Maureen. "Begrudging His Bedazzling," copyright © 2008 by The New York Times Co. Reprinted with permission.

Dreifus, Claudia. "Chloe Wofford Talks About Toni Morrison," copyright © 1994 by The New York Times Co. Reprinted with permission.

Duffy, Peter. "The Boy Who Saw the Virgin," copyright © 2002 by The New York Times Co. Reprinted with permission.

Erikson, Chris. "On Smith Street, a Dream Made Real," copyright © 2000 by The New York Times Co. Reprinted with permission.

Fershleiser, Rachel, and Larry Smith. 2008. *Not Quite What I Was Planning: Six-Word Memoirs by Writers Famous and Obscure.* New York: Harper Perennial.

Fifield, Adam. "Talking Union," copyright © 2001 by The New York Times Co. Reprinted with permission.

Fifield, Adam. "The Underground Men," copyright © 2003 by The New York Times Co. Reprinted with permission.

Fisher, M.F.K. 1989. *Serve It Forth*. New York: Farrar, Straus and Giroux.

Flaherty, Francis. "Some Regrets on the Decline of Brands," copyright © 1993 by The New York Times Co. Reprinted with permission.

Flaherty, Francis. "Missing Out in a Can't-Miss Market Year," copyright © 1997 by The New York Times Co. Reprinted with permission.

Fowler, H.W. 1985. *A Dictionary of Modern English Usage*. (2d ed.) New York: Oxford University Press.

Franklin, Jon. 1994. *Writing for Story*. New York: Penguin.

Freedman, Samuel G. 2006. *Letters to a Young Journalist*. New York: Basic Books.

Gardner, John. 1999. *On Becoming a Novelist*. New York: W.W. Norton.

Gilbert, Avery. 2008. *What the Nose Knows*. New York: Crown.

Haberman, Clyde. "Let Others Hit the Panic Button; Caviar's Served," copyright © 2006 by The New York Times Co. Reprinted with permission.

Hemingway, Ernest. 1932. *Death in the Afternoon*. New York: Scribner.

Herr, Michael. 1977. *Dispatches*. New York: Alfred A. Knopf.

Hopkins, Gerard Manley. 1880. "Spring and Fall: To a Young Child" (poem).

James, Henry. 1993. *Collected Travel Writings: Great Britain and America*. New York: Library of America.

Kane, Thomas S. 2000. *The Oxford Essential Guide to Writing*. New York: Penguin.

Kelly, Sean, and Rosemary Rogers. 1993. *Saints Preserve Us!* New York: Random House.

Kilgannon, Corey. "Darkness at Noon," copyright © 2001 by The New York Times Co. Reprinted with permission.

Kinetz, Erika. "A Patch of Dirt With a Haunting Past," copyright © 2001 by The New York Times Co. Reprinted with permission.

Kinetz, Erika. "Streets That Are Lighted by the Glow of Love," copyright © 2003 by The New York Times Co. Reprinted with permission.

King, Stephen. 2000. *On Writing*. New York: Simon & Schuster.

Klinkenborg, Verlyn. 2002. *The Rural Life*. New York: Little Brown & Co.

Kugel, Seth. "A Filipino Boy Band Meets Its Public," copyright © 2003 by The New York Times Co. Reprinted with permission.

Lardner, James. "The Endangered Quotation Mark," copyright © 1984 by The New York Times Co. Reprinted with permission.

Lee, Denny. "It's Not the Porn, It's the Color Scheme," copyright © 2003 by The New York Times Co. Reprinted with permission.

Lee, Denny. "Prima Donna of the Tank," copyright © 2003 by The New York Times Co. Reprinted with permission.

Lethem, Jonathan. 1999. *Motherless Brooklyn*. New York: Doubleday.

Lukas, Paul. 1997. *Inconspicuous Consumption*. New York: Crown.

McDonald, Brian. 2008. *Last Call at Elaine's*. New York: St. Martin's.

McPhee, John. "Profiles: A Forager," *The New Yorker*, April 6, 1968.

Mindlin, Alex. "A Namesake Park, and a Luminary Little Remembered," copyright © 2008 by The New York Times Co. Reprinted with permission.

Mooney, Jake. "If the Unitard Fits," copyright © 2005 by The New York Times Co. Reprinted with permission.

Neuwirth, Robert. 2005. *Shadow Cities*. New York: Routledge.

O' Grady, Jim. "He Keeps Marching Bands' Feet in Step With the Beat," copyright © 2002 by The New York Times Co. Reprinted with permission.

O' Grady, Jim. "It's Summer, but Plans Are Afoot to Vanquish High-Tech Hooky," copyright © 2003 by The New York Times Co. Reprinted with permission.

O'Rourke, P.J. "Ecology? Let's Talk Windshield Bugs," copyright © 1994 by The New York Times Co. Reprinted with permission. (Adapted from O'Rourke's *All the Trouble in the World*. New York: Atlantic Monthly Press.)

Orwell, George. 1946. "The Politics of the English Language" (essay).

Pedersen, Laura. "Petworking," copyright © 2000 by The New York Times Co. Reprinted with permission.

Preston, Richard M. "The Mountains of Pi," *The New Yorker*, March 2, 1992.

Prose, Francine. 2007. *Reading Like a Writer*. New York: Harper Perennial.

Read, Herbert. 1980. *English Prose Style*. New York: Pantheon Books.

Robinson, Peter. "Business School: A Traveler's Advisory," copyright © 1994 by The New York Times Co. Reprinted with permission. (Adapted from Robinson's *Snapshots From Hell: The Making of an M.B.A.* New York: Warner Books.).

Shapiro, Michael. "A Moment of Truth in Dodgerless Brooklyn," copyright © 2005 by The New York Times Co. Reprinted with permission.

Shea, Ammon. 2008. *Reading the OED: One Man, One Year, 21,730 Pages*. New York: Perigee.

Siegal, Allan M., and William G. Connolly. 1999. *The New York Times Manual of Style and Usage*. New York: Random House.

Sims, Norman, and Mark Kramer, eds. 1995. *Literary Journalism*. New York: Random House.

Smith, Charles Kay. 1974. *Styles and Structures.* New York: W.W. Norton.

Spiegelman, Art. 1986. *Maus: A Survivor's Tale.* New York: Pantheon.

Stewart, James B. 1998. *Follow the Story.* New York: Simon & Schuster.

Stott, Bill. 1991. *Write to the Point.* New York: Columbia University Press.

Strunk, Wm., Jr., and E.B. White. 1979. *The Elements of Style.* (3rd ed.) New York: MacMillan Publishing Co.

Terkel, Studs. 1974. *Working.* New York: Random House.

Terkel, Studs. 2007. *Touch and Go.* New York: New Press.

Vitello, Paul. "Helping the Disadvantaged, a Suffering Pet at a Time," copyright © 2006 by The New York Times Co. Reprinted with permission.

Wolff, Tobias. 2003. *Old School.* New York: Random House.

Wyatt, Sarah. "An Empty Spot at the Counter," copyright © 2003 by The New York Times Co. Reprinted with permission.

Yardley, Jim. "A Lament by the Hudson, as Trump Eclipses the Moon," copyright © 1997 by The New York Times Co. Reprinted with permission.

Zane, J. Peder. "In the Vineyard: Immigrant's Search for Logic Leads Him to Top of C.P.A. Class," copyright © 1995 by The New York Times Co. Reprinted with permission.

Zeiger, Arthur, ed. 1959. *Encyclopedia of English.* New York: ARCO Publishing.

Zinsser, William. 1990. *On Writing Well.* (4th ed.) New York: HarperCollins.

Index

abbreviations, clunky look of, 159
abstract adjectival phrases, role
 of, 111
accuracy in writing, 163–90
 distorting the truth, 183–87
 elusiveness of truth, 164–65
 fairness, 173–77
 hiding behind bland language
 or others' words, 167–71
 lapses in reporting, 173–77
 objectivity, difficulty of attain-
 ing, 164–65
 resting on logic and proof,
 179–82
 unavoidability of assertion,
 189–90
Ackerman, Diane, 106
action
 commentary vs., 75–78
 main engines of, 79–83
action verbs, 81
active voice, 43
actors vs. talkers, as sources, 9–11

Adachi, Jiro, 264
Allam, Abeer, 140–41
alliteration, 40–41
allusions, 265–67
Alphabet Juice (Blount), 150
"alternation of opposite ele-
 ments," 82
ancillary topics, disciplined ap-
 proach to, 65–69
anecdote leads, 209–12, 217–20
Angelos, James, 215
Angier, Natalie, 17–18
artful writing, 101–57
 close-to-the-vest writing,
 139–42
 contrasts, value of, 131–33
 fancy-pants prose, 155–57
 figures of speech, 117–20
 five senses, 105–8
 nonword tools, 143–47
 observation and vivid images,
 109–11
 quotations, value of, 125–29

artful writing (*continued*)
 showing vs. telling, 113–15
 symbols, 135–38
 word-love, 149–54
 yarn-spinning, 121–24
Art of Gradual Revelation,
 139–42
asides, narrative, 65–69
authority, hiding behind,
 167–71

bad people, empathy for, 20
Bahrampour, Tara, 35–36, 231,
 234–37
Baker, Nicholson, 109–11
balance kickers, 242
banks (subtitles), 251–54,
 261–64
bar charts, 145
Barry, Dan, 37–38, 107, 111
Beloved (Morrison), 19
Beshkin, Abigail, 136–37
Big Name Dropping, 67–68
Big Thought. *See* theme
billboard paragraphs, 229–31
Black Like Me (Griffin), 18–19
Blair, Jayson, 163
bland headlines, 258
Bleifuss, Joel, 73
Bleyer, Jennifer, 212
blind headlines, 258
bling headlines, 258
Blount, Roy, Jr., 122–23, 150
Blundell, William E., 82, 202,
 241
Bly, Carol, 187
body language, 14–15

Bok, Derek, 29
books on writing, xviii–xix
brands, putting a human face on,
 3–6
Brannock device, 274
breathless prose, 85–87
brevity in writing, 59–63
"brunch rule," 159
Burns, John F., xv–xvi
"but" (transition), 235–36
"buts" ("to be sures"), 51–52
Byrne, Josefa Heifetz, 151
by-the-way details, disciplined
 approach to, 65–69

Cappon, Rene "Jack," 8, 266
causation, as proof, 181
center stage, positioning theme
 at, 53–58
chain of events, symbol for,
 135–36
charts, as substitute for words,
 144–45
Chekhov, Anton, 37
Clark, Roy Peter, 87
close-to-the-vest writing,
 139–42
commentary vs. action, 75–78
complex writing, 59–62
concise writing, 61–63
concrete language, 255–59
connecting with sources (empa-
 thy), 17–21
Connolly, William G., 101–2
Conover, Ted, 18
consolidation of similar points,
 89–91

context paragraphs, 221–27
contrary voices (theme), 51–52
contrasts, artful, 131–33
correlation, as proof, 181–82
crescendos, and sequence of
 topics, 94–95
Critchell, David, 240
Crow, Kelly, 242–43
Cullen, Ed, 111

"dare the lightning," 169–70
de Boinod, Adam Jacot, 151
deception by selection, 185
decks (subtitles), 251–54,
 261–64
defensive empathy, 20–21
dense writing, 85–87
description
 of emotions, 13–16
 and movement in a story, 75–78
 observation and vivid images,
 109–11
details
 excessive, 59–63
 relating to theme, 35–38, 60–61
detours from story line, 65–69
Diaz, Junot, 14
*Dictionary of Modern English
 Usage* (Fowler), 157
differing viewpoints, 51–52
Dillard, Annie, 68
diminuendos, and sequence of
 topics, 95
ding words, 258–59
Dispatches (Herr), 41
dissenters (to theme), 51–52
distortions of truth, 183–87

D'Mello, Judy, 207–8
dotdotdot kickers, 242–43
double-take leads, 205–6
Dowd, Maureen, 208
dramatic contrast, 131–33
drawings, 143–47
drive-by deliciousness, 65–69
Duffy, Peter, 43–44, 222

ego and the writer, 27–29,
 155–57
Ehrenreich, Barbara, 18
Eichenwald, Kurt, 27
Elements of Style (Strunk and
 White), xviii–xix, 60, 86
Emerson, Ralph Waldo, 42
emotional aspects of story, 7–8
emotions, description of, 13–16
emotions of the writer, 27–29,
 155–57
empathy for sources, value of,
 17–21
Encyclopedia of English, 119
endings (kickers), 239–44
 balance, 242
 dotdotdot, 242–43
 human-note, 241–42
 perspective-shifting, 242
 summary, 239
 "voice unheard" and "topic
 untouched," 240–41
engines to propel story, 79–83
Erikson, Chris, 225–26
"Essay on Friendship" (Emerson),
 42
exploration of subject, thorough,
 47–49

face, human, 7–21
 actors vs. talkers, as sources,
 9–11
 describing emotions, 13–16
 emotional aspects of story,
 7–8
 empathy for sources, value of,
 17–21
 inner life of source, 17–21
 talking heads, as sources, 9–11
fact-checking, 163
fact leads, 202–3, 214–15,
 217–20
facts vs. emotions, 13–14
fairness, 173–77. *See also* truth
 and fairness
fancy-pants prose, 155–57
fearful writers, xv-xviii, 155–57
feather-duster leads, 197–98
feelings, description of, 13–16
fever charts, 145
Fifield, Adam, 44, 209–12, 223
figures of speech
 as enlarging reader role, 118
 as story engine, 80
 vividness of, 117–18
Firstman, Richard, 122
five senses, 105–8
 hearing, 107
 sight, 106
 smell, 106, 107
 taste, 106–7
 touch, 106
focusing paragraphs, 229–31
foils (dramatic contrasts),
 131–33
footnotes, 67n

Fowler, H.W., 157
Frankel, Max, xv
Franklin, Jon, 118–19
Freedman, Samuel G., 170, 186
future action, as story engine, 80

Gallicisms, 157
Gardner, John, 79, 154
gatekeeper, writer as, 59–63
general and specific statements,
 as story engine, 81–82
Gibbons, Euell, 273
Gilbert, Avery, 106
graphic novels, 146–47
graphics, as substitute for words,
 143–47
Griffin, John Howard, 18–19
grouping similar points together,
 89–91

Haberman, Clyde, 37
half-a-face principle, 119
Harry Truman leads, 215
Harvard Independent, xvii–xviii
headlines (titles), 249–59
 as distilled writing, 251–54
 bland, 258
 blind, 258
 bling, 258
 finding concrete words for,
 255–59
 satisfaction of writing, 252-54
hearing, sense of, 107
Hedges, Chris, 23
Hemingway, Ernest, 119, 133
Herr, Michael, 41
hidden action, as story engine, 80

Hopkins, Gerard Manley, 138
Hoyt, Clark, 171
human element in story, 7–8
human face, 7–21
 actors vs. talkers, as sources,
 9–11
 describing emotions, 13–16
 emotional aspects of story,
 7–8
 empathy for source, 17–21
 inner life of source, 17–21
 talking heads, as sources,
 9–11
human-note kickers, 241–42
humor, 271–74
hyperbole, 119

iambic pentameter, 41–42
Iceberg Theory, of Hemingway,
 119
ideas, as story engine, 80–81
illustrations, 143–47
immersion writers, 18–19
Inconspicuous Consumption
 (Lukas), 274
indirection, 117–20
"in media res" leads, 208
inner life of subject, 17–21
interaction with reader, 117–20
interviewing
 opening emotional window, 16
 patience in, 126–27
 quotation and, 125–29
"in the news" connections, for
 narrative asides, 67
intimidated writers, xv–xviii,
 155–57

James, Henry, 95
jargon, 155–57
job titles, 167–68
Johnson, Samuel, 129
Johnston, David Cay, 27
Jordan, Lewis, 249
juicy tidbits, 65–69
justificatory settings, 225–27

Kelly, Sean, 17
Kennedy, John F., 90–91
kickers, 239–44
 balance, 242
 dotdotdot, 242–43
 human-note, 241–42
 perspective-shifting, 242
 summary, 239
 "voice unheard" and "topic
 untouched," 240–41
Kilgannon, Corey, 113–14, 115
Kinetz, Erika, 128, 144–45, 206,
 242
King, Martin Luther, Jr., 41
King, Stephen, 78, 120, 170
Klinkenborg, Verlyn, 107
Kramon, Glenn, 165
Kugel, Seth, 207

Labor Theory of Writing, 67–68
Latinate words, 61
leads, 193–220
 anecdote, 209–12, 217–20
 arousing reader curiosity,
 201-03
 as broad-brush statement,
 201-03
 comparing different, 217–20

leads (*continued*)
 double-take, 205–6
 fact, 202–3, 214–15, 217–20
 Harry Truman, 215
 hooking the reader with,
 201–3
 "in media res," 208
 mystery, 207–8
 plain-speaking, 215
 role as riddle, 201-03
 scene, 213–14
 throat-clearing (Um), 19
 vividness of, 198–99
 warring roles of, 197–99
 word choice in, 217–20
LeBlanc, Adrian Nicole, 18
Lee, Denny, 89–90, 241–42
Lethem, Jonathan, 97
letter shapes, 152
Letters to a Young Journalist
 (Freedman), 170
listening, art of, 126–27
Lukas, Paul, 274
lullabies, 39–40

McDonald, Brian, 107
McPhee, John, 120, 151, 273
made-up action, as story engine,
 80
main theme of story, positioning
 at center stage, 53–58
Malcolm, Janet, 128
maps, as substitutes for words,
 146
Maus (Spiegelman), 146–47
Meaning of Tingo (de Boinod),
 151

mental action, as story engine,
 80–81
metaphor
 describing body language,
 14–15
 extended, uses of, 122-23
 role as story engine, 73–74, 80
 theme-related, 37–38
meter (poetic), 40–41
Mezzanine (Baker), 109–11
Miller, Judith, 194
Mindlin, Alex, 36, 213–14
mix of sentences, as story engine,
 82
"moreover" (transition), 236
Morrison, Toni, 19
Motherless Brooklyn (Lethem),
 97
motion. *See* narrative motion
*Mrs. Byrne's Dictionary of
 Unusual, Obscure, and
 Preposterous Words* (Byrne),
 151
Murray, Donald M., 62, 63
mystery leads, 207–8

name-dropping, 67–68
narrative motion, 73–95
 action vs. commentary, 75–78
 breathless prose, 85–87
 grouping similar points
 together, 89–91
 main engines of, 79–83
 sequence of topics and,
 93–95
natural action, as story engine,
 79

Natural History of the Senses (Ackerman), 106
near misses, in anecdote leads, 211
needless words, deleting, xviii, 59–63, 86
Neuwirth, Robert, 226
New York Post, 87, 171
New York Times Manual of Style and Usage (Siegal and Connolly), 101–2, 159
Nickel and Dimed (Ehrenreich), 18
Nietzsche, Friedrich, 269
nonword tools, 143–47
numbers, artful presentation of, 245
nut paragraphs, 229–31

objectivity, elusiveness of, 164-65
obscure words, 61
observation and vivid images, 109–11
O'Grady, Jim, 35–36, 241
Old School (Wolff), 253–54
"Omit Needless Words," xviii, 59–63, 86
Onion, 272–73
onomatopoeic words, 40, 150
On Writing Well (Zinsser), 239
O'Rourke, P.J., 74
Orwell, George, 119
overattribution, 156
overexplanation, 156
oversize egos, 155–57
overstuffed writing, 59–62
oxymorons, 119

pacing, 85–87
paragraphs
 billboard (nut or focusing), 229–31
 context (setting), 221–27
 static, 76–77
parallelism, 82
paraphrase, 159
passion in writing, 27–29
passive voice, 43, 170
Pedersen, Laura, 133
photographs, 143–47
pictures, 143–47
"pie" charts, 145
plain-speaking leads, 215
positioning theme at center stage, 53–58
Preston, Richard, 123–24
Pride of Authorship, 67–68
profluence, 79
proofs, relative value of various, 179–82
Prose, Francine, 40
psychological barriers to writing, 27–29, 155–57
punctuation, 245–46
puns, 66, 265–67

qualifications to theme ("to be sures"), 53–58
Queenan, Joe, 255–57
quotations
 art of listening and, 126–27
 editing of, 159
 great value of, 125–29
 nonsense, 169-70
 paucity of, 125–29

quotations (*continued*)
"show, don't tell" rule, 114–15,
127
writers' dislike of, 128–29

Raines, Howell, 117–18
Random Family (LeBlanc), 18
Rasenberger, Jim, 226–27
Read, Herbert, 42, 111
readers, active role for, 117–20
Reading Like a Writer (Prose), 40
Reading the OED (Shea), 151
repetition, good and bad uses of,
41, 156, 236
reporting
actors vs. talkers, as sources,
9–11
fairness to sources, 173-77
interviewing, importance of,
126
sources, evaluating, 180–81
witnessing vs. interviewing,
115
rhyming words, 150–51
rhythm of sentences, 40–42
"riddle" principle of leads, 202–3
right-branching sentences, 78
Rimer, Sara, 177
Roberts, Sam, 249
Robinson, Peter, 271–72
robust verbs, 43, 81
Rogers, Rosemary, 17
Roget, Peter Mark, 154
Rolling Nowhere (Conover), 18

Saint Martin de Porres, 17
Scanlan, Christopher, 87

scene leads, 213–14
Self-Made Man (Vincent),
18–19
senses, 105–8
hearing, 107
sight, 106
smell, 106, 107
taste, 106–7
touch, 106
sensitive subjects, 175–77
sentences
rhythm of, to echo meaning, 40
varied structure, as story
engine, 82
sequence of topics, as story
engine, 93–95
settings, 221–27
Shadow Cities (Neuwirth), 226
Shakespeare, William, 20,
41–42
shapes
of letters, 152
of whole words, 153
Shapiro, Michael, 140
Shea, Ammon, 151
shoehorn, 66–67
shortening articles, methods for,
59–63
"show, don't tell" rule, 113–15,
127
sidebars, 67
sidelights, narrative, 65–69
"sideways" writing, 117–20
Siegal, Allan M., 101–2
sight, sense of, 106
similar points, grouping together,
89–91

similes, 14–15, 80
simplifying the story, 59–63
Sims, Norman, 120
sly writing, 139–42
smell, sense of, 106–7
Snoots, 155–57
"soft" letters, 39–40
sounds of words
 beauty of, 150–51
 meaning and, 39-42
sources
 actors vs. talkers, 9–11
 empathy for, 17–21
 inner life of, 17–21
 value as proof, 180–81
specific and general statements,
 as story engine, 81–82
Spiegelman, Art, 146–47
Spindler, Amy M., 27
"spreading out" technique, for
 kickers, 241
Stalking the Wild Asparagus
 (Gibbons), 273
static paragraphs, 76–77
Stephens, Edward, 165
Stewart, James B., 202
"still life" paragraphs, 76–77
Story Devil, 184–87
Story Doctoring, at *New York
 Times*, xvi–xvii
story-level writing rules vs. style-
 level ones, xix–xx
story motion. *See* narrative
 motion
story theme. *See* theme
Stott, Bill, 169
strong verbs, 81

Strunk, William, Jr., *Elements of
 Style*, xviii–xix, 60, 86
style-level writing rules vs. story-
 level ones, xix–xx
subject (person). *See* source
subject (topic). *See* theme
subjects, sensitive, 175–77
subtitles (banks), 251–54,
 261–64
Sulzberger, Arthur Ochs, Jr., 271
summary kickers, inadequacy of,
 239
superfluous words, xviii, 59–63,
 86
suspended sentences, 41
symbols, 135–38
synonyms, 150–51, 153–54

talking heads, as incomplete
 sources, 9–11
taste, sense of, 106–7
telling vs. showing, 113–15
temptations of the storyteller,
 183-87
tender topics, 175–77
Terkel, Studs, 127, 128–29
Thackeray, William Makepeace,
 111
theme, 31–69
 awareness of, as writing aid,
 xix–xx
 caveats about, 51-52
 choosing just one, 31-33
 exploring thoroughly, 47–49
 including "buts," 51–52
 selecting details that echo,
 35–38

theme (*continued*)
 positioning at center stage,
 53–58
 preserving primacy of, 31–33
 qualifications to, 51–52
 short detours from, 65–69
 sound meanings of words and,
 39–42
 subtitles and, 261–62
 verbs and, 43–45
 writer's intense focus on, 35–38
theme-colored glasses, 35–38
titles (headlines), 249–59
 as distilled writing, 251–54
 bland, 258
 blind, 258
 bling, 258
 finding vivid, concrete words
 for, 255–59
 satisfaction of writing, 252–54
titles (personal and organiza-
 tional), 167–69, 170–71
"to be sures" (caveats) 89–91
"topic untouched" kickers,
 240–41
touch, sense of, 106
transitions, 233–37
 abrupt, 233
 "but" and other common, 235–36
 story organization and,
 233–35
 typographical devices as, 233
 word repetition as, 236
trimming texts, 59–63
trochee, 42
trunk-and-branch problems
 (theme), 53–58

truth and fairness, 163–90
 distorting the truth, 183–87
 elusiveness of truth, 164–65
 hiding behind bland language
 or others' words, 167–71
 lapses in reporting, 173–77
 objectivity, difficulty of attain-
 ing, 164–65
 resting on logic and proof,
 179–82
 unavoidability of assertion,
 189–90
turbo verbs, 81
Twain, Mark, 154
typographical devices, as transi-
 tions, 233

Um leads, 197
unneeded details, in anecdote
 leads, 211

verbs
 engine of story motion, 81
 tool to strengthen story theme,
 43–45
villains, empathy for, 20
Vincent, Norah, 18–19
Vitello, Paul, 77–78
vivid headlines, 255–59
vivid imagery, 109–11
vivid words, 152–54, 258–59
"voice unheard" kickers,
 240–41

Weir, Richard, 49
White, E.B., *Elements of Style*,
 xviii–xix, 60, 86

whole person vs. talking head, as
 source, 9–11
Wolff, Tobias, 253–54
wordiness, avoiding, xviii, 59–63,
 86
word-love, 149–54
wordplay, 101–3, 265–67
words
 in leads, 217–20
 repetition of, 41, 236
 shape of, 153
 sound meanings of, 39–42,
 150–51
 synonyms, 82-83, 150–51,
 153–54

vividness of, 152–54,
 258–59
Working (Terkel), 128–29
writers' groups, 157
writing books, xviii–xix
"writing by committee," 33
writing ticks, 155–57
Wyatt, Sarah, 31–33

Yardley, Jim, 102
yarn-spinning, 121–24

Zane, J. Peder, 19–20
Zinsser, William, 239

ABOUT THE AUTHOR

FRANCIS FLAHERTY has worked for the past 16 years at *The New York Times*, most recently as the deputy editor of the City Section. He has written for *Harper's*, the *Atlantic*, *Commonweal* and the *Progressive*, and teaches journalism at New York University. Flaherty holds a B.A. from Harvard College and a J.D. from Harvard Law School, and lives with his wife and two children in Brooklyn, N.Y.